The American Photo-Text, 1930–1960

BAAS Paperbacks

Published titles

www.edinburghuniversitypress.com/
series/BAAS

The American Photo-Text, 1930–1960

CAROLINE BLINDER

EDINBURGH
University Press

Edinburgh University Press is one of the leading university presses in the UK. We publish academic books and journals in our selected subject areas across the humanities and social sciences, combining cutting-edge scholarship with high editorial and production values to produce academic works of lasting importance. For more information visit our website: edinburghuniversitypress.com

© Caroline Blinder, 2019

Edinburgh University Press Ltd
The Tun – Holyrood Road
12(2f) Jackson's Entry
Edinburgh EH8 8PJ

Typeset in 10/12 Adobe Sabon by
IDSUK (DataConnection) Ltd, and
printed and bound in Great Britain.

A CIP record for this book is available from the British Library

ISBN 978 1 4744 0410 5 (hardback)
ISBN 978 1 4744 0411 2 (webready PDF)
ISBN 978 1 4744 0412 9 (paperback)
ISBN 978 1 4744 0413 6 (epub)

Contents

PART III: THE 1950s

List of Illustrations

Acknowledgments

I would like to thank a number of institutions, who have been instrumental in allowing me access to photographic archives and papers: Margaret Bourke White Papers, Special Collections Research Centre, Syracuse University; Dorothea Lange Archives, Oakland Museum of California; Weegee Archive, International Center for Photography, New York; Walker Evans Archive, Metropolitan Museum of Art; James Agee Archive, Special Collections Library at the University of Tennessee, Knoxville; Nebraska University Press for permission to reprint Wright Morris; Center for Creative Photography, University of Arizona; Philadelphia Museum of Fine Art, Paul Strand Collection; Special Collections at the Art Institute of Chicago library; and, of course, Goldsmiths University, London, for providing research leave and contributing to illustrative costs.

More importantly, numerous friends, colleagues and family members have helped me with on-going advice and commentary on earlier versions: Natasha Blinder Nikolajsen, Alexandra Buhl, David Campany, Rick Crownshaw, Mick Gidley, Nicolo Giudice, Elena Gualtieri, Mike Hammond, Philip McGowan, Peter Nicholls, Kim Nikolajsen, Paula Rabinowitz and Guy Stevenson, not to mention all those very kind students who patiently listened to me pretending to know one or two things about photography.

For my family

Introduction: The American Photo-Text

The moment our discourse rises above the ground of familiar facts and is inflamed by passion or exalted by thought, it clothes itself in images.

Ralph Waldo Emerson, 'On Nature' (1836)[1]

When asked in a 1964 interview whether he considered himself a documentary artist, the American photographer Walker Evans replied, 'My thought is that the term documentary is inexact, vague, and even grammatically weak . . . what I believe is really good in the so-called documentary approach to photography is the addition of lyricism.' For Evans, this lyricism was definable through a 'purity, a certain severity, rigor, simplicity, directness' and, above all, 'clarity'.[2]

The idea of clarity, simplicity and directness as the definition of a particular form of photographic endeavour has become a mainstay in how we look at those objects, faces, artefacts and circumstances representative of twentieth-century American life, so much so that documentary photography – from Dorothea Lange's Depression era 'Migrant Mother' to Lewis Hine's construction workers – has largely determined what we perceive to be the true face of America in the first half of the twentieth century. This confluence of a personal and collective vision of American life, rural and urban, working and middle-class, was not the sole provenance of the photographer, however, as became manifest in a series of photo-textual collaborations from the 1930s, 1940s and 1950s. In these books, published and marketed mostly as collaborations between established photographers and writers, the call for a renewed lyricism within American photography was heard as much through a variety of textual forms as through the images themselves. As the context for what Evans called 'the circumstances native to American life'

became increasingly complex and manifold, so did the interaction between image and writing. Not only did the writing skills of individual photographers come to the fore through the use of creative captioning, poetry, quotations and narratives, but also the textual landscape of the photo-text became an integral part of how the photographic images were sequenced and structured. As introductions likewise became a crucial part of the photo-text, the choice of writer became an important denominator, a way to link the outward visual representation of subjects with their inner lives, just as postscripts and afterwords became a way to gloss the underlying ideological subtexts and meanings of the photographs.

This book discusses a series of photo-texts from the 1930s to the 1950s in order to study the development of the photo-text as a genre and, in particular, how the publication in book form enabled documentary photography to take on the vernacular qualities of American writing during the same period. Whilst the rise of the *Time/Life* emporium and syndicated newspapers was a crucial step towards consolidating American photography in the public mind in the 1930s and 1940s, the fascination with regionalised studies of sharecroppers and workers' fiction in the 1930s came to the forefront through photo-textual collaborations. As a more hardboiled vernacular became popular in the 1940s and 1950s, the photo-text similarly was as reflective of current literary and popular trends in publishing as it was symptomatic of the rapid advancements in photography during the same period.[3] Whether they were on the margins of the photographic establishment, as Robert Frank was in the 1950s, or firmly established and renowned, as Margaret Bourke-White was by the late 1930s, many photographers saw the advantages of aligning themselves with writers capable of rendering the vernacular tongue and sensibilities of the subjects portrayed. By striving to consolidate a form of native lyricism, the photo-text became the locus for how the practice of photography could become truly engaging, a more intimate form of communication rather than simply an authoritative outlet for news. This process went both ways as writers began to rely on photography to illustrate the narrative underpinnings of an increasingly visualised culture *and* to use it as a metaphor for the visionary capabilities of their texts.

As the following chapters illustrate, the blurred lines between the use of photography in more conventionally illustrative ways and as an investigation into what constitutes the essence of American

regional culture are partly what render these projects distinct. Capable of being both critical and representative of American ideology on a more complex level than that afforded by journalism, the ambitious photo-text could make the United States both more palpable and more palatable to a wider audience. At the same time, many of these books attempted to present the underside of American culture to a mass audience, and at times succeeded in doing so. For an audience emerging from the Depression into World War II and moving onwards through the Cold War, focusing on the domestic arena became a crucial way to navigate certain national issues as well as to confront certain national anxieties.

In order to understand the mechanism by which these photo-texts sought to 'Americanise' themselves, this study devotes itself to the 1930s, 1940s and 1950s precisely because these were the decades when photography's role as a quintessential part of both documentary and art practice became consolidated. This is not to say that the history of American photography prior to the Depression is not equally instrumental, but since it has been charted and analysed in numerous studies, many focusing on Alfred Stieglitz and other early proponents of American photography as an art form, it will not be dealt with here.[4] By the 1930s, however, much documentary photography had become synonymous with both a written *and* a visual form of vernacular lyricism. More than just an overriding interest in the objects, places and architecture indicative of native crafts and arts, the search for a vernacular aesthetic in speech patterns, the quotidian and everyday life became a cipher for a culture in which the farmer, the worker, the woman in the kitchen and even the man in the gutter were deemed suitable as subject matter. This is not to say that the photo-text always operated under the remit of a more leftist, people-centred context, although it often did. Nor is it to say that all photo-texts were gratuitous exercises in showing the worst off within American society to their middle-class counterparts, although they were that too occasionally. What it did mean was that photography overwhelmingly took its cue from the 'common' people, although many of the writers and photographers collaborating on the photo-texts were trained in ethnography, sociology and other academic disciplines that were distinctly not working-class. The search for an operable concept of the vernacular became a way, then, to investigate what it meant to identify and maintain a genuine American identity when national systems and

institutions were vulnerable, and at the same time remain critical of the injustices dormant within that system. In order to do so, it became crucial to consolidate the photograph's ability to render not just the external landscape but also the internal – even emotional – landscape of the people living there.

It is no coincidence, then, that this study takes the 1930s as its starting point. While Walker Evans was consolidating his role as a photographer of vernacular culture, life was going increasingly awry both economically and socially. This, in itself, lent itself to the dissemination of photographs as a way to show the poverty and destitution facing the nation and it provided a platform for a new type of critical discourse. In the face of economic and social anxieties, photo-textual practice for photographers such as Dorothea Lange and Margaret Bourke-White (both of whom had worked to promote Roosevelt's New Deal) promised a clear alignment between photography and a more redemptive version of the American dream. If that dream appeared to be temporarily derailed, the photo-text could at least illustrate the culture from which this dream emanated. In other words, it could illuminate the consequences of bad economic policies whilst pointing out the inherently American resilience of those people suffering under them.

The seeds of an ethos of documentary photography as something that could illuminate the essence of America and be critical towards its politics had, of course, been present in photographic projects prior to the 1930s. Jacob Riis's muckraking *How the Other Half Lives* (1890) remains one of the earliest and most forceful indictments of the slums of New York and the social problems of immigrant populations.[5] In this early photo-text, the accompanying writing by Riis is as prominently placed as his photographs and promises to 'explain', through extended analysis, why the situation pictured is as dire as it looks. Likewise, Lewis Hine's affective images of child labour in the United States, produced for the National Child Labor Committee, were often accompanied by his own captions and poster proclamations attesting to the circumstances and injustices of the labour system, a practice that he himself saw as paramount to the success of his attempts to change child labour legislation.[6] While Riis considered himself a journalist first and foremost and Hine worked under the tutelage of various reform groups, both photographers – whilst attuned to the potential of documentary photography as a political, ethnographic and social tool – were less interested in the lyrical and

narrative possibilities of photographs and text. For them, the accompanying writing was first and foremost an informative tool rather than a way to create a distinct narrative.

By the 1920s and 1930s, however, photographers such as Lange, Bourke-White and Doris Ulmann, all of whom studied at the New York Ethical Culture School, where Hine had also taught, felt the impetus towards project-based human interest photography, so much so that by the late 1930s, Evans's call for a lyrical tenor as an essential component within the documentary aesthetic articulates what had by then become an increasingly progressive photographic practice. In turn, these ideas had become the stepping-stone towards a consolidation of documentary photography as an art form, and thus as something eligible for publication in book form. By arguing for documentary photography as capable of being both emotive in spiritual terms and authentic in terms of subject matter, the photo-text was free to establish a distinct photographic vision where realism and lyricism could coincide.

This is not to say that the seeds of photo-textual interaction were solely part of a twentieth-century ethos. Within Walker Evans's concept of a lyrical documentary aesthetic, the strands of earlier nineteenth-century Transcendentalist ideas were germinating, reflecting in rather romantic terms a more idealistic belief in the visionary capabilities of the photographer's eye.[7] Such ideas, as this book will chart, often emanate most clearly in some of the essays and introductions that form a constituent part of the photo-texts overall. The two seminal essays by Lincoln Kirstein and William Carlos Williams that bookend Walker Evans's *American Photographs* (1938) are such examples. In these essays, the desire to articulate a new manifesto for photography not only entails a distinctly vernacular vision of America, but also contains an attraction towards transcendent definitions of photography's capabilities.[8] Instead of embracing photography primarily as a sign of the machine age and modernity, documentary observers of the 1930s gravitated towards those parts of the American landscape seemingly missed by progress and modernisation. Thus, paradoxically, many of these photo-texts were more indicative of the nineteenth century rather than of twentieth-century life.

This is why this study starts, not with the more iconic work by Evans, Bourke-White and Lange, but with the overlooked *Roll, Jordan, Roll* (1933) by Julia Peterkin and Doris Ulmann. This

photo-textual collaboration, one of the first to employ photography deliberately to return to a more pastoral, if politically problematic, vision of the South, looks towards the modernist practice of later photographers and yet equally reflects the biases and ideological leanings of previous decades. Ulmann and Peterkin's groundbreaking study of former slaves and their antecedents in North Carolina in the late 1920s and early 1930s remains, in many ways, unmatched in its attempt to portray both a region and a people. Breaking the colour line, Ulmann's history as a Pictorialist photographer of softly focused photogravures, most famously reprinted in Alfred Stieglitz's *Camera Works* in the 1910s, enabled her to combine a uniquely artistic vision with a sociological and ethnographic agenda, one both marred and accentuated by her outsider status as a white Northern photographer. Combined with the writer Julia Peterkin's version of an oral history, deliberately vernacularised to take the cadences and intonations of a region into account, *Roll, Jordan, Roll* is as much an indication of the author's Southern heritage and bias as it is of actual Southern life. In this respect, *Roll, Jordan, Roll* instigates what subsequent chapters will also examine: namely, a complex discourse within the American phototext regarding how to focus on a disenfranchised group of people in order ostensibly to elevate and dignify them. Ulmann and Peterkin's wistful and nostalgic desire to utilise a twentieth-century medium in order to render what, for many, was fast becoming an outmoded nineteenth-century ideology none the less ensured that their phototext was largely forgotten and, if not, often vilified as an antiquated and racist book.

For the successful commercial photographer Margaret Bourke-White, the distinction between her more formalist/urban images of the 1930s and her rural/agrarian ones was glossed over in what is often defined as the first 'proper' photo-text of the decade, *You Have Seen Their Faces* (1937), one of the very first to be marketed as the work of two well-known artists, despite the fact that *Roll, Jordan, Roll* pre-empted it by several years. Bourke-White's collaboration with the famous Southern writer Erskine Caldwell is dealt with in Chapter 2 through a comparison with another iconic photo-text, *American Exodus* (1939), by Dorothea Lange and the sociologist Paul Taylor.[9] Both Bourke-White and Dorothea Lange recognised an agrarian culture's potential to synthesise a version of what it meant to be an American – even if that identity was rapidly being

eroded during the Depression. It is no coincidence in this respect that Lange's continued fame as a documentary photographer relied as much on the iconographical status of her subjects individually as on their portrayal as part of a wider dispossessed collective. A few years apart, *You Have Seen Their Faces* and *American Exodus* – both photo-textual collaborations between partners in a joint literary and photographic documentary effort – nevertheless garnered very different reputations.[10] Dorothea Lange and Paul Taylor's *American Exodus* was heralded as a classic of concerned journalism – a reputation which largely has gone unchallenged – while Bourke-White and Erskine Caldwell's *You Have Seen Their Faces* has since been critiqued as a suspect exercise in exposing the sharecropper's plight in the 1930s. Although very different exercises in the relative use-value of photography as a medium for political change, both demonstrated a belief that the camera's role was partly sanctified by its subject, the idea of a vernacular photography justified through a constructed sense of pathos and veracity. Despite the varying backgrounds of the photographers, from portraiture to commercial and industrial photography, both books were thus knowingly and deliberately playing with a tradition of writing, in which sentimentalism and empathy played pivotal roles.

Whilst both Julia Peterkin and Erskine Caldwell were drawing on the rhetoric of nineteenth-century sentimental literature in their visions of the South, Ralph Waldo Emerson's philosophy and Walt Whitman's poetics – with their belief in commonality and collective desire – were being invoked in the 1930s to define a longer lineage of democratic art, including photography. The iconic essays by Lincoln Kirstein and William Carlos Williams, published together with Evans's images in *American Photographs* (1938), were instrumental in how the sequencing of the photographs was read. To a large extent, these essays did more than simply turn a collection of photographs into a viable book: they were seminal in establishing Evans's status as an iconic photographer of American vernacular culture. Setting the tone for future readings of American photography, Kirstein and Williams – among others – used the example of Evans to educate a wider public about photography as a political and aesthetic art form.

How Kirstein and Williams created this particular persona for Evans is the subject of Chapter 3, in which the writing in Evans's first monograph, *American Photographs*, seeks to identify not only

photography's reliance on the vernacular as subject matter but also the appropriate locations for such efforts. In these instances, a paradox is often present, as the South is rendered as an inhospitable geography and yet, at the same time, a photographic sanctuary for forms of life that were fast becoming outdated. While many of these studies shared the political bent of Riis and Hine's work decades before, the interest in rendering the actual tenor of the people photographed through quotations and extracts is – as will be shown – a way to prove the authenticity of the project as well. As we will see in the following chapters, the very idea of representing 'Americanness', black or white, male or female, Southern or Northern, urban or rural, does not just become the subject of the text or the image. It also extends itself into an equally pressing question: how does the artist/photographer/writer present him- or herself as suitable for the task of doing so?

The one collaboration most famous for its ethical and moral questioning of the documentary format is *Let Us Now Praise Famous Men* (1941), a collaboration between Walker Evans and the writer and journalist James Agee.[11] Chapter 4 looks briefly at this iconic photo-text, instigated during the 1930s but not published until 1941, and often defined as one of the most radical responses to the politics of the documentary style of the 1930s. The incorporation of images into the book is fundamentally different from that of Lange and Bourke-White. Unlike *You Have Seen Their Faces* and *American Exodus*, the photographs are printed at the beginning of the book without captions or titles. Thus, what was originally meant to have been a simple piece of photo-reportage for *Fortune* magazine became, through the efforts of both Agee and Evans, a much more complex and convoluted documentary photo-text. Not only did *Let Us Now Praise Famous Men* obsessively question its own documentary aesthetic, but it also presented the format of the photo-text as an investigative apparatus capable of looking into the very nature of photographic reality and writing itself. Through Agee's text, the questions of what an American vernacular might be, whom it belonged to and, more importantly, who had the right to render it are asked repeatedly.

Whilst *Let Us Now Praise Famous Men* has since been heralded as a masterpiece of photo-textual experimentation, an intensely regional look at two sharecropper families in Alabama, its vernacular credentials did not – as indicated earlier – exist in a national

vacuum. Agee's awareness of a literary transatlantic modernism was matched in this instance by Walker Evans's attraction to a variety of European models of both photography and writing, from the German photographer August Sander's typographical projects of the 1920s and 1930s to the French novelist Gustave Flaubert's nineteenth-century literary realism. In similar ways, Margaret Bourke-White's attraction to Russian formalist photography and James Agee's familiarity with European modernism, as examples of transatlantic cross-fertilisation, are evident in their American work as well.

Whilst the 1930s brought an interest in more continental models of modernist experimentation into the collaborative work of writers and photographers in the USA, others were intent on maintaining a distinctly American aesthetic. The writer/photographer Wright Morris's work provides an extraordinary vision of vernacular culture as absolutely central to the photo-text. Chapter 5 examines Wright's focus on his home town in Nebraska through several decades and on how it provides a timeless vision of a very particular local culture. In Morris's *The Inhabitants* (1946) and *The Home Place* (1948), the novelist and photographer frequently invokes the nineteenth-century writer and philosopher Henry David Thoreau in order to define a type of vision distinguished by a respect for landscape and the emotions contained therein.[12] A proponent of a distinctly vernacular aesthetic, Morris's interest in representations of the everyday is used to render the quintessential American 'native' in photographic as well as literary terms. In *The Inhabitants*, where photographs are accompanied by imagined snippets of conversations and commentary, we sense an astuteness regarding the wider lineage of vernacular photography and a response to earlier photo-textual attempts by Walker Evans and Dorothea Lange at rendering an agrarian nation. As in Evans's *American Photographs*, Morris's aesthetic concerns traces back to a vernacular tradition that owes as much to nineteenth-century American philosophy as it does to twentieth-century visual modernism. While this link to a nineteenth-century aesthetic is partly channelled through Morris's reappropriation of Transcendentalist writing in a number of his later essays on photography, it is in *The Inhabitants* that Morris most clearly constructs this vantage point. For Morris, the world is always seen as mediated, through both the photographs and the accompanying vernacular rhetoric of the 'inhabitants' he

looks at and writes about. Structured as a continuous investigation into how we orchestrate our place in the world as both Americans and artists, the tenets of a nineteenth-century aestheticism are as prevalent in Morris's photographs as his acknowledgment of a 1930s documentary heritage.

This sense of the American landscape as mediated through the gaze of the photographer, as well as filtered through a literary sensibility, is also evident in the post-war era's turn towards urban life. Chapter 6 examines how the photographer Weegee (Arthur Fellig) presents an idiosyncratic vision of the city through the movements of those usually on the margins of society. In Weegee's most famous work, the photo-text *Naked City* (1945), with photographs, text and captions by Weegee himself, the city is both romanticised as a collective melting pot and revealed as a morbid site of crime and violence. In this hard-hitting homage to the mean streets of New York, the ability to straddle an uncomfortable line between the horrors and charm of urban life comes through in Weegee's use of puns as captions and a sentimentalism masked by the hardboiled cynicism of his writing. As the city becomes an artistic vehicle for an outplaying of certain external and internal worries to do with cohabitation, race and class, the photographic journalism witnessed in Riis and Hine is mediated by Weegee into a more confident sense of genre and, more importantly, a defence of the photographer's right to occupy the same landscape as his or her subjects. This mediation, significantly, is very much due to Weegee's extraordinary abilities as a writer, an aspect of *Naked City* that is continuously overlooked in favour of his more famous imagery of criminals and violence. Weegee's writing is as influenced by hardboiled detective fiction as it is by tabloid journalism, partly because of his work as a crime photographer for various New York broadsheets. None the less, Weegee also shared an obsession with what James Agee would call the lyricism of the city: a lyricism designed to render the streets as staging areas for something intimate, as well as fantastical and imaginative. Here, the city becomes a place whose utilitarian function is circumvented in favour of play and even violence. Witnessing in this context, as Weegee's deadpan captions insinuate, becomes more than an obsession with the initial witnessing of a crime and the witnessing of the photographer documenting the crime. It becomes, also, the child witnessing the adult and re-enacting, through mimicry and play, the gestures of adulthood in all its various configurations. That all the

world is a stage is part of Weegee's rhetoric, and that photography also engages in various forms of masquerading and play acting is part of this. As in other photo-texts, particularly those of the 1950s, the city is used as a backdrop for an investigation into human nature itself, much different from the distinctly agrarian regional identity of earlier documentary efforts.

In Weegee's case, the textual apparatus that enables him to blur any clear-cut divisions between the photographer and his subject cannot be circumvented. Compared to the studies of rural life in Lange, Bourke-White and Evans, the division between public and private becomes less demarcated and the vernacular becomes more fluid, contested by the increasing pace of urban life, the promise of upward mobility, and the racial and social problems that it brings with it. The vernacular as an aspect of an increasingly dog-eat-dog world is self-evident in *Naked City*, and as such Weegee shares intrinsic qualities with the consolidation of the noir aesthetic in cinema and pulp fiction of the 1940s as well.

While Weegee was chiefly interested in an urban sensibility in *Naked City*, he was also responding to an increasingly politicised tone within documentary practice. The photographer Paul Strand, a prominent member of the New York Photo League, who had been an active socialist throughout his life and one of the first acolytes of Alfred Stieglitz's Pictorialist movement in the 1910s, had, by the 1930s, collaborated on documentary films and other projects about America; by the 1940s, he was moving into photo-textual work. One book by Strand straddles the concerns of the 1930s, through a regional homage to the history and traditions of New England, with a distinctly post-war political sensibility. Chapter 7 examines the first in a series of regional studies by Strand, *Time in New England* (1950), in which the photographer's iconographical landscapes and portraits are paired with a cross-section of historical and fictional accounts of New England life from 1630 to 1950. The texts, chosen and edited by the writer/curator Nancy Newhall, constitute a counterpoint to Strand's images, designed to historicise the ideological parameters, subjects and faces of a vernacular New England. At the same time, it seeks to reclaim an arena for photography that is redemptive in its rhetoric and capable of manifesting, in the true sense of the word, the democratic underpinnings of America. For Strand and Newhall, the New England vernacular provided a set of ideological and aesthetic mechanisms capable of crossing the border

between the textual and the visual, thus accentuating the vernacular as a fundamental narrative on America, as well as a structuring device for a particular form of American photography. Partly a post-war response to the trauma of fascism in Europe, *Time in New England* sought to confirm the intrinsic values of America as a safe haven for democratic principles, a project jeopardised by the encroaching McCarthyism of the late 1940s and 1950s that drove Strand out of the USA the same year *Time in New England* was published.

Chapter 8 continues the examination of how photo-textual practice consolidated itself in the 1950s as a political as well as lyrical gesture by going back to the city, particularly in the under-estimated collaboration between Langston Hughes and Roy DeCarava, *The Sweet Flypaper of Life* – an urban study from 1955.[13] In comparison to Robert Frank's melancholy view of a country crisscrossed by highways and transport in *The Americans* (1959), as examined in Chapter 9, Langston Hughes and Roy DeCarava's poetic homage to Harlem seems an apparently effortless homage to the resilience and beauty of an African–American neighbourhood in the face of economic adversity. *The Sweet Flypaper of Life* uses the African–American vernacular of the first-person narrator to fuse text and imagery into a vision of togetherness in the face of urban and racial anxieties. Although Frank's *The Americans* is primarily set in the small towns and on the highways of the Midwest and *The Sweet Flypaper of Life* is located in Harlem, the two share an ambivalent love affair with the communities that make up the landscapes and streets forgotten by mainstream America. Largely neglected since its publication, *The Sweet Flypaper of Life* takes the vernacular voice of an elderly African–American woman – channelled through Langston Hughes – and allows it to create a wistful vision of solidarity, as well as solitude, within a Harlem setting. Instead of moving towards a liberating vision of the African–American voice as based on the desire to break out of its environment, *The Sweet Flypaper of Life* paradoxically places its faith in an identity confirmed by its Harlem location. As with Wright Morris's Nebraska-bound homestead, the desire here is to pay homage to a vernacular tradition that combines the lyrical tenor of the narrative voice with the images of definable places: places defined as much by their inhabitants as by external social and economic forces.

If Strand and Newhall's collaboration in *Time in New England* and Langston Hughes and Roy DeCarava's in *The Sweet Flypaper of Life* share the anxieties of the post-war era regarding the direction of American democracy, then Robert Frank's images of America actively engage in straddling pre-existing notions of what constitutes the regional, and whether it holds the same currency in the 1950s as it did in the 1930s. Chapter 9 looks at how Frank's focus on the vernacular is both an investigation into what constitutes iconography – what, for instance, Walker Evans's landscapes and interiors might look like in an increasingly commodified state – and a return to the self-same concerns that inflect *Roll, Jordan, Roll*: namely, the juxtaposition between commonality and individualism within America's so-called democracy. The existential leanings of Frank – who had emigrated to the United States from Switzerland in 1947 – stem from his continental background and disposition as immigrant himself, but they are also very much born out of a genuine interest in American popular writing of the 1950s. Friends with a number of Beat writers – Jack Kerouac, in particular – Frank recognised the Beats as one of the first literary movements truly to capture the changing vernacular of an increasingly youthful nation. Once again, despite *The Americans* being marketed primarily as a monograph of Frank's photographs, Kerouac's introduction to the US edition reminds us in very crucial ways of the intersections between an image-led form of writing and its actual visualisation. Looking at how the Beat aesthetic operates in this context is a useful exercise in rethinking how a photo-textual vernacular has changed from the 1930s to the 1950s. The fact that the Beat project – especially as mediated by Kerouac – is heavily inspired by nineteenth-century Transcendentalism and, at times, sounds and feels like a rechannelling of James Agee's poetics is no coincidence. Frank's fascination with the infrastructure of the United States – its trains, buses, roads and highways, and their ability to take people away from familiar environments – is as fundamental to his vision as the descriptions of neighbourhoods and streets are to DeCarava's Harlem.

While the photo-text as a distinct genre has been under-estimated in the wider context of American studies, numerous critical works in the last few decades have sought to trace the interaction between text and image, albeit often in a larger, more international context. In François Brunet's *Photography and Literature* (2009), for instance,

the discovery of photography by writers across decades and centuries is seen as a litmus test for how quickly photography entered the trajectory of modern art. However, as the photo-textual examples chosen here illustrate, the use of text as a way to legitimise or explain images can be traced back to various nineteenth-century American ideas as well: ideas about democracy and vision, and about identity and representation.

During the decades that followed the 1950s, many of the photographic studies to focus specifically on United States regionalism (from Robert Adams's *The New West* (1974) and Lee Friedlander's *The American Monument* (1976) to Stephen Shore's *Uncommon Places* (1982) – to mention just a few) tended to forego the obvious textual apparatus of previous decades, pushing the meaning and purity of the photographic print alone to the forefront. With the seminal 'New Topographics: Photographs of a Man-Altered Landscape' exhibition in Rochester, New York, of 1975, a series of images of various suburban and seemingly mundane built environments without humans in the frame, the onus on photo-books became to produce a much more knowing look at the results of post-war commodification and gentrification, a tendency that, in many respects, has lasted till today. The importance of textual material in conjunction with photographs has possibly survived in the turn towards a more intimate, biographical form of photo-textual endeavour, one in which the identity politics of race and gender, rather than class and regionalism, have taken precedence. For more contemporary American photographers, such as Claudia Rankine, who also uses poetry with her visual work, and Sally Mann, whose memoirs are photo-textual experiments in tracing the personal in a more public sphere, photo-texts are a way to poeticise various landscapes, external and internal. Many of the photographers examined in the following chapters went on to work on other photo-textual projects but, interestingly, these are often overlooked due to the iconic nature of their previous work. Roy DeCarava's deeply personal photo-text, *the sound I saw* (2001) is a labour of love constructed over several decades, made up of a selection of his well-known images of musicians and jazz clubs with his own poetic statements and lyrical writings inserted. Wright Morris went on to work on more photo-texts in the 1960s and 1970s, as did Paul Strand, the more famous photographer of the two, so the field was by no means exhausted by the 1960s. In all of these cases, there is a

shared interest in illuminating the fissures and subtexts of the visual material and vice versa.

Rather than provide a cohesive explanation of what the photo-text is exactly, we can, then, only compare some of the many discourses that the interaction between text and photography has offered. In the photographer Sally Mann's recent photo-text, *Hold Still: A Memoir with Photographs* (2015), the archival photographs of her family become not only a way to discuss her own psyche and mechanism as an artist, but also a way to acknowledge the historical antecedents of her own practice.[14] Such examples proliferate and they prove, perhaps, that the photograph as tangible object continues to have an unabated fascination for artists across both media.

For Paul Strand, the fact that objects obtain their use-value in a photographic sense because of the individual vision of the artist is not that dissimilar to Bourke-White's constructed mode of photography. Strand and Bourke-White may not have shared each other's politics but they did share a similar devotion to the photographer as central to the documentary ethos. None the less, while Bourke-White is often critiqued for being too commercial in her approach to documentary aesthetics, Strand is usually seen as a purist: a 'straight' photographer rather than a manipulative one. In similar terms, DeCarava may share Weegee's use of street scenarios as exemplary fragments of the urban landscape, but Weegee's vision is a distinctly darker one, nevertheless. Using photography to examine America's metaphorical loss of innocence, partly as a response to the cultural anxieties of the Cold War, is, notwithstanding, a mainstay for all of these photographers.

If Paul Strand and Walker Evans tended to focus on portraiture as they would buildings, implements, the artefacts of personal as well as public life, and various boundaries, doors, walls and windows, the presence of the private and the public, and at times the diffusion between them, also complicated their politics. Even though the 1950s texts are set within very different landscapes from their 1930s counterparts, they provide – in the end – settings for various performative and visual strategies that are both different from and similar to those established by Lange and Evans in the 1930s. In the end, as Alan Trachtenberg points out, within documentary lies 'the ambition to tie the panorama of America to categories of existence true for all times and places'.[15]

Notes

1. Ralph Waldo Emerson, 'On Nature' [1836], reprinted in Carl Bode, ed., *The Portable Emerson* (New York: Penguin, 1946).
2. Walker Evans, *Walker Evans at Work*, ed. J. L. Thompson (London: Thames and Hudson, 1984), p. 238.
3. James L. Baughman, *Henry R. Luce and the Rise of the American News Media* (Baltimore: Johns Hopkins University Press, 2001) and Alan Brinkley, *The Publisher: Henry Luce and his American Century* (New York: Alfred A. Knopf, 2010).
4. Pam Roberts, *Alfred Stieglitz: Camera Work* (London: Taschen, 2013).
5. Bonnie Yochelson, *Jacob A. Riis – Revealing New York's 'Other Half': A Complete Catalogue of his Photographs* (New Haven, CT: Yale University Press, 2015).
6. Robert Macieski, *Picturing Class: Lewis W. Hine Photographs Child Labor in New England* (Boston: University of Massachusetts Press, 2015).
7. Caroline Blinder, 'The Transparent Eyeball: Emerson and Walker Evans', *Mosaic: A Journal for the Interdisciplinary Study of Literature*, 37:4 (December 2004), pp. 149–65.
8. Walker Evans, *American Photographs* (New York: Museum of Modern Art, 1938).
9. Margaret Bourke-White and Erskine Caldwell, *You Have Seen Their Faces* (New York: Duell, Sloan and Pierce, 1937).
10. Dorothea Lange and Paul Taylor, *An American Exodus: A Record of Human Erosion* [New York: Reynall and Hitchcock, 1939] (Paris: Jean Michel Place, 1999).
11. For critical essays on *Let Us Now Praise Famous Men* see: Caroline Blinder, ed., *New Critical Essays on James Agee and Walker Evans: Perspectives on* Let Us Now Praise Famous Men (New York: Palgrave Macmillan, 2010).
12. Wright Morris, *The Inhabitants* (New York: Scribner's, 1946) and *The Home Place* (New York: Scribner's, 1948).
13. Langston Hughes and Roy DeCarava, *The Sweet Flypaper of Life* (New York: Simon and Schuster, 1955).
14. Sally Mann, *Hold Still – A Memoir with Photographs* (New York: Little, Brown, 2015).
15. Alan Trachtenberg, *Reading American Photographs: Images as History. Mathew Brady to Walker Evans* (New York: Hill and Wang, 1990), p. xv.

PART I
THE 1930s

Portraiture as Place in Julia Peterkin and Doris Ulmann's *Roll, Jordan, Roll* (1933)

Julia Peterkin and Doris Ulmann's ground-breaking study of former slaves and their antecedents in South Carolina in the early 1930s, *Roll, Jordan, Roll,* remains, in many ways, unmatched in its attempt to portray both a region and a people. None the less, created at a time when documentary studies of America during the Depression were yet to take hold, this collaboration between a photographer better known for her art photography and portraits and a writer known for her fictional short stories of Southern life remains nearly unknown. This first chapter will look at some of the reasons for this and in the process establish some of the recurring tropes that *Roll, Jordan, Roll* – unbeknownst to later photo-textual collaborations – inadvertently instigated.

Breaking the colour line as a white Northern photographer, Doris Ulmann's background was not in documentary studies but in Pictorialist photography, a movement best known for its attempts to incorporate photography into the wider canon of fine arts through its focus on such painterly subjects as landscape studies and portraiture. In this respect, Ulmann occupies a unique position within photo-textual history: a position indicative of the move from Pictorialism's reliance on the fine print and traditional painterly subjects around the turn of the century into a more discernible interest in the representation of topography and vernacular culture in the 1920s and 1930s. If Pictorialism had predominantly focused on the beauty of the fine print, topographical identity and a particular notion of regional lyricism now came to the fore.[1]

As a starting point for this survey of the American photo-text, Ulmann and Peterkin's combination of fiction and ethnography

thus provides a crucial entry into thinking about the problematics of photo-textual interaction as it plays out during the 1930s, 1940s and 1950s. It forms a bridge between earlier photography's reliance on portraiture and later documentary styles, and brings to light some of the problems encountered by documentary photography, particularly in relation to regional and racial identity. In subsequent chapters, the ways in which photo-textual studies of regional people play on, and subvert, the essentialist qualities of the sharecropper, the farmer and the city-dweller will be paramount. In many respects, the collaboration in *Roll, Jordan, Roll* constitutes a litmus test for how these mechanisms operate, for their potential in providing a cross-section of the American populace, and also for how they function as indicators of the ways in which photographic practice began to rely on the textual material surrounding it.

Ulmann's relationship with the writer and plantation owner Julia Peterkin began with a common interest in documenting what they called various indigenous 'types'. According to Ulmann's biography, 'It was Peterkin who had invited Ulmann to come south with a promise to introduce the photographer to African Americans at different sites within South Carolina, including her plantation at Fort Motte.'[2] The two women had briefly met in New York in 1929, and the invitation from Peterkin, who only a year earlier had won the Pulitzer Prize for her 1928 novel *Scarlet Sister Mary*, was a way for Ulmann to continue her ethnographic interests away from her usual Pictorialist endeavours. The possibility of collaborating on a photo-textual project on the shrinking population of Gullah African–Americans of South Carolina – more specifically, the descendants and ex-slaves that still lived on Peterkin's plantation, Old Lang Syne – was a unique opportunity. According to one reviewer, 'the recording of character, types, and modes of living of people who inhabit some of the remote rural districts . . . will become very valuable as time and customs change the character of these "Folks"'.[3] Thus, the characterisation of the images as predominantly 'folk' studies would have attracted Ulmann professionally, but for Julia Peterkin, what was to become *Roll, Jordan, Roll* had – as we will see – a much more personal meaning.

This chapter will thus try to unravel some of the idiosyncrasies that have kept the book out of the wider canon of both Southern literature and photography through a closer look at the intersections between Peterkin's writing and Ulmann's photography. Despite its ground-breaking attempts at a genuine fusion of writing and image,

some of the deep-rooted problems of *Roll, Jordan, Roll*'s politics illuminate schisms and contradictions that are not only intrinsic to the documentary style itself but also unavoidable due to the combination of Ulmann's more objective eye and Peterkin's personal investment in the project. While it is Peterkin's retrograde stance on racial relationships in the South that has placed *Roll, Jordan, Roll* on the margins of the modernist canon, Ulmann's Pictorialist credentials have also gradually been marginalised from most studies of 1930s photography. What *Roll, Jordan, Roll* shows, though, is the way in which Pictorialism – rather than give way to a documentary eye defined only in modernist terms – incorporated various ethnographic and documentary aesthetics for its own purposes. To add to the complexity of *Roll, Jordan, Roll*, Julia Peterkin's version of plantation history, deliberately vernacularised to take the cadences and intonations of a region into account, indicates her Southern heritage and bias, an issue that also problematises Ulmann's attempts to cast a documentary eye on the South as a Northern photographer. In this sense, the book was based on a wistful and nostalgic desire to utilise a distinctly twentieth-century medium – photography – in order to render a distinctly nineteenth-century ideology of class and racial division. While the book broke new ground in terms of photo-textual interaction, its problematic vision of regional identity, whilst it has kept it out of academic discourse as well as the public eye, none the less shares similarities with later photo-texts. As will be shown, in her attempt to incorporate the voices of her subjects, Peterkin inserts herself into a domain in which she is inevitably both an outsider as a white plantation owner *and* an insider in terms of her Southern affiliation. This dichotomy, on the one hand, constitutes the book's creative tension but, on the other, establishes a long-term juxtaposition within the genre of the photo-text itself: the contrast between the stillness and anonymity of the photographic material, and the distinct 'sound' of the characters who are named and whose stories constitute the textual material that accompanies those photographs.

Born in 1880 and raised by her Confederate grandparents, Julia Peterkin lived in Methodist parsonages, having lost her mother to tuberculosis as a toddler. At seventeen, with a Master's degree, she became a teacher in the remote village of Fort Motte, South Carolina. There, in 1903, she married William George Peterkin, heir to historic Old Lang Syne plantation, whose community of 500 black labourers descended from the original eighteenth-century settlement

and who were broadly known as Gullah people, descendants of enslaved Africans who lived in the low country regions of Georgia and South Carolina. In the spring of 1904, Peterkin's surgeon father delivered her son, then promptly sterilised her—with her husband's consent. In later years, Peterkin articulated the trauma of this experience obliquely in her many stories of women dying in childbirth, dead babies and other, both palpable and more obtuse, losses. For Peterkin, her plantation home Old Lang Syne was thus a site of trauma, as well as a safe haven and an extended family. Despite the obvious segregation in place on the plantation, Peterkin's sense of kinship with Old Lang Syne meant that, despite her growing literary reputation, she steadfastly stayed there, choosing instead to write copious letters to other writers and to her agent, H. L. Mencken, in particular. Peterkin's invitation to Ulmann was thus, in some ways, an acknowledgment of her artistic ties and sensibilities but also, crucially, a way to recentre Old Lang Syne in her own and a wider audience's consciousness.[4] Inviting Ulmann to come and photograph the plantation was a way for Peterkin to allow her entry into her own family, just as Ulmann's Pictorialist credentials could be used to render a very particular vision of the Gullah population.

In the introduction to *Roll, Jordan, Roll*, Peterkin starts, not by presenting the narrative as a sociological study, but by accentuating her own kinship on an emotional level with the African–American population on the plantation. According to Peterkin,

> These two groups, one black, the other white, observe distinctly different customs and habits of life. They go their separate ways until adversity shows its face; then they stand firmly together against it, for they realize their dependence on each other. Outsiders who do not understand the relationship between them sometimes marvel at its existence.[5]

As though pre-empting the charge of simply continuing a broadly romantic vision of plantation life, Peterkin's introduction is replete with oblique references to her kinship with the African–American population. It also, crucially, reflects the Southern sense of being judged by Northern eyes, a rebuttal in advance to those 'outsiders' whose 'opinions and impressions' Peterkin considered potentially prejudiced because of her status not just as a plantation owner, but as a Southern female writer.

While later critics have noted affinities between Peterkin's deci-
sion to write about African–American life without the presence of
white characters and other contemporary modernists such as Jean
Toomer (*Cane*, 1923) and Zora Neale Hurston (*Their Eyes Were
Watching God*, 1937), Peterkin's immediate literary ancestors are
as much slave narratives, testimonies and the sermons intrinsic to
the daily life in the region.[6] Not surprisingly, the most favourable
reviews of Peterkin's writings up until *Roll, Jordan, Roll* came from
some of the more established members of the Harlem Renaissance,
for whom Peterkin's use of an African–American dialect to render
first-person narrative, rather than being a liability, was seen as a
genuine attempt to articulate African–American culture. Peterkin's
story *Green Thursday* (1924) was reviewed by W. E. B. Du Bois,
who praised it profusely. Despite being a 'Southern woman', Du
Bois claimed, 'she has the eye and the ear to see beauty and know
truth'.[7] For her contemporary audience, then, Peterkin's voicing
of the prejudices and stereotypes of her time proved that she was
rendering an 'authentic' vision of the South, one in which regional
customs and attitudes were articulated in uncensored form. The
fact that Peterkin's first-person narrators were engaged in a form of
racial ventriloquism was thus secondary to the ethnographic focus
on daily struggle, sustenance and survival. This creates a strange
tug in *Roll, Jordan, Roll*, a tension between the subject matter,
the daily fears and joys of people living in an agrarian context as
seen through the eyes of a white plantation owner, and the writing
style itself, a distinct form of vernacular *and* racial ventriloquism.
As Peterkin takes great care to articulate her characters' thoughts,
fears and desires, as she perceives them to be, she unavoidably mim-
ics her own perspective on the Gullah population. In her extended
Introduction, for instance, Peterkin outlines her version of the social
hierarchy in place, a hierarchy that will emanate in a dispersed form
throughout the vernacularised narratives that follow:

> On large plantations, where Negroes are in a tremendous major-
> ity, the field hands have few contacts with white people and no
> need to amend their speech or give up the customs and traditions
> of their African ancestry. Living close to the earth, they know the
> ways of beasts and birds, clouds and winds, and interpret signs
> given them by sun, moon and stars. Their manners and tastes,
> though shaped by a code which differs from the one observed by
> their white neighbors, are given rigid adherence. . . .[8]

By establishing a closed community, separated from white rules of law, Peterkin establishes a stage in which the unusual and yet 'codified' enactments of Gullah life can take place. It is no coincidence that these stories often circle around superstitious rituals, jealousy and love, themes that render the plantation as a timeless place governed by natural cycles. Rather than an economic entity with an actual history of enslavement and subjugation, the 'manners and tastes' of the 'Negroes' are made paramount.[9]

According to Elizabeth Robeson in 'The Ambiguity of Julia Peterkin', the favourable reception of Peterkin's writing by a black intelligentsia at the time was understandable. Based on Peterkin's ability to upend 'the traditional plantation novel by replacing its gross stereotypes with rural black southerners of complexity, stamina, integrity, and courage, while valorizing the African spiritual inheritance as a transcendent force of cultural regeneration', Robeson does not see the paternalism of Peterkin's rhetoric as necessarily problematic.[10] One of the reasons for this is that Peterkin's vision carried a predominantly nostalgic charge by the 1930s. For many writers, the 'spiritual inheritance' of the South was seen as an antidote to the encroaching industrialisation from the North, a way to assuage any lingering concerns over racial disparity – an anxiety that affected not just the Southern plantation owners but also many writers and artists from the South in general. While such anxieties were present from the Reconstruction era onwards, the 1930s – as the next chapter will also examine – was noticeably marked by the possibility that agrarian culture might be facing its own extinction as the Depression took hold. In her book *A New Heartland: Women, Modernity, and the Agrarian Ideal in America*, Casey argues that one should not under-estimate the sense of pronounced marginality of both women and rural dwellers in the face of 'a modern urban–industrial hegemony'.[11] Instead of these people adapting themselves to changing circumstances, rural life remained central to their cultural images of themselves and their communities, largely because of the staying power of an agrarian ideal, inherited and mediated over several centuries.

In Figure 1.1, 'Kitchen Maids', the juxtaposition between the faces of the unnamed women and their starched white collars and caps accentuates their roles primarily as efficient servants. In keeping with the book's tendency to present small anecdotal stories about the workers on Old Lang Syne, rather than a working image of the plantation

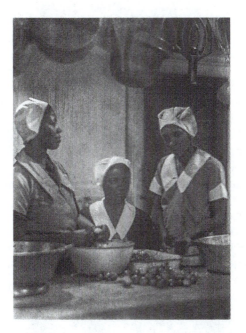

Fig. 1.1 'Kitchen Maids', ca. 1929–32. Platinum print in Julia Peter-kin and Doris Ulmann, *Roll, Jordan, Roll*, p. 23. Image courtesy of the Art Institute of Chicago, Ryerson & Burnham Libraries.

system, from children to field workers, from house servants to young maids, from old survivors of the Reconstruction era to active preach-ers, the stress is on vignettes of specific moments and situations: a moment of kitchen gossip, a story retold. Despite the promise of a continuous and never-ending life cycle of birth, marriage and death, Peterkin also favours stories about those characters whose missteps and haphazard behaviour humanise and often infantilise them. In Chapter VIII, for instance, the story of a devout recluse on the planta-tion, living in a self-inflicted state of abstinence, describes how

> One night she had a vivid dream and the 'voice' told her she must go to Rome and tell the Pope he was going to die. The voice was so loud it woke her up and she lay in the darkness frightened half to death, for she had never seen the Pope and did not know how to reach Rome.[14]

With no titles or subheadings, such stories, in the vein of a self-contained short story or a vignette based on anecdotal tales, render the Gullah environment both naïve and superstitious. While the various stories are connected, characters rarely interact across the chapters. In this way, individual incidents remain, if not insignificant, then deliberately divorced from the larger issues involved in the daily running of the plantation.

Despite this, there is a strange mix of something voyeuristic and at the same time reverent in *Roll, Jordan, Roll*. Throughout, Peterkin's authorial voice is omnipresent and privy to the most private emotions of individuals who would never communicate such things within the segregated parameters of the community. One chapter, about a young woman, Jenny, who brutally assaults a man she is in love with to teach him a lesson, turns into a rather sentimentalised story of love redeemed as the man forgives her and moves in with her. At the end of the chapter, a photograph by Ulmann of a young man, possibly the one who survives, is presented (Fig. 1.2).

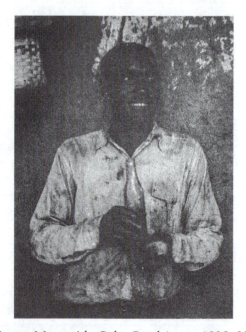

Fig. 1.2 'Young Man with Coke Bottle', ca. 1929–32. Platinum print in Julia Peterkin and Doris Ulmann, *Roll, Jordan, Roll*, p. 55. Image courtesy of the Art Institute of Chicago, Ryerson & Burnham Libraries.

In this example, what could be read as a derogatory version of a culture not complex enough to muster the proper responses to violence, love and revenge turn into a story about a culture where violence is ordinary and simply a part of everyday life. This is so much so that the accompanying portrait of someone who may be the assaulted man – although this is unverified – comes across as strangely incongruous, nearly comical in the face of the narrative itself. It is, in other words, as though Ulmann's illustrative choice tempers and directs the preceding narrative in a direction nearly antithetical to its main gist: namely, that a woman within the Gullah community will do anything to get her man back.

Such incidents, as related by Peterkin, seem to fit into the agrarian ideology in ways that are often problematic. The schism between the smiling face of a young man casually drinking from a bottle and a story of love and revenge cannot be completely incidental. If the instinctual way of life of the Gullah population and its survival in the face of wider regional changes are a source of creative inspiration for Peterkin, they have different repercussions within the actual community, a community in which people are still put on trial and convicted by a white legal system. Writing in the introduction, Peterkin argues that

> Some of the charm that made the life of the old South glamorous still lingers on a few plantations that have been cut off from the outside world by rivers, wide swamps and lack of roads . . . undisturbed by the restless present. Wistfully holding on to the past when they were part of a civilization never excelled in America, they keep their back turned to the future and persistently ignore that strange thing called progress . . . change without betterment.[15]

These sentiments echo those of John Crowe Ransom, who, in *I'll Take My Stand*, argued for the merits of looking back at the heyday of Southern life rather than towards a desegregated future: 'It is out of fashion these days to look backward rather than forward . . . the unreconstructed Southerner . . . persists in his regard for a certain terrain, a certain history, and a certain inherited way of living.'[16]

Like the Southern Agrarians, Peterkin's assertive introduction to *Roll, Jordan, Roll* indicates the desire for Old Lang Syne to represent the South as a region as a whole and not just the plantation itself. It is all the more astonishing that Ulmann, predominantly known for her portraiture of famous publishers, physicians and other white-collar professionals, understood Peterkin's remit in aiming for a more universal image of Southernness. Rather than fix on markers particular

to Old Lang Syne, Ulmann's Pictorialist aesthetics, with their soft focus and timeless settings, were perfect for providing a lyrical vision of local culture, one whose strength relies on the universality of its themes rather than regional specificity.

In many ways, the interaction between the photographs and the text in *Roll, Jordan, Roll* thus says more about the anxieties concerning regional identity than about authenticity or documentary truth.[17] Rather than focus on religion and its place in the Gullah community within Christian parameters, for instance, Peterkin and Ulmann choose to focus on the ways in which ancient rituals and customs infuse Gullah life. The book steps away from the idea of bringing white Christianity to the Gullah population in favour of preserving – through text and image – a vision of Gullah spirituality at risk of disappearing. Rather than establish churches as extensions of white dominance, the spiritual becomes an emblem of faith in the community and its ability to survive. According to Peterkin, 'The spirituals go far deeper than they appear on the surface to do, for they define at least one moment of the history of a whole group of human beings in this steadily moving eternity called time.'[18]

In this context, history – rather than a document of past traumas and conflicts – becomes something that fluidly binds traditions and art together. If Ulmann's Pictorialist aesthetics are designed to look as though they might be fifty years older than when they were actually taken, this is a deliberate choice, a version of the folkloric designed to render a timeless rather than changing vision of the South. As such, the photographs, by focusing so often on religious ritual and community, offer a decidedly subjective rather than objective vision of the landscape, just as Peterkin's vernacular narratives provide a highly subjective take on what constitutes community in the context of a wider social order.

According to Nghana Tamu Lewis in 'The Rhetoric of Mobility, the Politics of Consciousness: Julia Mood Peterkin and the Case of a White Black Writer', Peterkin was highly attuned to this sense of 'whiteness as caught in the undertow of encroaching modernity'.[19] By projecting an image of 'blackness' – 'at once intelligible, inspirational, inferior, and obsolescent – Nostalgic, mystical, and mythological imagery converges . . . to thematize black power and subjugation while privileging white prophecy and progress.'[20] The issue of 'cultural subjectivity', as Lewis puts it, inevitably marks the ways in which an appearance of veracity is presented, albeit one that is highly mediated. As Lewis also points out, Peterkin's precarious

place, as both inside the plantation system yet outside the world of her employees, creates a perspective that has to be mobile in order to operate effectively, just as 'the principal narrator in each novel is articulated to the plantation system, though also somehow outside of the system'. For this reason, 'Commentary on the plantation community's traditions and beliefs is interspersed within the narrative proper', which, as Lewis argues, 'ultimately vacillates between acculturating and displacing the "outsider" perspective'.[21]

In her attempt to incorporate the voices of her subjects, Peterkin inserts herself into a domain in which she is inevitably both an outsider as a white plantation owner *and* an insider in terms of her Southern affiliation. In both instances, she has to make the subjects portrayed come to life for an audience unfamiliar with Old Lang Syne. None the less, to avoid the sense of being simply a descriptive tour guide of Ulmann's very lyrical and emotive photographs, the text, although linked thematically, has to remain separate from the images to a certain extent. Throughout *Roll, Jordan, Roll* there are no captions, titles or names under the images. The Gullah remain nameless in the photographs, as seen in both Figures 1.1 and 1.2, even though Peterkin presumably would have been able to ascertain their identities. In this way, the book's creative tension is partly predicated on a juxtaposition: the contrast between the stillness and anonymity of Ulmann's portraits, and the distinct 'sound' of Peterkin's characters, who are named and whose active telling of various stories constitutes the narrative itself.

For Lewis, this dual – even schizophrenic – perspective is a strategic ploy, a way for Peterkin to capitalise on the myth of (white) Southern womanhood whilst gaining 'access to herself as agent in relation to black people and purchasing power with it . . . in relation to (white) men'.[22] Lewis's reading of *Roll, Jordan, Roll* ambitiously attempts to read the dichotomies of Peterkin's writing as an indicator of an agenda that is both racial and gendered. None the less, Lewis does not question how this in turn might tally with Peterkin's collaboration with Ulmann as a (white) Northerner and a white Northern woman. Once we take into account the perspective of Ulmann's privileged eye as an outsider, another form of cultural ventriloquism – other than that of a white plantation owner ventriloquising her black employees – emerges. In order to understand these mechanisms, it is worth situating Ulmann in the wider canon of 1930s photography to understand why Peterkin, despite their varying backgrounds, would want her as 'illustrator'.

Doris Ulmann's background as a Pictorialist photographer was well known by the early 1930s. A native of New York, Ulmann was educated at the Ethical Culture School, a socially liberal organisation that championed individual worth, regardless of ethnic background or economic condition, and at Columbia University, where she intended to become a teacher of psychology. A member of the Pictorial Photographers of America, Ulmann graduated from the Clarence White School of Photography, the most prominent school for photographers at the time.[23] The Clarence White School extolled the importance of combining artistic methodologies with a sociological outlook, a remit that Ulmann followed in her later photographic projects. Ulmann was married for a time to Dr Charles H. Jaeger, a fellow Pictorialist photographer and a surgeon at the Columbia University Medical School, who was instrumental in facilitating her first major publication: *The Faculty of the College of Physicians & Surgeons, Columbia University in the City of New York: Twenty-Four Portraits* (1919). This was followed in 1922 by the *A Book of Portraits of the Faculty of the Medical Department of the Johns Hopkins University*, the 1925 *A Portrait Gallery of American Editors* and then, in 1933, *Roll, Jordan Roll*.[24]

Ulmann's portraits of prominent artists and writers in the 1920s thus formed the groundwork for her collaboration with Peterkin in 1927; this was even more the case with her association with the musician and folklorist John Jacob Niles, with whom she began to assemble documentation of Appalachian folk arts and crafts in the 1930s for her posthumously published 1937 book, *Handicrafts of the Southern Highlands*. A project not dissimilar to *Roll, Jordan, Roll*, consisting of images of local people engaged in handicrafts, weaving, sewing and woodwork, *Handicrafts of the Southern Highlands* shares *Roll, Jordan, Roll*'s vision of a culture not only separated from industrialisation and modernity but seemingly content in its isolation. It was while doing these ethnographic studies in August 1934 that Ulmann collapsed due to ill health, while working in North Carolina, and died soon after.

Despite her move towards ethnography in the 1930s, Ulmann's work was none the less committed from the beginning to a predominantly Pictorialist aesthetic, in which the emphasis on composition (line, mass and colour) before fact and information was crucial, and Peterkin knew this as well. One of the ideas advocated by Ulmann's teacher, Clarence White, was compositional clarity as a combination of textures and details aimed at creating both a sense of harmony and multi-dimensionality. For Ulmann, this idea of compositional clarity is

evident in *Roll, Jordan, Roll*, where the focus on textiles (the uniforms of the housemaids in Fig. 1.1), backgrounds and vegetation within singular shots not only forms a part of the wider contextual narrative, but also is instrumental to how we situate the figures within the wider landscape. Rather than focusing on the texture or sheen of individual items, it considers the structural arrangement of the shot overall crucial. For Ulmann, it is the juxtaposition of background and figure that renders the depth and composition of the photograph clear, which is why there are so few close-ups and even relatively few medium shots in *Roll, Jordan, Roll*. In aesthetic terms, the untouched Southern landscape also afforded Ulmann the opportunity to insert the inhabitants into what she saw as a predominantly pastoral environment, the very antithesis to her home town of New York.

This partly explains why the very few readings of *Roll, Jordan, Roll* ignore Ulmann's Pictorialist aesthetics, as Peterkin's emphasis on an earthy, more readily realist vernacular discourse seems more in line with our ideas of modernism in the 1930s. None the less, as seen, the way in which the two operate in synthesis to produce a vision of the South that is nostalgic, and at the same time respectful of the culture it emanates from, is somewhat more complicated. Instead of thinking of the book as primarily propelled by the juxtaposition between Realism and Pictorialism, the photo-textual interaction mimics both Ulmann's sociological/ethnographic eye *and* the fictional strand of Peterkin's ventriloquism of the African–American voices around her.

If *Roll, Jordan, Roll*, though, is deliberately trying to forego any political context in favour of an idea of a timeless South in the vein of the Agrarians, it paradoxically uses many of the tropes of modernism, rather than Realism or Pictorialism, to do so. This partly explains why the Harlem Renaissance intelligentsia and writers like Du Bois were keen on incorporating Peterkin's work into a wider canon of African–American modernism, but it also reminds us of the attractiveness of the South as a safe haven for a purer, more essentialist form of American identity. As such, many modernist critics largely focused on the book's agrarian credentials rather than Peterkin's use of vernacular folklore or Ulmann's images of 'blackness' in the South – or rather, it was the very use of vernacular folklore and the images of stereotypical 'blackness' that seemed to constitute a modernist version of the agrarian. According to her contemporary, the critic Sterling A. Brown, 'From her (Peterkin) we might get a hint of the need of going back to the soil: of digging our roots deeply therein . . . and if so, there could be few better mentors than Julia Peterkin.'[25]

Peterkin herself, however, never 'promised' that *Roll, Jordan, Roll* would promote a particular Southern form of life, despite her assurances in her Introduction that Old Lang Syne could carry more universal meaning. Nor does she promise that the book will constitute a documentary project per se. Despite this, Elizabeth Robeson, in 'The Ambiguity of Julia Peterkin', also sees *Roll, Jordan, Roll* as 'a plantation eulogy cleverly presented as documentary', thus ignoring the fact that Ulmann's Pictorialist aesthetic sits uneasily with what we think of as the prevailing documentary aesthetic of the 1930s.[26] More importantly, Peterkin's choice of Ulmann indicates that she was not interested in the 'standard' documentary look of the 1930s. Just as Peterkin was happy to appropriate the language of her African–American employees, Ulmann was not averse to manipulating her subjects through costume, setting and posing, if it aided in rendering a particular vision of a region and its customs. In her studies of the Appalachians for *Handicrafts of the Southern Highlands*, for instance, her subjects were asked to dress in their ancestors' costumes to accentuate the timeless aspect of their work and labour, an ethnographic practice that only a decade later would have been criticised for its inauthenticity.

The careful set-ups and neat photographic vignettes may give the photographs in *Roll, Jordan, Roll* a manufactured air, but they also convey the sense that Old Lang Syne is a protected realm, a place where African–American folk culture is maintained for posterity. While Ulmann's photographs may add to this sense of a constructed rather than actual South, Peterkin's tendency to eulogise the vanishing world through intimate stories of folk life cannot detract from the fact that Ulmann's images are of real people and not imaginary characters. In fact, the interaction between text and imagery in *Roll, Jordan, Roll* is promulgated on ensuring that the reader suspends his or her disbelief in this regard: in other words, that we forge an intuitive if unverifiable link between the stories narrated and the faces we see in the photographs.

Another problem with defining Peterkin as regressive in terms of her textual politics is that one risks ignoring the presence of the type of pastoralism seen in *Roll, Jordan, Roll* in other Southern modernist texts. To some extent, Peterkin exemplifies a constituent – if problematic – part of Southern modernism rather than something that counters it, something that Ulmann clearly incorporated into her visualisation of the place as well. These mechanisms, or rather an occasionally ambivalent take on an idea of the South as a safe haven of sorts, can also be traced in the sequencing of Ulmann's

photographs. Looking closer at Ulmann's images – particularly as sequences rather than individual images – alternating rhythms of anti-pastoral and pastoral modes begin to be discernible. Typically, a photograph appears to be a rather straightforward image of contentment and self-sufficiency, as in Figures 1.1 and 1.2. In other images, however, there are glimmers of something that shadows the idyllic Eden of Old Lang Syne through the use of Gothic tropes as well. The very stillness of Ulmann's landscapes, with people submerged in swampy marshes or partly made one with the surrounding nature, provides a palpable sense of something hidden, even ghostly. Thus, once again, a dichotomy seems to be at work, for while Peterkin's narratives speak of a vibrant culture, seemingly comfortable in its own isolation, the photographs seem to be memorialising events in a darker, more contemplative way (Fig. 1.3).

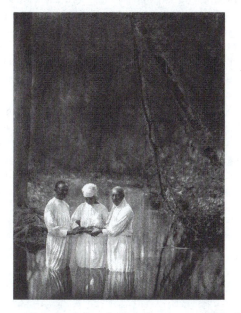

Fig. 1.3 'Swamp Baptism, South Carolina', ca. 1929–32. Platinum print in Julia Peterkin and Doris Ulmann, *Roll, Jordan, Roll*, p. 82. Image courtesy of the Art Institute of Chicago, Ryerson & Burnham Libraries.

'The candidates all arrive at the "pool" dressed in long white robes, which are carefully put away after the ceremony to serve as their shrouds some day.'[27]

In such cases, *Roll, Jordan, Roll* seems to resist modernity to allow the Gullah to act as repositories of ancestral memories, many painful, rather than being active participants in an on-going changing future. The supposition is that these people, engaged in activities like the river baptism that have not changed for centuries, are physically mired in the landscape they occupy; they have no place to go. Because of this, aspects of these memories and activities also resist white appropriation and thus remain intact, even when acquired by the gaze of Ulmann or the reconstituted voice of Peterkin. As the photographs render very private moments in the lives of these people, the question of whether Ulmann's gaze constitutes an infringement of their privacy or a respectful rendering of it is not always clear.

Thinking about the ways in which the photographs illustrate the narrative material in the book, in line with Pictorialist practice, Ulmann's framing is none the less as neat and contained as a nineteenth-century photogravure. However, it is also this outdated look in a 1930s context that perhaps contains something ghostly, a haunting sense of stillness and underlying malaise. The long line of the swamp tree that leans towards the three baptismal figures in Figure 1.3 coincidentally looks like a potential rope, an unwelcome reminder of a torturous past and present in which lynchings are a part of everyday life. Like the short story format followed in the individual chapters by Peterkin, Ulmann's photographs are cropped in ways that are more similar to classical painting than modernist formalism, and there is a noticeable symmetry through placement of the characters, the architectural backdrop and the ways in which nature forms a background to events. In this sense, the photographs do not so much advance the narrative in a conventional sense as they form a staging area for something that can be read in terms of both a safe haven in pastoral terms *and* a look into a violent past.

To return to the question of Ulmann's ventriloquism of the African–American voices on the plantation: Peterkin herself provides clues by aligning the gaze of the photographer with that of her subjects. As Peterkin writes of the African–Americans, 'They can read no printed words, but their eyes can measure the importance of what they see in landscapes, faces, gestures, skies.'[28] By reinvesting the local population with the ability to intuit things beyond intellectual reasoning, by making them conduits of spiritual knowledge first and foremost, a curious definition of visual comprehension emerges as well. Just as a performative and trans-

formative form of conjuring is a mainstay in the religion, super-
stitions and belief systems of the Gullah culture, so, too, does
photography become a way to create a symbiosis between humans
and nature that is transformative. A fantasy in a sense is at stake
here and it is the fantasy of investing the 'folk' with particular
essentialist qualities: with the ability, in other words, to see things
that others cannot see.[29]

This sense of the photographs as visual renditions of something
symbiotic between humans and nature is none the less, in the work
of Ulmann, a symbiosis that is markedly different from the type of
photo-text that will later emerge within the context of the Depres-
sion. Whilst Dorothea Lange and Margaret Bourke-White focus on
the discord between humans and nature during times of economic
and ecological disaster, *Roll, Jordan, Roll* seems strangely insulated
from such concerns. A major difference between *Roll, Jordan, Roll*
and later photo-texts thus lies in Peterkin and Ulmann's focus on
people framed and constructed through and by an environment that
is seemingly insulated from external economic factors. According to
Susan Williams Miller in '"Something to Feel About": Zora Neale
Hurston and Julia Peterkin':

> One cannot stop at reading the breadth of Peterkin's creative
> gesture as altogether proscriptive. Her frequently expressed
> candor about the value of plantation society and black culture
> speaks volumes of her willingness to confront the privilege of
> her own subjectivity vis-a-vis black people, even if only to affirm
> it in the end.[30]

The possibility that both Peterkin and Ulmann were conscious
of the wider regional and social implications of their study can also
be found in the fact that not all of the photographs in *Roll, Jordan,
Roll* were actually taken at Old Lang Syne. While critics assumed
for many years that the stories and photographs in the book were
drawn almost entirely from the area around Fort Motte, Philip
Walker Jacobs and others have demonstrated that many of the pho-
tographs were taken in Mississippi and Louisiana, and then inserted
into the book.[31] In this context, the deliberate lack of captions or
any titles or dates for the photographs provides us with a photo-
text curiously conscious of the constructed nature of the documen-
tary format itself. Not only does the staging of characters and use

of images from various places contradict our concept of a 'proper' documentary agenda, but also earlier fiction by Peterkin often reads as preliminary versions of what later emerges in *Roll, Jordan, Roll*.

For Jan Kreidler, this nonchalance regarding documentary truth was simply secondary to Peterkin's other concerns: 'As a female in a traditionally patriarchal society, . . . Peterkin challenged the established authority by ignoring it, writing the Gullah community into existence, and breaking from former derogatory African American stereotypes that perpetuated social inequity.'[32] Kreidler's comments, depending on perspective, could be seen as a form of 'whitewash' of Peterkin's often racist rhetoric. None the less, the concept of writing a community into existence has a lot of currency in this context, just as it will in many of the subsequent photo-texts in this study. If Peterkin is reusing earlier material and stories in a revised form or style, it is a trope that – as the following chapters will illustrate – reappears in numerous photo-texts, from the layout and structure of Walker Evans and James Agee's *Let Us Now Praise Famous Men* to Wright Morris's Nebraska books. Similarly, the reliance on vernacular speech to add a sense of authenticity to the regional tenor of a study is re-enacted in nearly every documentary project during the 1930s, 1940s and 1950s. In *The Sweet Flypaper of Life*, Langston Hughes – as we will see in Chapter 8 – engages in his own form of ventriloquism as his narrative of Harlem life is transmuted into the narrative of an old black woman looking back on her life. While part of this is a process of working out what the photo-text and its documentary methodology are able to do, for Peterkin and Ulmann it was also the most expeditious way to bring out what they considered the essentials of human behaviour and psychology in the South. Henry Bellamann, in 'The Literary Highway', a review of Peterkin from 24 January 1932, asserts as much when he writes,

> the age-old material that exists everywhere in one guise or another is here. It is the material of life. The negro characters of her books breathe the same air as others. They live under the same sky. They love and suffer and dies as others. Their fate is the common human fate.[33]

Such comments are actually in line with Peterkin's own assertions that the importance of plantation life lies in its ability, above all, to render an enlarged, more universal outlook on life. More

interesting, perhaps, is the way in which Peterkin describes this through the metaphor of vision first and foremost:

> I soon discovered that the ability to see is an acquirement. It takes skill to mark differences between things that look just alike, and to make out distinctions between forms that are very close kin. To learn how to do it requires time and patience . . . to know how all things are bound together into one common whole. . . . No two of us live in the same world. We must each make our own environment and mold our individual universe, and the only material we have to use for this purpose is what our sense has gathered for us. . . . All well-being depends on seeing things. The more things we see clearly, the more interesting is the exclusive world that we must make for ourselves.[34]

There is an anachronism, none the less, at the heart of Peterkin's version of what seeing clearly is. For one thing, Ulmann's Pictorialist aesthetic, with its softly lit environment and frequent use of shadows, seems to counter the notion of absolute clarity. However, it quickly becomes apparent in *Roll, Jordan, Roll* that what constitutes vision, as opposed to factual truth, is the recognition of place or, more crucially, the importance of it as the primary marker of identity. The sense that modernity might possibly tear asunder the fantasy of a coherent place called the South, inclusive for both white and black Southerners, is a common impetus for Peterkin and Ulmann's version of the documentary gaze. For Peterkin, Old Lang Syne necessarily has to be fictionalised in order to get to the heart of this perpetual conundrum. As Peterkin puts it, 'bound together into one common whole. . . . No two of us live in the same world.' Peterkin may be speaking of an insurmountable racial divide – this would make sense – but she is also hindered by an idea of paternal benevolence that desires to collapse that division. As she herself admits in the introduction to *Roll, Jordan Roll*, 'But instead of my dominizing the old plantation, I find that the old place has played a trick on me: it has made me merely one of its creatures whose destiny is bound up with everything else here.'[35]

Despite the palpable sense in *Roll, Jordan, Roll* of Peterkin's desire to share a common destiny with the Gullah population on Old Lang Syne, a desire that must by necessity be manufactured rather than genuine, critics still read the book in primarily documentary

terms. Melissa McEuen, in *Seeing America: Women Photographers Between the Wars*, argues, for instance, that we must see Ulmann's photography as still broadly documentary, not

> as a distinctive and recognizable style that focuses on specific subjects but instead as a touch stone measuring two elements; first, the photographer's role as both recorder and participant in the cultural dramas in which she engaged, and second, the extent of her desire to have her images used for larger social or political purposes.[36]

Ulmann's untimely death at the height of her more ethnographic work means that we can only speculate as to what extent she wanted her photographs used for what McEuen calls 'larger social or political purposes'. We know from Ulmann's other fieldwork that she was familiar enough with the necessary components, such as surveys, to claim that there was an investment in the process of representation beyond that traditionally associated with Pictorialist work, but visually her images are significantly different from other documentary practice in the 1930s. More crucially, perhaps, is the fact that the field of photo-textual interaction in terms of regional studies was an absolutely new and largely unexplored one.

The studio-in-the-field approach of Ulmann – and the idea that photography can capture cultures and people at risk of being subsumed under other cultures – was designed in the first instance to signal photography's ability to render the specifics of certain places before they were inexorably altered. The fact that Ulmann's Appalachian work – published after her death and, as such, possibly different from her own projected plans – remains her best known is a testament to her abilities in this context. However, this does not mean that the onus was on *Roll, Jordan, Roll* to create a social document in the same vein as her more 'famous' work – not that the photographs were 'hampered' by Peterkin's fictionalisations. Similarly, Peterkin's fictional stories about Gullah life may have been accentuated, changed and given a different inflection because of the accompanying photographs but we know that her writing still maintained the tenor of her other published work. In fact, the contradictory nature of the book resides in its deep-rooted desire to maintain a fictionalised fantasy of plantation life as a form of communal life, despite the segregated history of that life. Despite

all of this, Ulmann's aim seems to have been to be true to Peterkin's vision, to investigate what a Pictorialist approach to vernacular culture could do in lyrical rather than realist terms, first and foremost. From the influence of the Agrarians in *I'll Take My Stand* to Ulmann's growing interest in Nativism and the Appalachian mountaineers, the collaborators of *Roll, Jordan, Roll* undoubtedly shared certain anxieties about industrialisation and modernisation. To some extent, it is possible that Peterkin's nostalgia for the Southern plantation was matched by Ulmann's refusal to embrace new technology in her photographic work. Ulmann most frequently used a 6.5 × 8.5 inch whole plate camera positioned on a tripod, and because composing single photographs required significant mechanical preparation she took no action shots, relying on sliding the lens cap off to admit light instead of using a light meter. Inevitably, the duration of various sessions meant that there could be no semblance of spontaneity in the process, which also explains why the postures of the sitters in her images are carefully delineated and established beforehand. In this sense, her aesthetic choices fit neatly into what we think of as a more nineteenth-century approach to photography, in stark contrast – as subsequent chapters will show – with other Southern studies aimed at documenting a rapidly vanishing lifestyle.

In this respect, it is too easy to read *Roll, Jordan, Roll* simply as a nostalgic desire by two privileged white women to return to a pre-industrial feudal age. Peterkin and Ulmann may have produced a photo-text that in many ways seems out of time, but the work itself constitutes one of the first attempts to create a genuinely synthetic interaction between photographs and text. In addition, it does so not by pretending to be straightforwardly documentary but by embracing the contradictions inherent in early 1930s modernist practice: namely, the mix between fiction and fact, between twentieth-century photographic realism and nineteenth-century Pictorialism.

This mixture may be one of the reasons, paradoxically, why *Roll, Jordan, Roll* has lacked the attention given to other photo-textual collaborations of the 1930s. To complicate matters, the mixture of aesthetic innovation with classical themes is also circumscribed by the very context of the book's production: that is, the fact that two affluent white women decided to create a work of art based on the life of poor African–Americans. Setting aside the racial perspective and the fraught issue of who is allowed to represent whom, with what means and towards what purpose, the neglect of this book

in critical terms says a great deal about the creation of a twentieth-century history of American documentary photography as well. If the canon has been reluctant to deal with Ulmann and Peterkin's collaboration, it is partly because the political parameters of their work do not fit existing models of the 1930s as an era largely governed by state-sponsored documentary projects. Both Peterkin and Ulmann were fascinated by the dream of an America still propelled by self-sufficient labour and content to rely on distinctly regional traditions and customs, an issue that adds an under-explored economic dimension to their collaboration as well. The many images of people fishing, doing handicrafts and engaging in agrarian culture in general, whilst an antidote of sorts to large-scale mechanised modes of production, were also, in many ways, an escape from reality, and certainly an escape from the reality of the Depression, as subsequent chapters will examine.

To this day, most writing on *Roll, Jordan, Roll* seeks either to redeem the book or to critique its politics, not by accepting the challenge of its racial prejudices but by establishing Peterkin and Ulmann as either prototypical feminists or modernists; in reality, they were situated somewhere in between. The book is clearly a eulogy for the South but it is also a eulogy for a particular form of photography. Following the death of Ulmann in 1934, the use of Pictorialist aesthetics survived chiefly in work designed to be *not* documentary, and even there it quickly became a retrograde stylistic remnant of earlier times. It may take many more decades before the history of 1930s photo-textual collaboration begins to take the strange collaboration that is *Roll, Jordan, Roll* genuinely into account.

Notes

1. As explained by Mike Weaver, Pictorialism can be defined as a mode of picture making 'in which the sensuous beauty of the fine print is consonant with the moral beauty of the fine image, without particular reference to documentary or design values, and without specific regard to topographical identity'. Mike Weaver, *The Photographic Art: Pictorial Traditions in Britain and America* (New York: Harper & Row, 1986), p. 8. The Pictorialist perspective focused on the camera as a tool for artistic and aesthetic value first and foremost. Pictorialists in the United States included Alvin Langdon Coburn, F. Holland Day, Gertrude Käsebier, Edward Steichen, Alfred Stieglitz and Clarence H. White. In the late work

of Stieglitz and that of Paul Strand, as examined in Chapter 7, American Pictorialism turned towards modernism, becoming less involved with atmospheric effects and beautiful subject matter. Some of the older ideals of pictorial beauty were none the less retained by the group called the Pictorial Photographers of America.

2. As quoted in Philip Walker Jacobs, *The Life and Photography of Doris Ulmann* (Louisville: University of Kentucky Press, 2001), p. 63.

3. As quoted in Jacobs, *The Life and Photography of Doris Ulmann*, p. 68.

4. Elizabeth Robeson, 'The Ambiguity of Julia Peterkin', *The Journal of Southern History*, 61:4 (1995), p. 767.

5. Julia Peterkin and Doris Ulmann, *Roll, Jordan, Roll* (New York: Robert O. Ballou, 1933), p. 11.

6. For more on the modernist aesthetics of vernacular and regional culture in the context of the Gullah see: Crystal Margie Hills, 'Wees Gonna Tell It Like We Know It Tuh Be: Coded Language in the Works of Julia Peterkin and Gloria Naylor', Thesis (Georgia State University, 2008), available at <http://scholarworks.gsu.edu/english_theses/45> (last accessed 23 July 2018). For more on Zora Neale Hurston's use of African–American speech patterns see: Tiffany R. Patterson, *Zora Neale Hurston and a History of Southern Life* (Philadelphia: Temple University Press, 2005).

7. W. E. B. Du Bois as quoted in Charles Joyner, 'Foreword', in Julia Peterkin, *Green Thursday* (Athens: University of Georgia Press, 1998), p. xxxv.

8. Peterkin and Ulmann, *Roll*, p. 23.

9. Janet Gallingani Casey, *A New Heartland: Women, Modernity, and the Agrarian Ideal in America* (Oxford: Oxford University Press, 2009).

10. Robeson, 'The Ambiguity of Julia Peterkin', p. 767. Most of Peterkin's literary repertoire, particularly her novels *Black April* (1927), *Scarlet Sister Mary* (1928) and *Bright Skin* (1932), focus on black characters.

11. Casey, *A New Heartland*, p. 10.

12. *I'll Take My Stand by Twelve Southerners* (New York: Harper and Brothers, 1930), quoted in Lucinda H. Machethan, 'I'll Take My Stand: The Relevance of the Agrarian Vision', *Virginia Quarterly Review* (Autumn, 1980), vol. 56.

13. Peterkin and Ulmann, *Roll*, p. 12.

14. Ibid., p. 109.

15. Ibid., p. 9.

16. As quoted in Machethan, *Virginia Quarterly Review*, p. 14.

17. *Roll, Jordan, Roll* was published in two editions: the trade edition contained seventy-two Ulmann images and a limited edition had ninety hand-pulled gravures.

18. Peterkin and Ulmann, *Roll*, p. 139.

19. Nghana Tamu Lewis, 'The Rhetoric of Mobility, the Politics of Consciousness: Julia Mood Peterkin and the Case of a White Black Writer', *African American Review*, 38:4 (2004), pp. 589–608.

20. Ibid., p. 600.

21. Ibid., p. 603.

22. Ibid.

23. Not coincidentally, both Margaret Bourke-White and Dorothea Lange studied under Clarence White at the Ethical Culture School in New York. For more on the importance of the Clarence White School of Photography see: Bonnie Yochelson, 'The Clarence White School of Photography', available at <https://www.moma.org/interactives/objectphoto/assets/essays/Yochelson.pdf> (last accessed 23 July 2018).

24. Doris Ulmann's works include: *The Faculty of the College of Physicians & Surgeons* (New York: Columbia University, Hoeber Press, 1919); *A Book of Portraits of the Faculty of the Medical Department of the Johns Hopkins University* (Baltimore: Johns Hopkins Press, 1922); and *A Portrait Gallery of American Editors* (New York: W. E. Rudge, 1925).

25. Sterling A. Brown, 'Arcadia, South Carolina', review of *Roll, Jordan, Roll*, by Julia Peterkin and Doris Ulmann, *Opportunity* (February 1934), as cited in Elizabeth Davey, 'The Souths of Sterling A. Brown', *Southern Cultures*, 5:2 (January 1999), pp. 20–45.

26. Robeson, 'The Ambiguity of Julia Peterkin', p. 769.

27. Peterkin and Ulmann, *Roll*, p. 88.

28. Ibid., p. 12.

29. In subsequent chapters, the ways in which photo-textual studies of regional people play on, and subvert, the essentialist qualities of the sharecropper, the farmer and the city-dweller will be paramount as well.

30. Susan Millar Williams, *A Devil and a Good Woman, Too: The Lives of Julia Peterkin* (Athens: University of Georgia Press, 1997), p. 102.

31. Jacobs, *The Life and Photography of Doris Ulmann*. Chapter 3, 'Photographing the South', traces the genealogy of Ulmann's fieldwork.

32. Kreidler, Jan, 'Reviving Julia Peterkin as a Trickster Writer', *The Journal of American Culture*, 29:4 (2006), p. 470.

33. As quoted in Robeson, 'The Ambiguity of Julia Peterkin', p. 723.

34. Peterkin and Ulmann, *Roll*, p. 67.

35. Ibid., p. 12.

36. Melissa A. McEuen, *Seeing America: Women Photographers Between the Wars* (Lexington: University Press of Kentucky, 2004), p. 5.

Articulating the Depression in Dorothea Lange and Paul Taylor's *American Exodus* (1939) and Margaret Bourke-White and Erskine Caldwell's *You Have Seen Their Faces* (1937)

Two of the most influential photo-texts from the 1930s, Margaret Bourke-White and Erskine Caldwell's *You Have Seen Their Faces* (1937) and Dorothea Lange and Paul Taylor's *American Exodus* (1939), garnered very different reputations, despite being just a few years apart. *American Exodus* was critically acclaimed and heralded as a classic of concerned journalism – a reputation largely unchallenged to this day – while the bestselling *You Have Seen Their Faces* has since been critiqued as a gratuitous and even politically suspect exercise in exposing the sharecroppers' plight during the Depression.

Nevertheless, *American Exodus* and *You Have Seen Their Faces* (*YHSTF* onwards) do more than provide straightforward representations of the American landscape and its inhabitants during the 1930s. In crucial ways, both photo-texts are symptomatic of a wider level of fascination with the same dramatisation of an American vernacular that incorporates empathy, sentiment and drama, as seen in Julia Peterkin and Doris Ulmann's *Roll, Jordan, Roll*. While *Roll, Jordan, Roll* was marked by Ulmann's Pictorialist aesthetics, Lange and Bourke-White shared a fascination with the realist techniques of the camera that was much more in keeping with what we now consider documentary practice. Thus, while *American Exodus* and *YHSTF can* be read as examples of photo-texts with

primarily political aims, they too share an interest in how text and photography inform the documentary process that goes beyond the subject matter itself.

This chapter compares some of the ways in which both books established the photo-textual format at a time when such projects had little precedence and where the few that did exist – such as *Roll, Jordan, Roll* – were marketed to a predominantly small audience. Despite the firm belief in documentary photography as a means toward genuine political and social enlightenment, *YHSTF* and *American Exodus* are also exercises in the staging of a documentary style: a style that, inadvertently and sometimes deliberately, comments on photography's limitations as well as advantages. While the success of the two books at the time of publication relied heavily on how convincingly they combined a sense of authenticity with an emotive documentary style, their current status as photo-textual collaborations has had more to do with the iconicity of the singular images, particularly in Lange's case, than with them as coherent narratives in their own right. It is this focus that this chapter will widen by looking at some of the juxtapositions of images and text in the books overall.

By the mid- to late 1930s, Lange and Bourke-White both worked for large organisations with overt, as well as more implicit, political affiliations. In Bourke-White's case, she had consolidated her reputation as the first staff photographer for Henry Luce's *Time/Life* magazines, while Dorothea Lange had worked for the photographic division of the Resettlement Administration, the Farm Security Administration from 1937 onwards, under the direction of Roy Stryker.[1]

When Bourke-White agreed to collaborate with the then famous writer Erskine Caldwell on a documentary project on Southern sharecroppers in 1935 (the title *You Have Seen Their Faces* had been devised by Caldwell two years before), she had already undergone a transformation from being primarily a corporate/advertising photographer to specialising in increasingly popular human interest stories. Images, newsreels and reports detailing the effects of the Depression in both urban and rural terms were being disseminated to bolster President Franklin Delano Roosevelt's New Deal policies, and while the aim of both *YHSTF* and *American Exodus* was to deal with the acute trauma of the Depression, they knowingly responded to an existing tradition of proletarian and populist fiction designed more

widely to tell the story of the forgotten sharecropper.[2] As Bourke-White optimistically wrote in a draft introduction to *YHSTF*,

> If our collaborative work will do something to make the problem real to our readers, to destroy the aura of sentimentality that still befogs issues in the South, if it will make these faces in our book come alive, then we will have succeeded in what we set out to do.[3]

The redemptive rhetoric in Bourke-White's Introduction, like so many other projects of the 1930s, stresses the humanity and endurance of the subjects portrayed. In an attempt to counter an otherwise sentimentalised reading of the South, the photographs in *YHSTF*, close-ups or medium shots of individuals and groups of people, are none the less recognisably 'Southern'. There are few people at work but a significant amount in church, sitting on porches, in chain gangs, lost in the forlorn interiors of dilapidated shacks. Consisting of six untitled chapters with about 10-12 images, each chapter starts out with a brief first-person statement from a local inhabitant. No names or dates are attributed to the 'statements', merely a place. Following the statement – a quotation or saying written in the vernacular – Caldwell outlines the nature of the problem referred to, whether it be race relations or agricultural or economic issues, in a longer, more articulate journalistic form. As Caldwell polemically states in the first chapter,

> Mark against the South its failure to preserve its own culture and its refusal to accept the culture of the East and West. Mark against it the refusal to assimilate the blood of an alien race of another colour or to tolerate its presence. Mark against it most of, if not all, the ills of a retarded and thwarted civilization.[4]

In this sense, it is crucial that the very title itself – *YHSTF* – is not an admonition but rather a statement of fact, and that in similar terms, the camera's persuasive abilities are a given. For Caldwell, the Southern sharecropper is symptomatic of the temporary derailment of the American dream, rather than its non-existence. As he puts it,

> The everyday sharecropper is anything but a heroic figure at present; if he continues being the nation's under-dog, that is what he

will become. As an individual, he would rather be able to feed, clothe, and house his family properly than to become the symbol of man's injustice to man.[5]

For Caldwell, individual agency is still a crucial part of the nation's identity, so much so that it possibly supersedes collective action. The implication is also that even well-intentioned policies risk emasculating the Southern man, who wishes, above all, to be self-sufficient. Caldwell's invocation of the innate desire to be self-sufficient, not to rely on hand-outs or liberal sympathy, places the narrative squarely in a long tradition of conservative discourses on the importance of self-reliance and the South as a place where 'old' sentiments and values ideally remain intact.

Taking Erskine Caldwell's reputation into account as a best-selling author of Southern tales of backward sharecroppers, often violently graphic and at times grotesquely humorous, it may seem strange that Bourke-White – a professional photographer of advertising and mainstream journalism – decided to collaborate with him. However, for Caldwell, the generic qualities of the photo-text not only were attractive, but also enabled him to expand his audience and to prove his credentials as a 'Southern' writer. For Bourke-White, her choice of locations is markedly different from the images of large-scale industry and production that she had hitherto documented, so much so that the extreme poverty portrayed, compared to her usual focus on the advances of capitalism, seems almost out of place. The women's old-fashioned sunbonnets are as prominent as the modern newspaper advertisements that adorn the interiors of the dilapidated shacks, and the many references to watermelon and snuff in the accompanying captions seem curiously nineteenth-century – if not almost comical – in their connotations. If the regional titles in Dorothea Lange's *American Exodus*, published only a few years later, provide a panoramic view of a nation under duress, the lack of chapter titles in *YHSTF* seems to dispense with the necessity of situating the project in a specified locale or even period. There is, in other words, a focus on the conceptualisation of the South and the use of the camera as a means towards this conceptualisation. As Caldwell writes,

The South has always been shoved around like a country cousin. It buys mill-ends and wears hand-me-downs. It sits at second table and is fed short-rations. It is the place where the ordinary

will do, where the makeshift is good enough. . . . It is the Southern Extremity of America, the Empire of the Sun, the Cotton States; it is the Deep South, Down South; it is The South.[6]

For Phil Hansom, in 'You Have Seen Their Faces, of Course: The American South as Modernist Space', the conceptualisation of the South enables the book to 'transform a region and its inhabitants into a genre product' and in the process construct 'its reading audience in a specific power relation to the South'.[7] This constructed environment is designed, for Hansom, to turn the act of looking into both a commodified gesture and a distancing one. There is, in other words, no real empathy or interest in political terms with the plight of the subjects themselves. On the contrary, Hansom reads the documentary apparatus as using 'realist rhetoric and photographic discourse' to naturalise what is essentially a reading of the South as backwards and primitive.[8] Hansom rightly points to some of the problems in Caldwell and Bourke-White's definition of the South but the real issue is the photo-textual narrative itself. For Hansom, the flaw in YHSTF is that – like all documentary works – it 'operates on a political level . . . actively determining the relations that appear as "real" life'.[9] In this respect, YHSTF is guilty of creating a 'textual conglomeration of the generic understanding of the area (the South)', thus creating a disingenuous work in which the stereotyping of the region subsumes all other narrative structures within the book.[10] Because Bourke-White and Caldwell's practice is compromised by the 'unreal' nature of the narrative structures in YHSTF, any individual agency or hope becomes fictitious and the project loses its status as a genuinely socially concerned piece of work. Looking back at Roll, Jordan, Roll, we might level the same criticism. Unlike Bourke-White and Lange's projects, however, Roll, Jordan, Roll does not 'pretend' to be working towards actual social change: in fact, perhaps the opposite, in that it filters its vision of the South through a nostalgic rather than critical lens.

For other critics, the overt fictionalisation in YHSTF and the way in which it takes liberties with the so-called veracity of the images by adding made-up captions are partly what makes the book genuinely 'honest'. As Alan Trachtenberg points out in his Foreword to the reprint of YHSTF, 'these detractors (of the book) are simply mistaken. They miss the fictionality of the work and see its deviations from objective fact, (the invented dialogue that serves as captions, for example) as wicked distortion.'[11] As Trachtenberg

points out, it is the very fictionality of *YHSTF* that accords it a unique status within documentary practice in the first place. If the 'objects identified as making up the South are as much created as found' in *YHSTF*, as Hansom puts it, the ethnographic impetus is compromised from the onset. In other words, why criticise the photo-text for not having enough empathy with the sharecroppers when it may have had no clear-cut political aim in the first place? In visual terms, it is clear that much of *YHSTF* focuses on the apparent primitivism of the backward existence of the Southern sharecroppers rather than their perseverance in the face of destitution.

All the stranger, then, that Bourke-White's extensive work in Russia in the late 1920s and 1930s, and her images of the American steel industry and its workers during the same period, are prototypical in their glorification of the worker's stance. In fact, Bourke-White's interest in a highly industrialised modernity in the late 1920s is as different to the landscape of *YHSTF* as one can imagine. In this context, the South in *YHSTF* appears more as an antithesis to the modern rather than as a viable version of an agrarian culture gone awry. Instead of presenting us with a vision of the South as under-developed, the melodramatic vision of people living in clapboard houses without electricity or plumbing appears antithetical to any concept of a progressive modernity.

For Paula Rabinowitz, such a vision of the South as a space untouched by modernity constitutes yet another instance of how documentary practice quickly became inscribed within popular culture as part of a process of national self-fashioning. Through the documentation of extreme poverty, Rabinowitz argues, 'America became modern, became a mass society, by looking at those whose lives had escaped modernity.'[12] So successful was this version of national identity that by the late 1930s, according to Rabinowitz, 'Even the grotesques Margaret Bourke-White pictured in her book *You Have Seen Their Faces* looked disturbingly American. . . .'[13]

The idea of the South as a grotesque landscape not only inserts *YHSTF* into a lineage of earlier Southern writing, from William Faulkner to Erskine Caldwell himself, but also it ensures a fundamentally symbolic role for the region, albeit in ways different from those found in *Roll, Jordan, Roll*'s idealised landscape. In this case, the exaggerated form of mimicry both masks and illuminates the violent undertones of a society only one generation removed from slavery. In an environment where the unspoken hostilities between white and African–American Southerners constitute a fundamental

aspect of the region's psychological make-up, it is no coincidence that *YHSTF* chooses to over-determine, rather than discretely place, the accompanying captions.

In this respect, while the captions appear to normalise the bizarre through a downplaying of the content of the photographs, one could equally argue that the captions actually heighten the bizarre nature of the scenarios in front of us. In 'Natchez, Mississippi' (Fig. 2.1), the actual structure (both architecturally and in economic terms) of the old couple has washed away. If the image was not surreal enough in its portrayal of a private space made entirely public and essentially uninhabitable, the surreal quality is accentuated through Caldwell's caption, which provides the image with a narrative context: 'I spent ten months catching planks drifting down the river to build this house, and then the flood came along and washed the side of it off. Doggone if I don't like it better the ways it is now.'

Caldwell's caption dramatises the image by providing a narrative context through an invented vernacular voice, albeit a voice that – contrary to Julia Peterkin's version of folk wisdom – represents

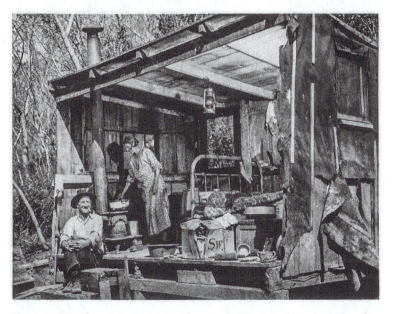

Fig. 2.1 'Natchez, Mississippi', Chapter 6, Fig. 3, in Margaret Bourke-White and Erskine Caldwell, *You Have Seen Their Faces* (New York: Duell, Sloan and Pearce, 1937). Courtesy Otis and Macintosh.

the people portrayed as perfectly adapted, like animals, to living outdoors. Despite such condescension, the caption also imparts a knowingly satirical edge to the image: an edge that veers closely towards something very different from the documentary or anthropological purpose of the book. In this instance, the caption indicates not the despair at hand but the humour implicit in the man's acceptance of it. This jocular version is also inscribed as particularly Southern and the vernacular invoked thus sounds more comedic than anything else. In another example of this bizarre sense of distancing, in 'Okefenokee Swamp, Georgia' (Fig. 2.2), 'The little's one gets taken care of', the caption ironically stresses the fact that there is hardly any food on the table, thus juxtaposing a very visible moment of lack with a blatantly false assertion. Instead, the scene of domestic tranquillity appears staged, a sense increased by Bourke-White's lighting of the scene and the artificiality of a family 'acting out' a dinner that virtually does not exist.

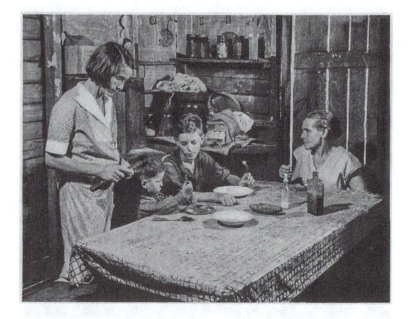

Fig. 2.2 'Okefenokee Swamp, Georgia', Chapter 4, Fig. 3, in Margaret Bourke-White and Erskine Caldwell, *You Have Seen Their Faces* (New York: Duell, Sloan and Pearce, 1937). Courtesy Otis and Macintosh.

The mechanisms at work in *YHSTF* – to the extent that they provide an almost uncanny sense of the South rather than a 'real' one – are thus not about the 'truth' of documentary practice, or indeed its ability to provide an authentic sense of 'The South'. For subsequent audiences in the late 1930s, this appeared to be no issue, as the forceful, even gratuitous, nature of the images made up for any lack of veracity. Rather than us reading the captions and quotations as signs of a lazy sociological practice that fails to question the circumstances of the sharecroppers' lives, they become exercises in how to inscribe photography with meaning – a meaning that contemporary audiences mostly accepted. In 'Natchez, Mississippi' and 'Okefenokee Swamp, Georgia' (Figs 2.1 and 2.2), the photographs risk superseding any comprehensible narrative, unless inscribed with some sort of meaning through the accompanying 'caption'.[14] Caldwell and Bourke-White even go out of their way, in their Introduction, to remind the readers that the captions do not promise an accurate transcript of the subjects per se but are something else:

> No persons, place, or episode in this book is fictitious, but names and places have been changed to avoid unnecessary individualization; for it is not the authors' intention to criticize any individuals who are part of the system depicted. The legends under the pictures are intended to express the authors' own conceptions of the sentiments of the individuals portrayed; they do not pretend to reproduce the actual sentiments of these persons.[15]

On the one hand, the legends allow for a creative rewriting of the subjects' 'sentiments', a procedure that arguably legitimises a form of manipulation. On the other hand, the frank description of the mechanics of the documentary process seems to counter any genuine subterfuge and the photographs really do become stepping-stones for 'the authors' own conceptions of the sentiments of the individuals portrayed'. For Bourke-White, in particular, this may have been a way to professionalise a documentary procedure that she had no experience working with; it becomes – in other words – a way to recognise the mechanisms at play in the production of documentary work. By showing that it is not intuitive but, in fact, a highly constructed exercise, Bourke-White foregrounds the fictionality of the invented captions. We may want the documentary perspective to be appropriately emotive but, in the end, Bourke-White's

photographs end up telling a very different story. Bourke-White's detailed postscript about her equipment at the end of the book – as an example – clearly diffuses the emotional connection she may have felt with the subjects. It is as though Bourke-White, by providing an insight into her camera technique, makes the mechanics of the process override her own emotional attachment and, by proxy, ours as well.

Such processes combine to create a South that is imagined as well as theatrical, a space where even houses collapse like stage sets and where photographs of black convicts on a chain gang look more like stills from Mervyn Leroy's popular 1932 film 'I Was a Fugitive on a Chain Gang'. This almost cinematic sense of theatricality indicates that *YHSTF*'s use of the documentary aesthetic, like that of much 1930s drama, combines a nominal notion of realism with something more akin to melodrama. Contrary to what we will see in Lange and Taylor's *American Exodus*, no actual landscapes exist in Bourke-White's version of the South without the people occupying it actually being in frame. Like a stage, any vacant space appears to be waiting for the people who inhabit it and they, in turn, are lit in ways reminiscent of cinematic stills, of staged scenarios, rather than documentary realism. The effect of juxtaposing advertising techniques and cinematic set-ups with the faces of the starving Southerners is clearly a choice by Bourke-White: a choice based on ensuring that we will indeed *See Their Faces*.

What happens in *YHSTF* is thus more a staging of the documentary, a deliberate alignment with the mechanics of fiction – and in many ways a melodramatic form of fiction at that, than a straightforward exploration of documentary as realism. In a sense, *YHSTF* may be the very first photo-textual collaboration to establish a space in which the documentary aesthetic seems to reproduce itself, to draw attention to itself as method – much more so than in *Roll, Jordan, Roll*, where Ulmann and Peterkin are intent on creating a genuinely synthetic vision of a pastoral South. This does not mean that the book's agenda was to make the documentary process entirely transparent, merely that it did not envision the documentary process as anything other than a direct representation of the writer's and photographer's intentions. In keeping with this, the final chapter of *YHSTF* very deliberately avoids a hopeful vision of a Southern future: what we see is a group of physically undernourished and occasionally malformed people. There are no smiling

children in this vision, no sense of a future generation, precisely because Caldwell and Bourke-White saw the South as inherently backward and primitive. The final photograph, in itself an ironic gesture towards the futility of Southern hope and religion, shows a makeshift sign, 'Look – Now is the Day of Salvation!', a stark reminder that, for this region, the day may be far off. This reference to Southern evangelism is not merely about the church's failure to lead the South out of poverty. It is also, on a wider level, about the photo-text itself as incapable of being redemptive in anything other than ironic terms (Fig. 2.3).

No wonder that, when *YHSTF* was reviewed in 1937, the papers were polarised according to regional allegiances. Most Northern papers praised the book as 'a courageous standpoint of realism, buttressed by the hard facts of sociology', whereas the *South Carolina Herald*, amongst others, considered it 'a slander on the South'.[16]

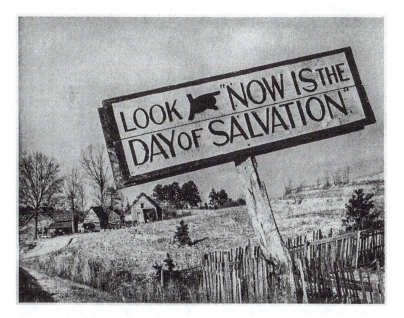

Fig. 2.3 'Look – Now is the Day of Salvation', Chapter 6, Fig. 9, in Margaret Bourke-White and Erskine Caldwell, *You Have Seen Their Faces* (New York: Duell, Sloan and Pearce, 1937). Courtesy Otis and Macintosh.

For Herschel Brickell in the *New York Evening Post* of 8 November 1937, *YHSTF* was 'the most graphic account of the tenant-farmer problem in the South ever produced', even though 'the edge is taken from the sociological value of *YHSTF*; they are mostly pictures of ugly things – not all – made beautiful by the sheer art of a skilfully manipulated camera'.[17] In other words, the skilfully manipulated camera – whilst able to aestheticise the subject – could not be 'truthful' in documentary terms. For Dorothea Lange and Paul Taylor, on the other hand, the documentary aesthetic could – if done properly – be a moral guide towards genuine change.

American Exodus (1939) – the photo-text put together by Dorothea Lange and her soon-to-be husband, the statistician and sociologist Paul Taylor – is, as the title indicates, about a nation wrested from the land that constitutes both its identity and its sustenance. It is a book full of roads and of people wandering those roads and highways in search of work. The roads are also, we quickly realise, meant to emblematise how the photo-text can guide the reader as a form of moral and regional compass.

Out of the 108 photographs in *American Exodus* (only two of which are not Lange's), many present agricultural loss in acute terms by showing either farmers inactive, situated within the afflicted land, or the blown-out, dust-ridden, arid land itself. A sense of neutrality is re-enacted through the use of minimalist captions that often simply state the scenario, snippets of newspapers, reports and headlines that intersect with the photographic material. Throughout, land is a constant theme, through photographs of either receding views, highways that continue into the distance, or Lange's famous shots of lonely sharecropper shacks sandwiched between relentlessly white skies and dust-covered furrows. *American Exodus* critiques the ruthlessness of the agricultural peonage and yet it also clearly roots national culture in the ownership and tilling of land. If it is the upheaval of that land that forms the underlying problem of *American Exodus*, it is the promise of regeneration in agricultural terms that promises its redemption.

The documentation of movement, of people forced from one region to another, is the main theme of *American Exodus* and, unlike in *YHSTF*, the pathos generated through exaggerated imagery is downplayed in favour of a sociological methodology that is less 'fictitious' in its lineage. This does not mean, however, that sentiment, and empathy in particular, are not two of the constituent parts

of *American Exodus*'s general indictment of agricultural peonage. Empathy is, in fact, Lange's main achievement in many respects. In Lange's photographs, the visual aesthetic is always geared towards the most effective way of aligning the viewer's gaze with that of the photographer; we are meant to feel that we too are witnesses to an actuality shown in the clearest, most unaltered terms.

In this respect, the success of Lange and Taylor's collaboration hinges on the caption being the very opposite of Caldwell's in *YHSTF*. In *American Exodus*, the captions appear unobtrusive, respectful of circumstance, compared to those of Caldwell, in their approach to the perceived forcefulness of the image itself. This more minimalist approach appears, then, to distance itself from the type of irony and certainly from the comedy implicit in Caldwell's folksy commentary. If there is an attempt to speak on behalf of the subjects in *American Exodus*, Lange and Taylor are eager to pre-empt any charges of fictionalisation, and this earnestness, in terms of structure as well as approach, is self-evident throughout the book.[18] Through clearly demarcated regional headings – Old South, Midcontinent, Plains, Dust Bowl and Old West – Lange and Taylor promise simply to illuminate the state of the nation, as seen by them on the road. In Taylor's writing, this is made clear:

> We use the camera as a tool of research. . . . We adhere to the standards of documentary photography as we have conceived them. Quotations which accompany photographs report what the persons said, not what we think might be their unspoken thoughts. Where there are no people, and no other source is indicated, the quotation comes from persons whom we met in the field.[19]

Contrary to *YHSTF*, *American Exodus* promises that the captions are actual quotations, even if they are generated through a documentary procedure as 'conceived' by Taylor and Lange. The promise is clearly a response to *YHSTF*, which pre-empted *American Exodus* by two years, but it is also part of an overall plan to make the photo-text a bona fide form of sociological investigation. Nevertheless, despite the desire to establish the captions as more trustworthy, the captions in *American Exodus* are often devoid of factual information in an attempt to guarantee the efficiency of the images. Rather than complicate things by providing 'excess' information, the captions appear

nearly as a form of shorthand or note taking. In the Dorothea Lange Archives, field notes and other written materials also indicate that she was less concerned with noting down exactly who was being quoted, in what circumstances and where, a fact that is rarely mentioned in writing on Lange. Often a person is quoted, for example, but their name or situational context is not given.

In 'US 80 near El Paso', the photograph of a black woman and man by the side of a billboard is accompanied by a comment indicating that the woman has been cited (Fig. 2.4). Still, we do not know this for certain: the commentary could be an amalgamation of emotions cited by several people encountered 'on the road'. What the 'free-floating' citation does is accentuate the call for empathy, as seen in the woman's gestures and in the sentiment conveyed in the writing, her outstretched hands and tilted head both questioning and resigned at the same time. It is through such gestures that Lange ensures an appeal directly to the viewer. The viewer will also know that the billboard – the purveyor of American dreams rather than the reality of life on the road – makes the convergence between the statement and the woman's gesture all the more disheartening. As we glance, we see the words 'service'

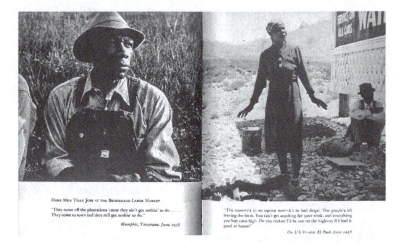

Fig. 2.4 'On US 80 near El Paso, June 1938', in Dorothea Lange and Paul Taylor, *An American Exodus*. Copyright © Oakland Museum of California Art Department, Dorothea Lange Collection.

and 'cars', and we know that the likelihood of this couple ever seeing either is very remote.

For John Rogers Puckett, such procedures in *American Exodus* confirm the accompaniment of the factual voice of Paul Taylor as something beyond a rhetorical construct. In fact, Puckett sees it as no less than the articulation of some sort of truth:

> The style of Taylor's essays is factual, informative, informal. . . . Taylor emerges as a quiet, scholarly man – reasonable, knowledgeable and compassionate – who clearly invests emotion in the work he is doing. . . . Limiting his discussion to economic forces . . . Taylor does not discuss Southern black white relations, or the role of politics and religion, nor does he depict the painful life of a tenant farmer, as Caldwell does. . . . This technique creates an intellectual rather than an emotional relationship. . . .[20]

Puckett's underlying assumption is that Taylor's sociological and therefore more 'scientific' approach, unlike *YHSTF*, avoids racial or class conflict. The definition of Taylor's approach as 'intellectual' rather than 'emotional' also points to something unspoken but nevertheless part of Puckett's overall reading. The intellectual approach is, to a large extent, posited as the domain of the neutral male observer and the emotional that of the more engaged female photographer.

The sense that a gendered positioning takes place within the documentary process, in both Lange and Bourke-White's case, is often implicit in the critical approach to their work. On a basic level, the appropriate behaviour for a female photographer is epitomised by Lange's emphatic approach, whereas Bourke-White's is unnecessarily masculine: that is, unnatural in her use of poverty as material for commercial gain. For Bourke-White, the famously vitriolic commentary by James Agee on her as a photographer in *Let Us Now Praise Famous Men* (1941) is underwritten by a misogyny that goes well beyond his political disgust with her photographic practice. In opposite terms, Lange's qualities as a female photographer are often seen to provide a sense of intimacy and empathy with her subjects, to provide – in some respects – the semblance of a maternal gaze.[21] In this respect, when critics speak of a Lange 'type' in her photographs, they are often implicitly considering what 'type' of documentary person Lange herself was.[22]

Bourke-White, on the other hand, is read in very different ways. Part of her persona as the first successful commercial female photographer has meant that she is seen as a professional first and foremost, and as a potential artist secondly. While this did not seem to bother Bourke-White, Lange herself knew that the connection between struggling to be a female photographer, a wider body politic and her own body could not be circumvented so easily. Speaking in interviews about her past, she would often make the connection between her life-long walking disability and her role as a photographer:

> I was physically disabled, and no one who hasn't lived the life of a semi cripple knows how much that means. I think perhaps it was the most important thing that happened to me, and formed me, guided me, instructed me, helped me and humiliated me. . . . We all have those things that form us. They are what we are built from, they are our architecture.[23]

Lange's comments are also indirectly about *American Exodus* itself as a form of disclosure, a disclosure of a crippled body politic and a disclosure of her own photography as being about personal catharsis and a form of national rebuilding. In this respect, photography for Lange becomes a deeply introspective act, one in which it is 'the photographer's sense of the familiar that provides the proof'.[24] As Lange says,

> in that intimacy, even with the commonplace, will be discovered passages and openings denied the outsider. The intimate will be admitted to subtleties and complexities shut to the stranger. . . . Through familiarity the photographer will find not only the familiar but the strange, not only the ordinary but, the singular.[25]

Lange's own description of the documentary process uses empathy and intimacy to explain the connection between the photographer and her subject. In the end, the gaze of the photographer relies on familiarity, on understanding, on a sense of cohesiveness that surpasses regional and other differences. For this reason, photography should aim for no less than to make the familiar universal and the commonplace monumental. As Alan Trachtenberg points out, Lange's 'humanitarian realism' risks 'capturing and binding the fleeting image to an abstraction, completing its meaning at the expense of particularity'.[26] Thus, despite the statistical data and regional markers in *American Exodus*, designed

to illuminate the acute nature of the problem, what ultimately remains in Lange's images is a sense of her emotional attachment to the subjects at hand.

While Lange's emotional investment in her photographs is unquestionable, there is also a universalising impulse in *American Exodus* that makes it very different from *YHSTF*. We need only look at the titles of the two photo-texts to see two very different conclusions to the crisis of capitalist agrarianism. One book posits the outcome in terms of human deformity and backwardness (the faces we will see), while the other, with its subtitle, 'a record of human erosion', links the emotional and psychological outcome with an economic one. In *American Exodus*, the 'human erosion' is also about the erosion of a collective that is worth saving: namely, the United States, a collective that, in turn, is invoked through a recognisable iconography of a previous America. This is an America created through westerns and films, and through narratives of expansion and frontier settlements, as much as through realist photography. It is, in other words, an America that many would feel a great deal of empathy towards in ideological terms. It is also, crucially, a very different America from the backward Southern landscape of *YHSTF*, where the landscape, rather than being at risk of erosion, is visualised through the debris of an inoperable agrarian past.

In these terms, the universalising impulse in *American Exodus* is also an impulse towards a more mythic reading of the American West. On the one hand, it functions as a reminder of how failure in agricultural terms has left the USA stranded in the nineteenth century while, on the other, it invokes an American idealism of perseverance and survival. *American Exodus* is historicised in ways fundamentally different from *YHSTF* precisely because it wants to paint a broad picture of human endurance whilst maintaining the seriousness of the situation at hand. Nevertheless, it too cannot help but occasionally mythologise the very thing that it seeks to critique.

The impulse to create a larger canvas for the farmers afflicted by the Dust Bowl is present from the beginning to the end of *American Exodus* and it is no coincidence that the book ends with a quotation from Pliny entitled 'The Earth'.[27] Rather than narrow the discourse down to something local and vernacular, Taylor and Lange insert an admonition in classical, timeless terms:

Here we bear our honors, here we exercise our power, here we covet wealth, here we mortals create our disturbances, here we

continually carry on our wars, . . . and unpeople the earth by mutual slaughter. And not to dwell on public feuds, entered into by nations against each other, here it is that we drive away our neighbors, and enclose the land thus seized upon within our fence; and yet the man who has most extended his boundary, and has expelled the inhabitants for ever so great a distance, after all, what mighty portion of the earth is he master of?[28]

Seemingly intent on evoking an American vernacular of perseverance against the odds, *American Exodus* nevertheless ends by invoking Greek ideals, a classical version of mythology and politics. The reference to the harmonious or belligerent co-existence of nation states is promulgated on a Western idealism that slots America into 'categories of existence true for all times and places'. In *YHSTF*, on the other hand, the distance created through the satirical dimensions of the 'legends', vis-à-vis the photographs, operates more as a commentary on human folly than a forewarning of later internationalist conflict, as in the Pliny quotation. More importantly, in photographic terms, the Pliny quotation pre-empts the use – much maligned by Roland Barthes and Alan Sekula – of similar universalist quotations in Edward Steichen's 'Family of Man' exhibition from 1955. While 'Family of Man' was heavily criticised for its reductive tendency to universalise human suffering at the expense of political and economic reality, *American Exodus*'s humanist narrative is tempered by the accompanying writing and its attempt to situate the images historically.

Thus informed, we may understand why the accompanying writing in *American Exodus* succeeds where Caldwell's possibly fails. While both books concern themselves with the transaction between photographer and subject, *American Exodus* makes an effort to create a canvas of authenticity for the scenes established. In the process, it establishes what we might call a distinctly Langean essence of understanding between viewer and subject, a reflection of ourselves that we can, in a sense, live with temporarily. In *YHSTF*, of course, the viewer is unlikely to identify with the stereotypical visage of the South and, indeed, is not meant to.

Contrary to the static sense of the South in *YHSTF*, the conflicts of agriculture, history and politics in *American Exodus* become the foundation for a vision of documentary photography as somehow beyond the actual, as if the temporality established in the book – like the images – is vying for a transcendence that will take it away

from the contemporary. It is telling that *American Exodus*'s original dust jacket shows a covered wagon with the accompanying caption 'Covered Wagon – 1939 Style'. Lange's cropping of the negatives in the first edition, with the images bleeding horizontally into each other, implies that a broader canvas is being painted, that the stories supposedly told by the subjects themselves are the background to a symbolic landscape, just as the wagon is symbolic of a particular American past.

Lange's 'Oklahoma Child with Cotton Sack Ready To Go into Field with Parents at 7 A.M.' represents another instance of Lange's use of empathy and her ability to heighten the injustice of the child's work by her gestures and the cropping of the image (Fig. 2.5). In 'Oklahoma Child', the caption goes out of its way to eliminate any incongruity between image and text; instead, the verbal 'truthfulness'

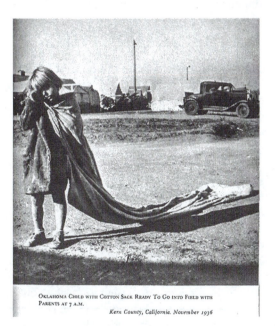

OKLAHOMA CHILD WITH COTTON SACK READY To Go INTO FIELD WITH PARENTS AT 7 A.M.
Kern County, California. November 1936

Fig. 2.5 'Oklahoma Child with Cotton Sack Ready To Go into Field with Parents at 7 A.M.', in Dorothea Lange and Paul Taylor, *An American Exodus*. Copyright © Oakland Museum of California Art Department, Dorothea Lange Collection.

is guaranteed by the way the caption fits the image seamlessly. There is also an underlying pastoral thrust at work here, and perhaps one that is not so fundamentally different from *Roll, Jordan, Roll*'s: a morality tale of poor country folk teaching the reader a lesson in sorrow and fortitude. No matter how abject 'Oklahoma Child' may be, like the 'Family of Man', she provides a self-evident vision of humankind as intrinsically good and redeemable.

Lange herself was aware of the pitfalls of consistently using very emotive photographs as a way to confirm a broadly humanist perspective. This partly explains her decision not to include her most famous image, 'Migrant Mother', in *American Exodus*. Regardless, Lange's work has, since then, provided a more modern sense of ethnography for a contemporary audience: an ethnography that wisely shies away from the unashamedly satirical dimensions of Bourke-White and Caldwell's vision, and which in some respects has ensured Lange's continued popularity. Bourke-White, on the other hand, chose to insert her visual aesthetic into a much more melodramatic and populist narrative, which partially accounts for *YHSTF* being, in many ways, more dated.

As important, however, for the continued success of *American Exodus* is the fact that it invokes an iconography of American fortitude that set the stage for a patriotic form of post-war documentary photography culminating in the 1950s. For Bourke-White and Caldwell, on the other hand, universalising the plight of the South was clearly not the issue in 1937; on the contrary, the aim was to isolate a problem, to make it visible and digestible. The fact that aspects of this recur in *Let Us Now Praise Famous Men*, which, after all, mines the same territory, is partially what makes James Agee so uncomfortable with the success of *YHSTF*. And yet, however much we appreciate the epic nature of *American Exodus*, the empathy filtered through Lange's humanist impulse is as problematic as the efficiency of Bourke-White's Southern stereotypes. *American Exodus* may provide us with a more palatable version of poverty but the question remains of whether it creates a representation of a collective experience that is more 'genuine' than that of *YHSTF*. In Lange's case, the importance of empathy did not preclude a documentary outlook but, in fact, established a particularly humanist viewpoint as essential to documentary practice. Compared to Bourke-White, Lange had an ability to generate empathy that made her an extremely capable propagandist – as Roy Stryker knew when he continued to employ

her for the Farm Security Administration's photographic division. For that reason as well, *American Exodus* constitutes a seminal moment in the journey towards establishing a post-war iconography of the American vernacular, despite being ingrained in our minds as a quintessential document of the Depression.

In the end, we can perhaps fault *YHSTF* for not showing a more emphatic face of the South, but as an example of a regional study it embraces many of the moral dilemmas that subsequent photo-texts sought to negotiate. It certainly extends the issue of staging and performance in *Roll, Jordan, Roll* by juxtaposing one type of photography with another type of writing. The following chapter will briefly examine how these dilemmas were negotiated by critics and followers of photography through the lens of another iconic photographer and contemporary of Dorothea Lange – Walker Evans. As the following chapter will investigate, for many during the 1930s, a truly genuine American version of documentary practice could be measured in the visual aesthetics of individual photographers. In order to do so, he or she had to be defined as an authorial presence in his or her own right. The photo-text, a place where writing could bolster the artistic credentials of the photographer's gaze, was an excellent forum in which to do precisely this.

Notes

1. In later interviews, Lange praised Stryker's direction of the photographic division and the pro-New Deal aspect of the material collected. For transcripts of interviews and field notes see: Howard M. Levin and Katherine Northrup, *Dorothea Lange: Farm Security Administration Photographs, 1935–1939*, vols 1 and 2, text Paul S. Taylor (Washington, DC: Library of Congress, 1980).
2. Erskine Caldwell was mostly known as the notorious writer of somewhat lurid narratives of Southern rural life. The accompanying captions in *YHSTF*, written and organised editorially by Caldwell, came out of an idea he had worked on for at least two years prior to meeting Bourke-White. When Bourke-White joined Caldwell, he was trying to downplay his reputation as the successful writer of gratuitously sexualised descriptions of Southern life. With Bourke-White's photographs, *YHSTF* promised the legitimacy of a politically correct journalistic enterprise rather than another populist bestseller.
3. From an untitled manuscript. Courtesy of the Margaret Bourke-White Archives, Syracuse University.

4. Margaret Bourke-White and Erskine Caldwell, *You Have Seen Their Faces* (New York: Duell, Sloan and Pierce, 1937), p. 108.
5. Ibid.
6. Ibid., p. 1.
7. Paul Hansom, '*You Have Seen Their Faces*, of Course: The American South as Modernist Space', in Paul Hansom, ed., *Literary Modernism and Photography* (London: Praeger, 2002), p. 53.
8. Ibid., p. 61.
9. Ibid.
10. Ibid.
11. Alan Trachtenberg, 'Foreword', in Erskine Caldwell and Margaret Bourke-White, *You Have Seen Their Faces* (Athens: University of Georgia Press, 1995), pp. v–viii, vii.
12. Paula Rabinowitz, *Black & White & Noir: America's Pulp Modernism* (New York: Columbia University Press, 2002), p. 111.
13. Ibid., p. 109.
14. While 'legend' comes from the Latin adjective *legenda*, 'for reading, to be read', it has, since the fifteenth century, referenced myth, fiction and fairy tales as well. 'Legend' can also mean a written explanation to an illustration. In this case, the use of the word 'legend' opens up the issue of fictionality within the documentary process.
15. Margaret Bourke-White and Erskine Caldwell, 'Introduction', in *You Have Seen Their Faces* (New York: Duell, Sloan and Pierce, 1937).
16. Extracts from press clippings in the Margaret Bourke White Papers, Special Collections, Syracuse University.
17. Ibid.
18. Following the publication of YHSTF in 1937, Bourke-White donated the manuscript and photographs from the book to the League of American Writers for an auction in aid of the Spanish resistance. At the time, Caldwell was one of the vice-presidents of the league, together with Van Wyck Brooks, Malcolm Cowley, Langston Hughes and Upton Sinclair. For more on the connections between Bourke-White and the wider literary and cultural modernism of the era see Sharon Corwin, Jessica May and Terri Weissman, eds, *American Modern: Documentary Photography by Abbott, Evans, and Bourke-White* (Chicago: Art Institute, 2010).
19. Dorothea Lange and Paul Taylor, *An American Exodus: A Record of Human Erosion* [1939] (Paris: Jean Michel Place, 1999), p. 6.
20. John Rogers Puckett, *Five Photo-Textual Documentaries from the Great Depression*, Studies in Photography, no. 6 (Ann Arbor: UMI Research Press, 1984), p. 99.
21. It is no coincidence that 'Migrant Mother', despite being far from Lange's favourite image, remains the most iconic of her photographs.

22. Letters from 1936 and 1959 indicate that Bourke-White and Lange were friendly enough to have corresponded over the course of several decades. In a letter from Lange to Bourke-White in 1959, she acknowledges Bourke-White's courage in her then public fight against Parkinson's disease.
23. Judith Fryer Davidov, *Women's Camera Work* (London: Duke University Press, 1998), p. 223.
24. Ibid.
25. Dorothea Lange, 'Photographing the Familiar', *Aperture*, I:2 (1952), as quoted in Puckett, *Five Photo-Textual Documentaries*, p. 99.
26. Alan Trachtenberg, *Documenting America 1934–1943* (San Francisco: University of California Press, 1992), p. 8.
27. By using the concept of exodus, *American Exodus* was also one of the first photo-textual projects to establish the idea of transience itself as an inherently ideological issue, setting the stage for numerous photographic studies, not least Robert Frank's *The Americans* (1959). For more on Dorothea Lange's influence on documentary aesthetics during the 1930s see Mick Gidley, *Photography and the U.S.A.* (London: Reaktion, 2011); Jan Goggans, *California on the Breadlines: Dorothea Lange, Paul Taylor, and the Making of a New Deal Narrative* (Berkeley: University of California Press, 2010).

Establishing a Photographic Vernacular in Walker Evans's *American Photographs* (1938)

Standing on the bare ground, – my head bathed by the blithe air and uplifted into infinite space, – all mean egotism vanishes. I become a transparent eyeball; I am nothing; I see all; the currents of the Universal Being circulate through me; I am part or parcel of God.[1]

Both Margaret Bourke-White and Dorothea Lange were instrumental in establishing the 'look' of what a socially concerned documentary aesthetic might be in the context of the Depression. At the same time, other photographers sought to take the same landscape – the same material in many respects – and reformulate the documentary aesthetic in line with their own artistic practice, the most famous being Walker Evans. This chapter will examine more closely why Evans so readily became one of the seminal American photographers of the 1930s, and it will do so by focusing on the writing that accompanied his 1938 show and subsequent catalogue, *American Photographs*. The first one-man photography exhibition at the Museum of Modern Art (MOMA) in New York, 'American Photographs' set the scene for subsequent photographic projects on the United States and consolidated what both Lange and Bourke-White had been moving towards throughout the 1930s: namely, a distinct interest in documentary photography as an art form indebted to other artistic media than newspaper reportage and journalism.

Whilst Evans was collaborating with his friend, the writer James Agee, on the photo-text charted in the following chapter, *Let Us Now Praise Famous Men*, during the mid-1930s, it was the publication and success of *American Photographs* in 1938 that really brought a new vision of the American landscape to a wider audience. For Evans, this

vision, a collection of vernacular architecture, signage, bars, drug-
stores and barbers, a now recognisable lexicon of Americana, was
more than simply an attempt to document those places overlooked
by mainstream culture. The photographs were also a response to the
sense of cultural transition the nation felt itself drifting through during
the Depression, an attempt to rehabilitate visually – in different ways
from Lange and Bourke-White – an *idea* of the heartland of America,
as much as the actual place itself. *American Photographs* is, perhaps,
the most impressive of these efforts, not because its realm is markedly
wider than that of Lange and Bourke-White, but because the sequenc-
ing of the photographs in the book attests to a narrative more oblique –
and perhaps because of this, more complex – than those found in *You
Have Seen Their Faces* and *American Exodus*. As the title *American
Photographs* suggests, Evans's book sought to define what might con-
stitute a distinctively American photograph, and he did so by focusing
not only on the destitution and hardship of the Depression but also on
the material, people and structures present in everyday life.

Unlike Lange's and Bourke-White's, Evans's sense of what might
photographically constitute the uniquely American and the abso-
lutely authentic is reconfigured in a desire to show how problematic
both these notions were: a contradiction, in large part, that cor-
responded to the self-same crisis in American political identity and
representation in the 1930s that had spurred Lange and Bourke-
White to focus on specific landscapes and regions. If Lange and
Bourke-White's work symptomatises – to some extent – the desire
to resecure an American identity in peril because of economic and
agrarian problems, their photographs voluntarily *and* involuntarily
also interrogate a national myth based upon the virtues of authen-
ticity and individualism. For Evans, that national myth was not
only a constituent part behind (or within) the image; the image was
also, in effect, a way to expose certain contradictions that lay at the
heart of the American psyche.

In his work on 'The Camera and the Verification of Fact', the
critic Miles Orvell describes Evans's realism as a

> way of making himself into a part of the camera, developing an
> eye that was more purely photographic than any other of his
> time, more purely attuned to the incongruities visible through
> the camera's lens. Evans saw with the eye of a camera, and with
> more than a little of its clinical detachment.[2]

Yet Evans himself resisted consideration of his photographs as literal documents carrying with them some absolute or unqualified authority, preferring to have them regarded as attempts to reconfigure a documentary style with lyrical rather than realist credentials. In Evans's photographs, that style often made use of a mode of typological representation where the particulars are staged in such a way that they convey a larger category of truth, producing what Miles Orvell calls a 'credible facsimile' rather than a literal document.[3]

Thus, while Evans was keenly aware of photography's growing role as an authority in political and social terms, and he himself had been working on and off for the Farm Security Administration in a similar capacity to that of Lange in the 1930s, *American Photographs* seems more intent on registering the untold and as yet unseen nuances of an American culture's conception of its own authenticity, an issue that will manifestly reappear in Wright Morris's 1940s photo-texts and in Robert Frank's version, *The Americans*, nearly twenty years later. While the manifest subject of *American Photographs* appears to rescue a more 'authentic' or 'realistic' sense of national identity for late 1930s America, it also reveals how elusive this identity has already become. None the less, Evans's book is also a collection of photographs that contains a story, a story about resecuring a sense of American identity in a time of crisis, without flinching before the signs of that culture's debilitation. More crucially, perhaps, it is also a story about the establishment of documentary photography as a lyrical rather than predominantly journalistic art form.

Throughout *American Photographs*, pictures of 'real people' are surrounded by and intertwined with images of an increasingly commodified culture – photographs of film posters, minstrel show bills, posed formal portraits, advertisements, billboards, publicity stills, materials that signal a photographic interest in the textual aspects of American culture. For Evans, the faces of the people pictured are always engaged in a dialectical relation with various images that reference the United States as a marketplace, a transactional sphere where Hollywood posters, the presence of different races and classes, the propaganda of political campaigns and so on are increasingly inseparable from what constitutes regional and local identity.

For subsequent generations of photographers, *American Photographs* thus paradoxically legitimised those environments, hitherto seen mostly in terms of social unease and destitution, as viable staging areas for something more artistic. If Bourke-White's vision

of the South was marked by the horrors of deformity and scarcity, Evans illuminated how the precarious nature of such environments could be beautiful as well, thus making them appropriate sites of artistic contemplation. This process of legitimisation, however, was not due simply to Evans's successful induction into the rarefied sphere of the museum. Although the exhibition at MOMA had much to do with it, Lincoln Kirstein's Afterword to the book of Evans's images and the subsequent Review by the well-known poet William Carlos Williams were *as* crucial in recognising the narrative potential of Evans's work. As opposed to the writing in *You Have Seen Their Faces* and *American Exodus*, designed to prove the documentary credentials of the projects, *American Photographs* was the first book of documentary photographs in which the images were seen as a starting point for a written examination of a wider photographic vernacular aesthetic. Here the photographs took centre-stage, and the writing accompanying them was charged with illuminating the value of the images, regardless of their documentary purpose. If the writing, in turn, reflected a vision of photography as a metaphor for something essentially visionary and American, Evans's work proved that everyday life could be the starting point for a rethinking of the camera's potential.

This chapter will thus look at how Lincoln Kirstein and William Carlos Williams took *American Photographs* as an opportunity to insert documentary photography into a wider and longer textual heritage. Rather than signal an alignment with the writing found in previous photo-textual collaborations, Kirstein and Williams were influenced in particular by the nineteenth-century philosopher/poet Ralph Waldo Emerson. Emerson's ruminations on the importance of vision as a mark for both individual and national identity became a way also to codify the aesthetic qualities of the camera, a vision of photography as native and transcendental, and thus worthy of canonisation by the art establishment. In this context, Walker Evans's success was read as a natural extension of a very writerly form of idealism, an idea firmly established in Kirstein's Afterword to the book itself.[4] Kirstein had curated the 1933 exhibition 'Walker Evans' Photographs of Victorian Architecture' and he had intimate knowledge of Evans's working methods, unlike the then director of MOMA's photography department, Beaumont Newhall, whom Evans avoided in order to retain control over the sequencing and layout of his images. Because of this, the catalogue/book version,

rather than being a faithful facsimile, was very different from the exhibition. Of the eighty-seven photographs in the book, thirty-three were not in the exhibition. As noted by Giles Mora in *Walker Evans: The Hungry Eye*:

> With its nearly square format; its plain jacket printed only with the title and the author's name; the strict monochrome of the black and white; the page arrangement of a blank left-hand page facing the photograph opposite; the removal of captions to the back of the book . . . and finally, the appearance of Kirstein's text *American Photographs* was not simply a museum catalogue.[5]

In Kirstein's Afterword, 'Photographs of America: Walker Evans', the catalogue title is reversed in order to accentuate one of the book's main themes: namely, the intrinsic link between the images and the photographer, and between the images and the place photographed. Before defining the uniqueness of Evans, Kirstein summarises previous photographic movements, from the 'Early masters of photography', for whom the 'single task was to render the object, face, group, house or battlefield airlessly clear in the isolation of its accidental circumstances', to Pictorialism with its 'old-fashioned "artistic" soft-focus' and the 'Candid Camera' with its 'pretensions to accuracy, its promise of sensational truth'. Evans, on the other hand, 'represents what is best in photography's past and in its American present'. This, Kirstein argues, is not because of his technical ability but because his 'anti-art-photographic' eye enables the images to 'exist as a collection of statements deriving from and presenting a consistent attitude'. Rather than regarding it as a book of prints connected by topic but without sequential meaning, Kirstein saw the narrative impetus of *American Photographs* in the book's ability to render 'a collection of statements', irrespective of the lack of captions or explanatory text. More importantly and in line with a distinctly Emersonian form of idealism, Kirstein ends his Afterword by aligning Evans's vision with the ability to render the 'continuous fact of an indigenous American expression, whatever its source, whatever form it has taken', a quotation that directly references Emerson's famous call for an American art form free from European influence.[6]

Kirstein's homage to Evans is thus based on two predominant ideas: firstly, that Evans is doing something very distinctly American, and secondly, that what he is doing can be aligned with other forms

of media. At the same time, Kirstein appears to insinuate that photography by the mid-1930s has already reached an impasse of sorts, despite taking the constituent parts of an existing documentary aesthetic – 'the continuous fact of an indigenous American expression' – as the hallmark of Evans's aesthetic. The difference lies in Evans's ability to target the old for the purpose of making it new. Having moved through Pictorialism, in which the artistic perspective relied on rendering the real beautiful, according to Kirstein, he sees Evans as proof that 'certain sights, certain relics of American civilization past or present, in the countryside or on a city street' already contain the lyrical, poetic tenor of a particular vernacular discourse. Kirstein does not overtly contrast Evans with previous documentary projects relating specifically to an agrarian landscape, such as Bourke-White's or Lange's, but it is clear none the less that by defining the photographer's role as more than utilitarian, he differentiates Evans from previous documentary efforts. What the Afterword does is move the argument away from a purely utilitarian definition of documentary photography in favour of reinserting nothing less than a sacred purpose into photography itself.

Likewise, in William Carlos Williams's 1938 Review of *American Photographs*, 'Sermon with a Camera', the attempt is to codify photography as a medium with far-reaching metaphoric, aesthetic and cultural ramifications. For Williams, the combination of a self-effacing aspect with a moment of total vision akin to Emerson's famous dictum in the 'Transparent Eyeball' section of 'Nature' (1836) – 'I am nothing; I see all' – in itself suggests a constant oscillation between positions behind and in front of a metaphorical camera. These positions, in turn, also mimic and reflect the role of the critic vis-à-vis the subject of photography. For Williams, then, the photographer, like all other artists, bears a tremendous responsibility: 'The artist must save us. He's the only one who can. First we have to see, be taught to see. We have to be taught to see *here*, because here is everywhere, related to everywhere else.'[7] Here, the language of Emerson and of transcendental idealism is adapted in order to define documentary photography as having something above and beyond a merely ethnographic or sociological purpose. Aligning the process of photography with Emerson's desire to absorb and be absorbed into nature, to become a transparent rather than simply reflective eye, allows both Kirstein and Williams to redefine Evans as a visionary artist. In following Emerson's dictum that 'The act of

seeing and the thing seen, the seer and the spectacle . . . are one', the transcendental ethos is aligned with the camera's ability to capture the real and the spiritual, the native and the universal simultaneously. As Williams states:

> Of only one thing, relative to a work of art, can we be sure; it was bred of a place. . . . It is the particularization of the universal that is important. It is the unique field of the artist, and Evans is an artist.[8]

In these terms, Evans's images of vernacular America, of regional architecture, objects, signs and people become representative of a 'moment of seeing' in which a secular local vision of America becomes a gateway into universal concerns. The chief aim, according to Williams, is to 'quicken and elucidate, to fortify and enlarge life'.[9] In democratic terms, Williams wants photography, in other words, to render the potential of all things great and small so that the index of American life is presented as being something as inclusive as possible.

Of course, previous documentary projects had also proven the importance of the vernacular as intrinsic to an idea of photography as both democratic and modernist, but in Evans's case, photography was an efficient way to blur the boundaries between a utopian and dystopian vision of the United States. For both Kirstein and Williams, once the camera was established as a visionary mechanism in its own right, it would be able to operate as a useful metaphor for the artist's relationship to his subject, to nature and landscape, and to an investigation into representation itself. The use of an Emersonian rhetoric, rather than a move backwards in time to a more pastoral vision of America on the cusp of industrialisation, became a short cut in this instance to a sense of history, of photography as firmly situated within an existing cultural landscape, and to something more abstract and philosophical by nature. Compared to Lange's and Bourke-White's call for change in political terms, *American Photographs* appeared content to navigate the landscape of the Depression rather than demand its alteration.

While Kirstein's Afterword is comfortable in mining the territory of documentary photography as art, the fact was, of course, that such a cultural landscape, with its literary allusions to both modernist and transcendental practice, would not have been familiar in any meaningful way to the subjects and people actually portrayed in the photographs themselves – an issue that James Agee painstakingly attempts

to communicate in *Let Us Now Praise Famous Men*. However, for Kirstein and Williams, writing for an audience of urbanites and intellectuals, connecting the everyday, the vernacular with a spiritualised and transcendent idea of vision allowed for the transcendental to operate as a useful metaphor for the link between the aesthetic potential of the camera and its mechanical practical use. In other words, Evans was read as uniquely suited for a new reading of photography: one that would maintain its social and ethnographic potential but also, as Williams put it, teach us really to see what was around us: 'We have to be taught to see *here*, because here is everywhere, related to everything else.'[10]

At first sight, it may appear contradictory to connect a spiritualised rendition of the vernacular with a photographer famous for his rendition of everyday man-made objects, towns and places static and in repose (Fig. 3.1). Nevertheless, what Kirstein and Williams

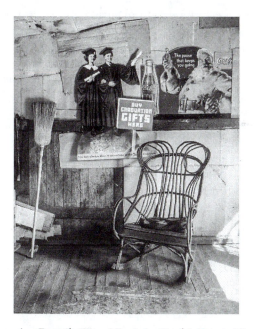

Fig. 3.1 'Interior Detail, West Virginia Coal Miner's House, 1935', Part 1, Fig. 23, in Walker Evans, *American Photographs* (New York: Museum of Modern Art, 1936). Copyright © Walker Evans Archive, The Metropolitan Museum of Art. Gilman Collection, Purchase, Gift of Arnold H. Crane. By Exchange, 2005.

realised was that, in order for photography to be both illuminative and symbolic, the quality of the vernacular per se was not really the issue: it was how one approached it. Rather than being a question of authenticity and veracity, the importance of the vernacular lay in what happened to it when framed by the photographer's eye, a point clarified by Evans himself in 1971:

> A distinct point, though, is made in the lifting of these objects from their original settings. The point is that this lifting is, in the raw, exactly what the photographer is doing with his machine, the camera . . . symbolically he lifts an object or a combination of objects, and in so doing he makes a claim for that object or that composition, and a claim for his act of seeing. . . . The claim is that he has rendered his object in some way transcendent, and that in each instance his vision has penetrating validity.[11]

Evans's own description of the 'lifting of objects' is more than a way to provide timeless or classical depictions of American society; it is about transposing a particular and emphatically personal point of view. Transcendence for Evans is not about transcending a historical context and/or social parameters; it is about 'making a claim for the act of seeing' itself. Kirstein's realisation of this forms a significant part of his original writing for *American Photographs*, in which he stresses the 'penetrating validity' of Evans's photographs. It is a validity that depends on Evans's ability to offer a new vision – detailed, poetic and moral. As Kirstein argues,

> Physically the pictures in this book exist as separate prints. They lack the surface, obvious continuity of the moving picture. . . . But these photographs, of necessity seen singly, are not conceived as isolated pictures made by the camera turned indiscriminately here or there . . . they exist as a collection of statements deriving from and presenting a consistent attitude. Looked at in sequence they are overwhelming in their exhaustiveness of detail, their poetry of contrast, and . . . their moral implication.[12]

Kirstein's 'moral implication' connects photography as a potentially ethical art form with the rectitude of the photographer's eye and his or her choice of subject. 'The exhaustiveness of detail' must co-exist with the photographer's 'consistent attitude'; hence the

thing itself (the object photographed) and the way the photographer looks at it cannot be separated. According to Kirstein, 'no matter how sensitive an artist's eye may be, it is irrelevant unless fixed on its special subjects. . . . The wavelength of his (Evans's) vision is exactly equalled by the radiation of the images which attract and repel it.'[13] The desired alignment between the subject and its moment of capture reiterates a crucial issue for both Evans and Kirstein: namely, how to deal with human experience when it threatens to overwhelm our normal conceptual framework. While the glimmers of such concerns are present in Dorothea Lange's work, for instance, the accompanying writing – rather than attempt to articulate such concerns – none the less reinserted the images into more comprehensive agendas, be they ethnographic, political and/or private. Partly, this was because the remit in such photo-texts as *Roll, Jordan, Roll, You Have Seen Their Faces* and *American Exodus* focused on the perspective of the writers/photographers as the moral centre of the texts – as the creators, in a sense, of their own landscapes. As seen in the previous chapters, this sense of visual ownership often complicated the racial and class politics enacted in the various photo-texts, but it also allowed them to convey a narrative designed to facilitate the interaction between text and image. For Evans, on the other hand, the image reigned supreme.

In the context of *American Photographs*, Kirstein and Williams's mission thus differs significantly from the type of writing usually present in the photo-text, and not simply because their writings are presented outside of the main body of the visual text as an afterword or a review. Rather than form a continuous guide to the narrative implied in the photographic sequence, as both Paul Taylor and Erskine Caldwell did, Kirstein's Afterword sets the scene for a particular retrospective reading of the images as iconic and timeless. In similar terms, Williams's Review – although setting the scene for *American Photographs* as the beginning of a new photographic tradition – does so by reinserting it into a longer tradition of vernacular American art.

The ability to define a unique and 'consistent attitude' – in other words, a vision of the photographer as more than simply the documentary field eye – is a fundamental starting point for how Evans was defined as a visionary. In those terms, it is not coincidental that it is Emerson's ideas concerning the American landscape that provide Williams and Kirstein with the necessary language to define

an idea of vision as a practical as well as spiritual given. Not only does Emerson's essay, 'Nature', lend itself to a philosophy in which the American landscape and the portrayal of its people are symptomatic of an ideal of democracy, 'a universe that is the property of every individual in it', but also it defines this process in distinctly ocular terms.

The focus on the ocular, together with a belief in commonality and collective desire, is here established as fundamental to a photographic tradition, which believes in art's ability to synthesise the political with the visionary. However, both Kirstein and Williams were aware that the seeds of this particular synthesis were present long before Evans. In Emerson, in particular, the ocular – that is to say, visionary – ability of the poet/writer/artist is based on his immersion into the surrounding landscape: 'Wise men . . . fasten words again to visible things. The moment our discourse rises above the ground of familiar facts and is inflamed by passion or exalted by thought, it clothes itself in images.'[14]

For Kirstein, all of these ideas, and in particular that of unification, find their proof in Evans's ability to record 'alike the vulgarization . . . and the naive creative spirit, imperishable and inherent in the ordinary man'. Able to 'elevate fortuitous accidents of juxtaposition into ordained design', Evans is presented as a mediator of the secular as it becomes divine, or the secular *made* divine through Evans's camera. As Kirstein writes, 'His eye is on the symbolic fragments of nineteenth century American taste, crumpled pressed-tin Corinthian capitals, debased baroque ornament, wooden rustication and cracked cast-iron moulding, survivals of our early imperialistic expansion' (Fig. 3.2).[15]

As such, Transcendentalism is not just about the unification of the individual with the spiritual but also about finding order amongst the fragments of material life, a reconciliation between the private and the public, the political, from 'imperialistic expansion' to the aesthetic in nineteenth-century 'American taste'. The mixture of old and new, hand-made objects and industrial manufacture, is not dissimilar to the mix-and-match attitude employed in ideological terms by Emerson, whose attempts to define a 'native spirit' function as a precursor to Julia Peterkin's interest in folk culture and Doris Ulmann's fascination with local arts and crafts. For Peterkin and Ulmann, the focus on pre-industrial manufacture, on handicrafts and local production, also signalled a deeper, more

Fig. 3.2 'Stamped Tin Relic', 1929, Part 2, Fig. 1, in Walker Evans, *American Photographs* (New York: Museum of Modern Art, 1936). Copyright © Walker Evans Archive, The Metropolitan Museum of Art. Walker Evans Archive, 1994.

emotional attachment to place than that afforded by simple portraiture. As noted in Chapter 1, there are problems in this, just as there is a real risk that, in transposing Emerson from his philosophical roots, Transcendentalism becomes just another catch phrase for certain ideas and juxtapositions present throughout several decades and centuries. Translating Transcendentalism in a twentieth-century context into something synonymous with a desire for spirituality – and, by extension, distaste for the commodification of art, as witnessed, incidentally, in Kirstein's comments on the 1930s as an 'epoch crass and corrupt' – also has its own problems. Transcendentalism may have originated in a desire for spiritual and intellectual reintegration, but the issue of coherency and democracy as something under siege during the Depression took very different forms. Regardless, it is no surprise that documentary photography was actively asserting, even while questioning, the ideals of a democratic heritage. For Kirstein, Evans's images record 'an age before an imminent collapse', and because they do so, they

inadvertently applaud democratic ideals that are now corrupted. As Kirstein sees it, Evans's

> work, print after print of it, seems to call to be shown before the decay which it portrays flattens all sagging roof-trees and rusts all the twisted automobile chassis. Here are the records of the age before an imminent collapse . . . to salvage whatever was splendid for the future reference of the survivors.[16]

Within the idea of a democratic heritage Kirstein outlines the importance of the visionary as a way to incorporate the transcendental and the vernacular into 'the record of an age'. In this respect, documentary photography, although based on a representation of the living, the discernible, partakes of the visionary aspects of the transcendental by promulgating the importance of regionalism as an internal as well as external landscape. Thus Emerson's nineteenth-century faith in the illuminative aspects of nature in a twentieth-century context becomes Kirstein's 'twisted automobile chassis', which, despite its non-salvageable aspect, nevertheless forms an essential component of the landscape of the twentieth century. It is because the photographer is visionary that these seemingly inconsequential objects – the battered wicker chair, the tin relic – become both prophetic and splendid.

Crossing the border between a nineteenth- and twentieth-century version of Transcendentalism in order to define a main current within the arts was, in many ways, an unspoken tendency in the 1930s. This is not to say that the tendency to 'spiritualise' the photographic process took the same form for various photographers. In comparison to Ulmann and Peterkin's use of nineteenth-century tropes to indicate a distinctly pastoral past, the use of Emerson by Kirstein and Williams indicates a desire to link Evans's practice with a longer philosophical tradition applicable to the identification of him as a quintessential modernist as well. Whereas Ulmann and Peterkin constructed *Roll, Jordan, Roll* to represent the loss of a culture that they perhaps overvalued, Kirstein sees the charge of *American Photographs* as resting on its very ability to show that 'The pictures of men and portraits of houses have only that "expression" which the experience of their society and times has imposed on them.'[17]

Setting their regional and political agendas aside, Kirstein and Williams none the less gravitate towards a definition of photography that in some ways is more Pictorialist than one might assume.

Kirstein's argument for photography's ability to transcend people and places in distinctly spiritualised terms *and* render the 'expression' that the experience of their society and times has imposed on them reflects a vision of photography both as vernacular, distinctly of this world, and as something *other*. Kirstein and Williams were thus, in different ways, using Transcendentalism unashamedly as the framework for a reading of photography as a form of on-going cultural movement. The appeal of such a movement to artists – not just during the Depression – who saw photography as no less than a way to re-educate the American public is therefore no coincidence. Once the transcendental gaze was defined in terms of perspective, in terms of a way of looking at things, the connection to the camera as an apparatus with visionary potential was made possible.

Thus, not only was the inseparability of photography, art and social justice present in the reform movements of the late nineteenth century, to use the language of justice and democracy to render the importance of photography as a tool for social change, but also Emersonian ideals regained ethical currency both during the Depression and after. Even if some of these photographers went to some lengths to remove themselves from a possibly antiquated and naïve, in their eyes, nineteenth-century vision of photography, the fact that we can trace an Emersonian ethos within the photo-texts indicates that even within the seemingly objective documentary camera eye, the concept of the visionary photographer was ever-present. Not only did it manifest itself in the writing surrounding the canonisation of photography, but also it lay within the vernacular language accompanying the images – from Caldwell's use of Southern dialect to James Agee's poetic renditions of local songs. These textual devices, despite their modernist credentials, were, then, also proof of the continued belief in a synthetic version of American culture, one in which the visual and the aural could truly coincide. For Williams, Evans's photographs not only could 'speak' the language of America, but also could indeed synthesise the connection between the everyman and the collective within American life:

It is ourselves we see, ourselves lifted from a parochial setting. We see what we have not heretofore realized, ourselves made worthy in our anonymity. What the artist does applies to everything, every day, everywhere to quicken and elucidate, to fortify and enlarge the life about him and make it eloquent.[18]

For Williams, photography can both speak to the viewer and discern the essential nature of what it purports to represent. If the photographer's task is to reclassify the objects it records, 'to reveal' its true essence by framing it in new ways, then *American Photographs* does just that by framing the everyday as something extraordinary, something worthy of being photographed.

Emerson's description of the 'transparent eyeball' functions, then, both as a metaphor for the artist's ability to discern the essential nature of objects and as a way to stress that the transcendental is not formless. Rather, it is reflected in the particulars that photography brings to light: Kirstein's 'unrelieved, bare-faced, revelatory' facts. For Emerson, the intent of the artist appears as an ordering principle 'in the objects it classifies', just as, for Williams, the intent of Evans is to make those objects 'eloquent' to speak directly to us of our own condition. What is crucial is the fact that reality is always actively constituted. Emerson is often misread in this regard, as people assume that within this actively constituted reality, the universal always prevails over the particular and the individual, the timeless over the temporal. Rather, Emerson's belief in the importance of the particular is about the mechanisms we have at our disposal to describe things in an honest and truthful manner. This is not to say that Emerson did not believe in a fundamental God-driven unity as underlying the worldly flux, but rather that art's role was to provide an insight into that unity. The only way to do this was through the accurate description of the particulars with which it was constituted, as apt a definition of the documentary ethos as one is likely to find.

Going back through the links between Emerson's classification of objects and Evans's mode of indexicality in *American Photographs*, Williams's argument begins to emerge more clearly. In Williams's reading, the insistence on the common life as the foundation for art embodies an American ideal: an ideal in which art should equally express and be representative of the American people.[19] This desire for an art that corresponds in an affirmative and true way to actual lives is, in many ways, the defining factor of the photo-text and it forms the background for Williams's claim that 'it is ourselves we see' in *American Photographs*. This is not to say that documentary photography cannot evaluate the life it portrays nor that it cannot be politicised in a complex manner. Even Williams has to admit reluctantly that, despite the lyrical tenor of Evans's vision of America, 'the total effect is of a social upheaval, not a photographic picnic'.[20]

For Alfred Kazin in *On Native Grounds* (1942), the lineage from a revival of literary naturalism in the nineteenth century to the documentary efforts of the 1930s proved that 'the two great associations of the literature of social description – the New Deal and the camera' – provided a literature in which 'words and pictures were not only mutually indispensable, a kind of commentary upon each other, but curiously interchangeable'.[21] Pragmatically, Kazin would state, 'nothing in this new literature, indeed, stands out as clearly as its attempts to use and even imitate the camera'.[22] Kazin's ideas, in many ways, extended the progressive reform ideas of the late nineteenth century into a post-1930s reading of the documentary ethos. For Kazin, the use of photography in the 1930s was a means to 'quicken the sensibility of fellowship' in an era that needed to be reminded of its collective status. More importantly, in Kazin's assessment of the documentary project, Emerson is strategically invoked for precisely this reason:

the camera . . . in itself so significant a medium of tension, fastened upon the atmosphere of tension. And if the accumulation of visual scenes seemed only a collection of 'mutually repellent particles' as Emerson said of his sentences, was not that discontinuity, that havoc of pictorial sensations, just the truth of what the documentary mind saw before it in the thirties?[23]

If Williams was coy about delineating the actual social upheaval of the 1930s in his Review of Evans, it was perhaps in some measure a response to Evans's particular documentary gaze, an observational, often distanced perspective quite the opposite of Lange's emphatic immersion in her subjects. Williams may have intuited that the upheaval of economic destitution – for Evans, in any case – would always be secondary to his personal mission as a photographer. According to Williams,

In Evans's pictures also we are seeing fields of battle after the withdrawal of the forces engaged. The jumbled wreckage, human and material, is not always so grim . . . but for all the detachment of the approach the effect is often no less poignant.[24]

Comparing Evans to the civil war photographer Mathew Brady, Williams is, of course, making a point about the Dust Bowl farmers

occupying their own war zone in the midst of the Depression. How-
ever, by using the word 'poignant' to describe the effect of Evans's
images, there is no call for real political action, no sense that these
images have an actual force that supersedes their artistic intent. On
the contrary, when Williams summarises what we may learn about
the human condition from Evans, he configures it in tones that par-
aphrase the opening paragraph of Emerson's 'Nature':

> and we shall see our own country and its implications the better
> for Evans's work and come to realize that the realm of art is here
> quite as well as elsewhere. . . . The artist must save us. He's the
> only one who can. First we have to see. Or first we have to be
> taught to see.[25]

By paraphrasing Emerson's famous introductory words – 'Why
should not we have a poetry and philosophy of insight and not of
tradition, and a religion by revelation to us, and not the history of
theirs . . . let us demand our own works and laws and worship'[26] –
Williams re-establishes the call for photography as something truly
indigenous and native to the American landscape.

It is the romantic thrust within the documentary project that
often seems to ground the photographer's ocular abilities in his
capacity to illuminate the symbolic quality of things, people and
places but it also, as seen in the previous photo-texts, necessitates
a rather complex negotiation of what photography's purpose is in
the first place. On the one hand, the iconic nature of Evans's images
seems to slot itself into a romantic tradition in which the local
becomes universalised, even as it speaks to us of things inherently
human and real. On the other hand, as Williams tries to articulate,
Evans also makes the eternal manifest in the temporal: 'Evans saw
what he saw here, in this place – this was his universal. In this place
he saw what is universal. By his photographs he proves it.'[27]

Thus, Evans may appear fixated on empty rooms and abandoned
architecture, but when these are set side by side sequentially, a story
does emerge about the people who lived there, why they left and
what traces they left behind. In these terms, Evans's transparent eye-
ball, the focus of his camera, is less a concept than a metaphor, and
less a metaphor than a certain prescription for activity. The event
of photography, in transcendental terms, becomes a way to pic-
ture how meanings come forth from behind their representations.

It is, in other words, about critical vision and how such a vision is defined. For Emerson, the essence of the transparent eyeball is to be between two things. In the grammar of seeing, the eye sees through one thing to the next thing, the lens is transparent only as it plays its part in the larger enterprise of vision, confirming once more that the transparent eyeball is, above all, a paradigm of visual perception. Hence, the meaning that appears in the figure of the eyeball is always linked to the artist's own identity. The 'I' of the text is also the eye that sees itself seeing and that oversees its own projection into the frame of the photograph. Paradoxically, the act of seeing is always in some way a simultaneous act of affirmation. It affirms the presence of the photographer in the act of photographing. It is a mode of awareness of the necessary distance, as well as proximity, between the photographer and the objects photographed. For Kirstein and Williams, it is also a suitable way to question how Evans's photographs stand in relation to the self, the photographer and the things photographed.

Within this context, the ideal of encyclopaedic representation, the ability to illustrate the symbolic nature of the vernacular, together with the transparent eyeball, both lifts and grounds *American Photographs*. It presents a particular vision of Evans in which an ecstatic definition of photography is something ever-present within the American arts. This project is frequently compromised by political, social and economic conditions, but it is still potent enough to present the photographer as part prophet, part visionary. It is no coincidence, then, that Kirstein can claim that Evans's vision is truly modern, even as he 'recognizes in his photographs a way of seeing which has appeared persistently throughout the American past'.[28] With this in mind, placing the metaphor of the transcendental eyeball at the forefront of Evans's work is more than merely an attempt to define a form of American photography independent of Europe's. It illuminates how photography, like writing in the 1930s, was founded on a desire to define a modernist aesthetic in which the search for transcendence could comfortably co-exist with the camera's mimetic capabilities.

None the less, Evans's almost instantaneous canonisation in the 1930s, a process facilitated by his ability to present himself as a sage and accomplished photographer from the outset, has, oddly enough, stood him in bad stead when it comes to examining his philosophical and literary lineage. One reason lies in the seductiveness of

Evans's self-assured stance as a self-made photographer. When asked whether he knew many photographers during the 1930s, Evans predictably responded,

> No, I wasn't drawn to the world of photography. In fact I was against it. I was a maverick. . . . I was on the right track right away, and I don't think I've made many false moves. I now feel almost mystical about it. I think something was guiding me, was working through me. I feel that I was doing better than I knew how, that it was almost fate. I really was inventing something, but I didn't know it.[29]

Evans's tendency to mythologise his own practice is seductive, partly because it supports a reading of him as above external influences, partly because it positions him both inside and outside the establishment. However, when asked about the importance of the 1938 exhibition at the MOMA, Evans had no problem admitting its importance:

> It was like a calling card. It made it. The catalogue, particularly, was a passport for me. It established my style and everything. . . . As time went by it became more and more important. It turned out to be a landmark. . . . It established the documentary style as art in photography.[30]

Despite Evans's claim to 'establish[ing] the documentary style as art in photography', Kirstein's Afterword and Williams's Review remind us of how much he also owed to a longer philosophical lineage. Nevertheless, many critics still persist in reading *American Photographs* as a vision of America somehow beyond and above other influences, an idea that is partly sentimental, partly illogical. Evans's choice of locations, his eye for the use-value of the inanimate, its aesthetic and emotive qualities, all indicate that he instinctively chooses objects, from Coca-Cola signs to worn-out wooden utensils, with a very clear and crafty sense that they could be read, on the one hand, as part of a troubled *Zeitgeist*, and on the other, in emotive terms as proof of the lyrical qualities of the American landscape. The fact that his seemingly distanced perspective, aided by a sense of flatness and careful arrangement of characters on a proportional line, is different from the angled and heroically

inflicted imagery of, for example, Lange does not mean that Evans aimed for uncompromising representations of Depression era culture. In creating a discourse of the vernacular as more than the sum total of actual lived existence, Evans took the idea of vision as inherent in the very nature of photography and allowed it to align itself to Emerson's idea of transparency. When Evans made 'a claim for the act of seeing as rendering the object transcendent', he also confirmed Kirstein and Williams's supposition that *American Photographs* had, once and for all, made the 'physiognomy of a nation' visible for all to see.

Notes

1. Ralph Waldo Emerson, 'Nature' (1836), reprinted in Carl Bode, ed., *The Portable Emerson* (New York: Penguin, 1946), p. 24.

2. Miles Orvell, *The Real Thing: Imitation and Authenticity in American Culture, 1880–1940* (Chapel Hill: University of North Carolina Press, 1989), p. 234.

3. Ibid., p. 239.

4. Lincoln Kirstein's interest in photography was present in various aspects of his cultural work. In the *Harvard Literary Quarterly*, founded by him and Varian Fry in 1927, a number of seminal writers and essays were featured that later contributed to the history of photography, amongst them James Agee, and 'The Reappearance of Photography' by Walker Evans himself in 1931.

5. Giles Mora and John T. Hill, eds, *Walker Evans: The Hungry Eye* (London: Thames and Hudson, 2004), p. 161.

6. Walker Evans, *American Photographs* (New York: Museum of Modern Art , 1938), p. 198.

7. William Carlos Williams, 'Sermon with a Camera', *New Republic*, 11 October 1938, available at <https://newrepublic.com/article/78785/sermon-camera> (last accessed 24 July 2018).

8. Ibid.

9. Ibid.

10. Ibid.

11. Walker Evans, Press Release on exhibition of signs and photographs of signs, Yale Art Gallery, December 1971, quoted in J. L. Thompson, ed., *Walker Evans at Work* (London: Thames and Hudson, 1984), p. 229.

12. Lincoln Kirstein, 'Afterword', in Evans, *American Photographs*, p. 193.

13. Ibid., p. 194.

14. Emerson, 'On Nature', p. 23.

15. Kirstein, 'Afterword', p. 194.

16. Ibid., p. 196.
17. Ibid., p. 197.
18. Williams, 'Sermon with a Camera'.
19. Matthiessen's insight into the importance of Transcendentalism for America's literary psyche was primarily about authorial canonisation, and a way to ensure that 'the stimulus that lay in the transcendental conviction that the word must become one with the thing' was pertinent to the context of twentieth-century photography. When Matthiessen spoke of 'the inevitability of the symbol as a means of expression for an age that was determined to make a fusion between appearance and what lay behind it', he was speaking not merely of the nineteenth century but in the context of his own time: the 1930s and 1940s. F. O. Matthiessen, 'Method and Scope', in *American Renaissance* (Oxford: Oxford University Press, 1941), p. 14.
20. Williams, 'Sermon with a Camera'.
21. Alfred Kazin, *On Native Grounds: An Interpretation of Modern American Prose Literature* (New York: Reynal and Hitchcock, 1942), p. 500.
22. Ibid.
23. Ibid., p. 501.
24. Williams, 'Sermon with a Camera'.
25. Ibid.
26. Emerson, 'Nature', p. 7.
27. Williams, 'Sermon with a Camera'.
28. Kirstein, 'Afterword', p. 198.
29. Paul Cummings, 'Walker Evans', in *Artists in Their Own Words* (New York: St Martin's Press, 1979), p. 86.
30. Ibid., p. 96.

PART II
THE 1940s

Modernism as Documentary Practice in James Agee and Walker Evans's *Let Us Now Praise Famous Men* (1941)

While Walker Evans's *American Photographs* remains the touchstone for how documentary photography was introduced into the art world in 1930s America, Evans's practice prior to this had elicited, if not curatorial acceptance, then much notoriety amongst fellow photographers and writers. Above all, it was his collaboration with the writer James Agee in the mid-1930s and Agee's role as a proponent of a vernacular form of writing, both modernist in tone and distinctly American, that consolidated Evans's interest in synthesising text and image. To this day, Agee's collaboration with Walker Evans in *Let Us Now Praise Famous Men*, written between 1935 and 1940 but not published until 1941, remains an undisputed modernist masterpiece, a complex and often faulty piece of confessional prose, documentary exposé and homage to a vernacular vision of the South. Unlike *Roll, Jordan, Roll* and *You Have Seen Their Faces*, Agee's internalisation of the documentary process provides a different entry into the phototext's modernist potential. Functioning as more than an extension of the type of ethnographic and documentary exercise seen in the work of Dorothea Lange and Margaret Bourke-White, *Let Us Now Praise Famous Men* (abbreviated as *LUNPFM* onwards) also charts Agee's process as a writer seeking to understand the purpose of photography during the darkest days of the Depression.

Several things distinguish *LUNPFM* from previous photo-textual collaborations, not least the positioning of Walker Evans's photographs before the main body of the text itself. In addition, Evans's portraits of sharecroppers, the interior architecture of their homes, their possessions, and the images of the surrounding towns, shop fronts and people are rendered without the obvious emphatic

perspective seen in Lange's work; nor do they employ the more gra-
tuitous intrusive gaze witnessed in Bourke-White's. By measuring
the frame squarely and straight on, Evans's aesthetic – as seen in
American Photographs – seems almost classical, slightly removed
from the subjects themselves: the mostly desperately poor share-
croppers in Alabama that Evans and Agee were sent to document by
their employer at the time, *Fortune* magazine. None the less, as seen
in the text itself, Evans's use of space is by no means economical or
sparse. Instead, Evans appears to straddle a line between caution
and confidence, applying a gaze that looks directly at the poverty
before him without the enforced political concern witnessed in ear-
lier documentary work done for the Farm Security Administration.
Without the overt desire to engage the viewer in sentimental terms,
Evans's political stance is significantly more obtuse and, perhaps
because of this, more complex as well.

For James Agee, on the other hand, and for his lengthy written
exposition that follows Walker Evans's photographs, it is clear none
the less that the presence of the images allows him to use the camera
as a metaphor for a certain form of writing (Fig. 4.1). In addition,
it works as a framing device, used throughout to render the impor-
tance of vision within the photo-text itself: vision in an ocular sense,
as well as in a literary one. In this respect, Agee continues Lincoln
Kirstein and William Carlos Williams's ideas of photography as an
illuminative practice, a way to render not simply the external circum-
stances of the sharecroppers' lives but their internal fears and desires
as well. For Agee and Evans, the pre-industrial nature of the objects
in the sharecroppers' rooms, the design and decorative impulses dis-
cernible there, are all indicative of the lyrical potential of a life lived
in humility and toil, and as such are a constituent and important
part of the textual apparatus. Thus, *LUNPFM* constitutes, among
many things, an exercise in the difficulties of commenting on an
environment whose austerity in material terms paradoxically proves
its value as a subject in artistic terms. However, to understand some
of the complex collaborative and artistic issues that both writer
and photographer had to grapple with to complete the book, some
knowledge of its inception is useful.

In the summer of 1936, Agee and Evans were sent to Alabama
on an assignment by *Fortune* magazine. The aim was to gather
material for an article on cotton tenancy, or more specifically, 'a
sharecropper family (daily and yearly life): and also a study of Farm
economics in the South'.[1] What they returned with, however, was

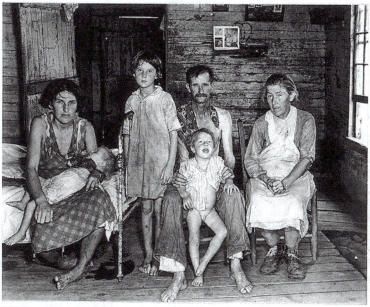

BUD FIELDS AND HIS FAMILY AT HOME

USF 342 — RA. 8147 A

Fig. 4.1 'Bud Fields and his Family at Home', in the photographic section of Walker Evans and James Agee, *Let Us Now Praise Famous Men* (Boston: Houghton Mifflin, 1941). Copyright © Prints and Photographs Division, Courtesy of the Library of Congress.

an unwieldy and extensive set of notes, comments and photographic material. When Agee reluctantly turned it into a forty-page article, *Fortune* promptly rejected the piece. After five years of numerous revisions, Houghton Mifflin finally published *Let Us Now Praise Famous Men*, which by now had become a 500-page manuscript. Although reasonably received, it sold just over 1,000 copies and it was not until its re-publication in 1960 that its status as perhaps *the* photo-textual document of the Depression solidified. Since then, *LUNPFM* has entered the canon of American literature, mostly as an example of how to combine photographs and writing, a testament to the clarity of Evans's photographic style and the lyrical intensity of Agee's prose, but also – importantly – a testament to the difficulty of writing about a group of disenfranchised people without sentimentality or condescension.

In contrast to Erskine Caldwell's descriptions of Southern life, Agee's text is, from the outset, markedly more experimental, a marker of his range in literary terms, as well as of the underlying anxiety he felt in having to deal with the subject at hand. Ranging from a list of participants in Section 1 of the book, poetry by Agee and quotations from *King Lear* and Marx's *Das Kapital* to interchapters on the role of the media in the 1930s in the last section, *LUNPFM* appears to be a palimpsest of both iconic and personal material. In addition, compared to the timeliness of Bourke-White's and Lange's projects, the fact that *LUNPFM* originated in the midst of the Depression, and yet did not come out until the encroaching forces of fascism had turned American politics from domestic issues and towards national patriotism in the early 1940s, is also significant. By the 1940s, most picture magazines, *Fortune* included, were using human interest stories on American industry, economics and business as a way to provide an optimistic outlook on the US economy rather than criticise the politics that were partially responsible for the results of that economy. When *Fortune* magazine commissioned Agee and Evans to head south to document the lives of a few sharecropper families, it was as much to showcase the abilities of the two artists as it was to inform their readership of the actual situation in the region.

Initially entitled *Cotton Tenants: Three Families*, *Let Us Now Praise Famous Men* was given its final title by Agee later when it was published, independently from *Fortune* magazine. With the quotation from Ecclesiastes, it thus indicates the move from a journalistic remit to something entirely different. None the less, *LUNPFM* is also responding to the documentary ethos of the 1930s and in particular to both *American Exodus* (1939) and *You Have Seen Their Faces* (1937), not to mention such seminal American novels as John Steinbeck's *The Grapes of Wrath* (1939), all of which played on the mythic and diaspora dimensions of the Depression era. In charting the human displacement and the ensuing tragic and epic narratives that emerged from this, the rhetoric of a chosen people in search of a home seemed all the more pertinent during the Depression. For Agee, however, the desire to avoid *LUNPFM* becoming a conventional *Fortune* piece, or, indeed, the type of photo-textual collaboration made popular by Caldwell and Bourke-White, meant that it had to work actively at its status as a non-conformist masterpiece. In other words, *LUNPFM* may have been part and parcel of a larger

1930s obsession with documentary aesthetics, but Agee's use of various textual devices sought to insert it deliberately into a wider modernist literary tradition as well: a tradition in which the vernacular voices established by such writers as Peterkin and Caldwell would be filtered through Agee's sensibility. As in William Carlos Williams's vision of a visualised vernacular art form in Evans's photographs, the voice of the people would once again come to the fore – albeit in a respectful and even loving way.

Agee's unease about conforming to *Fortune*'s alleged journalistic objectivity was thus part of the same larger and more encompassing idea that had occupied Williams in writing about Evans: namely, how to unite a moral and ideologically valid perspective within a documentary premise. As Agee put it in the prologue to *LUNPFM*, the chief aim was 'to deal with the subject not as journalists, sociologists, politicians, entertainers, humanitarians, priests, or artists, but seriously'.[2] By stating his objective, Agee was not only critiquing previous practice, he was, in a sense, spelling out the risks involved in *any* documentary practice. If the aim of *LUNPFM* was less than entirely clear, Agee knew what he did *not* want to do, promising in the very first section of the book never to take 'an undefended and appallingly damaged group of human beings, an ignorant and helpless rural family, for the purpose of parading the nakedness, disadvantage and humiliation of these lives before another group of human beings'.[3]

The problem inherent in such a lofty purpose was not lost on contemporary critics when the book was finally published in 1941. For Alfred Kazin, *LUNPFM* was no less than

> written to end all documentary books . . . because it is an unusually sensitive document and a work of great moral intensity . . . it represents a revolt against the automatism of the documentary school . . . an attack on the facile mechanics and passivity of most documentary assignments.[4]

Just as Kirstein had taken on board the implications of Evans's entry into the wider cultural landscape of the 1930s in his Afterword to *American Photographs*, Kazin's writing on *LUNPFM* in *On Native Grounds* confirmed the importance of photography for the American literary voice. Similarly, Lionel Trilling's *Kenyon Review* of *LUNPFM*, also from 1942, 'Greatness with One Fault in it', linked

Agee's more experimental prose with a distinctly moral and political agenda. For Trilling, the ornate descriptions of the sharecroppers, rather than alienating the reader, allowed a convergence between the individual artistry of Agee and Evans, and the collective plight of the sharecroppers.[5] For these early critics, Agee's style was more akin to that of such high modernists as William Faulkner and John Dos Passos than any kind of ethnographic and/or sociological scholarship, and as such, the photo-text was approached from a distinctly different angle from its precursors in documentary terms.

Since then, accepting Agee's writing into a canon of high modernism has proven less straightforward than Evans's ascendency into a similar photographic canon. Not only have the parameters of what constitutes American modernism shifted, but also the integration of a so-called documentary voice has proved equally hard to define. Following the resurgence of interest in *LUNPFM* in the 1960s and its popularity amongst a growing radicalised student body, William Stott's *Documentary Expression and 1930s America* (1973) and later Maren Stange's *Symbols of Ideal Life: Social Documentary Photography in America 1890-1950* (1989) considered the documentary aspects of *LUNPFM* as a distinct set of aesthetic and narrative devices and, on a wider level, a cipher for a particular 1930s *Zeitgeist*.[6] For Stott, Agee's tendency to be 'exuberant, angry, tender, wilful to the point of perversity' whilst also 'romantic and even sentimentalising' did not detract from the book's documentary qualities; it merely proved that a documentary perspective could be lyrical and political as the same time.[7] According to Keith Williams, for instance, in 'Post/Modern Documentary: Orwell, Agee and the New Reportage' (1997), 'questions about reality, truth, subjectivity and language raised by modernist writing . . . swarm back towards, and are even welcomed into, Agee's text. . . . The debate about realism was for Agee the point at which politics and poetics become indivisible.'[8]

Keith Williams's reading of *LUNPFM* as an acknowledgment of modernism's limitations is symptomatic, to some degree, of what started to happen to readings of documentary material from the 1930s on a wider level, although Agee and Evans were given considerably more leeway in terms of their approach than other collaborators during the same era. None the less, readings of *LUNPFM* as leaning against a post-modern as much as a modernist aesthetic also have their problems. As Alan Trachtenberg, one of the foremost proponents of

reading American photography within a wider cultural landscape, points out, there is a possibility that the combination of Agee's writing with Evans's photographs is genuinely symptomatic of a 1930s desire 'not so much for change as for "recovery", a return to basic values, to fundamental Americanism'.[9] On a purely emotive level, the sombre black and white portraits of the Gudger family, the interiors of the sharecroppers' homes with their Spartan pre-industrial furniture and bare wooden walls, lean towards this type of 'Americanism' and have therefore inevitably become iconic images of the 1930s. After all, Evans's images are not miles away from some of the work by Bourke-White and Lange, particularly the type of documentary photography meant to render the meagre yet dignified existence of people on the edge of capitalism. The chief difference between these efforts and *LUNPFM* lies in the fact that Agee's 500-page text, with its constant authorial intrusions and circuitous digressions, makes Evans's uncaptioned photos paradoxically appear both more accessible and obtuse simultaneously. If the actual names of the subjects on the photographs are deliberately withheld, what is the purpose of Agee's 'fictitious' version of those names in the text that follows? Questions arise, then, as to whether Evans's ascendancy in the 1970s as *the* photographer of 1930s Americana would have happened regardless of the text in *LUNPFM* or, indeed, whether it was boosted by it. Given the success at MOMA with *American Photographs*, perhaps Agee's collaboration with Evans was one of the things that, in fact, prevented Evans from being entirely co-opted into a more mainstream and populist version of what photography should look like in the 1930s? By collaborating with Agee, Evans ensured a complex backdrop for images that were never meant to be straightforward versions of rural poverty in the first place.

One of the reasons why the text in *LUNPFM* renders the photographs by Evans less transparent than does, say, Peterkin's anecdotal material relating to Ulmann's portraits, is the way in which other disciplines, such as poetry, sociology, ethnography and cinema, to name a few, add to the photo-text's overall hybridity. This hybridity, according to Agee, is there genuinely to reflect the circumstances of his subjects' lives, even if it cannot totally convey the 'immeasurable weight of their actual existence', or the fact that the sharecroppers – like Agee himself – exist 'in actual being'.[10]

Philosophically speaking, Agee's promise to convey the 'immeasurable' aspects of the sharecroppers' existence is, of course, impossible and this is accentuated by the numerous admonitions, retractions

and contradictions by, from and, indeed, within Agee. What can only be read as a tendency to conceptualise in abstract terms is often underpinned by a convoluted literary and – in the true sense of the word – sanctimonious style. Divided into chapters titled after what they purport to study – 'Money', 'Shelter', 'Clothing', 'Education', 'Work' and so on – which are then interspersed by the author's more private ruminations in sections such as 'Intermission: Conversation in the Lobby' and 'Notes and Appendices', *LUNPFM*'s structure is primarily contemplative rather than straightforwardly informative. From the beginning, there is a sense that the environment, whilst being indexed at some level, is also being dramatised. In the first half of *LUNPFM*, three short chapters, entitled 'Late Sunday Morning', 'At The Forks' and 'Near a Church', function as self-contained vignettes/short stories tracing the initial meetings of Agee and Evans with locals. In some ways, these encounters bear some similarities to such encounters in *Roll, Jordan, Roll*, moments that, not coincidentally, also describe meetings with local African–Americans in their own environments. Whereas this centres the descriptions and images in *Roll, Jordan, Roll* on a specific time and place, charted throughout, the African–Americans here disappear from sight – both photographically and literally – in the main body of *LUNPFM*, in which the white sharecropper families that Agee and Evans sporadically stayed with take precedence. While these 'stories' attest to Agee's ability to establish a more conventional narrative mode, the conventions are invoked only to be superseded by other forms – musical, poetic – and even isolate moments of stream of consciousness, as seen in one of the shortest chapters: 'Colon'. Between 'Part 1: A Country Letter' and 'Part 2: Some Findings and Comments', 'Colon' adds another lyrical digression to the overall inconclusive aspect of *LUNPFM*, another semicolon, both metaphorically and literally, within a longer continuous tale. If Evans captures the actuality of the living conditions of the sharecroppers, as both Kirstein and Williams seemed to think, Agee circles around the sharecroppers' lives, both narratively and semantically, without reaching any final or definitive sense of how to ameliorate their conditions.

Likewise, it is no coincidence that multiple sections entitled 'Porch' bookend the interior of *LUNPFM*, again both metaphorically and figuratively, and in terms of the photo-text's overall structure. These 'porches' constitute several of the quintessential and largely necessary threshold moments in *LUNPFM*, occupied

not only by the inhabitants of the homes but by the two people documenting them: namely, Agee and Evans. In similar terms, the 'Colon' section could be read as another threshold, a place where the grammatical definition can be extended to indicate a quintessential aspect of Agee's writing and a metaphor for the indeterminable non-ending aspect of the project overall. As Paula Rabinowitz argues in '"Two Prickes": The Colon as Practice', Agee's writing is not only performative but also a performance, staged both internally in psychological terms and externally through a variety of textual mechanisms. In this respect, the colon becomes a description of a methodology in which the extension, the supplement, the long sentence signal – once again – anxieties about closure and ultimately death: the death of the sharecroppers, which is a genuine possibility, and the death of the text itself.[11] At any intermittent point in the 'Colon' section, Agee meditates on the impossibility of rendering each sharecropper accurately and truly, and as he does so, he paradoxically re-enacts the on-going nature of his attempts through the structure of the writing:

> At this center we set this seed, this flower, whose genealogy we have suggested and whose context in eternal history, his royalty, his miraculousness, his great potentiality: we try at least to suggest also his incomparable tenderness to experience, his malleability, the almost unimaginable nakedness and defenselessness of this . . . the size, the pity, abomination of the crimes he is to sustain, against the incredible sweetness, strength, and beauty of what he might be and what he is cheated of:[12]

As seen above, the colon is both a sign of punctuation and a sign of continuation; it indicates, as Rabinowitz puts it, that the writing is 'complete but needing a supplement'.[13] Agee's disrespect for linear writing has a long and venerable history, however, precisely within modernist American literature. Like Walt Whitman and Hart Crane, both of whom can be gleaned from Agee's word use in the above passage, Agee not only foregrounds the importance of speech and sound, but also ties in ideas of the index, of simultaneity, of writing as circular and never-ending, with his perspective on the farmers. In essence, the colon is much more than an inserted section or an aside: it functions, even though seemingly divorced from political content, as a radical literary gesture in its own right.

By comparing just this one section with the earnest tone of Paul Taylor's sociological text in *American Exodus*, or the Southern vernacular of Erskine Caldwell in *You Have Seen Their Faces*, Agee's first-person perspective in *LUNPFM* emerges as a much more complex structuring device, constantly measuring its own limitations vis-à-vis the photographic gaze of Evans.[14] Agee and Evans's shared interest in providing a working definition of vernacular American culture in aesthetic terms is, in this sense, doomed to failure; painfully aware of its artistic credentials, it cannot do anything other than provide a version of documentary realism that constantly questions its own parameters. If one of the main questions in *LUNPFM* is how to render a quintessential American experience, then this question – which also permeates the efforts of previous photo-texts – is here placed at the very forefront.

In all of the photo-texts charted so far, the regional properties of the South afforded the opportunity to render a nation on the cusp of moving from an agrarian culture to an urban one. What differentiates *LUNPFM* is that, at the same time, Evans and Agee's interest in other models of the avant-garde, the unconscious, the psychoanalytical and the anarchical seem to resist rather than embrace an idea of a specifically American vernacular truth. Preceding the first section of the book, Agee's list of 'Persons and Places' contains Jesus Christ and Sigmund Freud, Louis-Ferdinand Céline and William Blake, amongst others. These are clearly inspirational figures for Agee since they do not – for obvious reasons – form a realistic part of the sharecroppers' daily lives. If Agee is happy to incorporate Whitmanesque as well as Surrealist imagery, to move from the vernacular to the classical, from the contemporaneous to the timeless, the risk is that the sharecroppers become subsumed in an aesthetic quest ill suited to any 'real' political change.

Despite protestations to the contrary, both Agee and Evans were thus acutely aware of their respective statuses as journalists and not just artists. In this sense, how *they* wanted to be remembered was as crucial as how they wanted the sharecroppers to be remembered. The issue of who exactly the famous men are in *LUNPFM* remains, as many have noted, far from obvious. The deliberate pun inscribed into the book's title lends itself towards a personal form of mythologising, which may be ironic but nevertheless indicates the problems faced by a photo-text in which the subject itself, although seemingly about poverty in an agrarian context, is as much about artistic self-realisation.

In fact, the tenuous line between self and other is a very serious strategy in *LUNPFM*. Taking as its starting point the line from Ecclesiastes, the 'praise' of famous men is also partly an elegy for the dead, or in more realistic terms, a way to remember or memorialise those sharecroppers for whom life has nearly turned into a form of living death. Memorialisation, or, rather, the attempt to convey the harsh realities of the sharecroppers' lives, becomes part, then, of a decidedly self-reflexive literary gesture, and the book's inevitable proximity to death is signalled not only in the textual references but in the photographs as well.

As in the previous photo-texts, the issue of how to commemorate vanishing cultures, even cultures on the cusp of extinction, and at the same time provide them with a voice is an on-going process (Fig. 4.2). In several instances, from *Roll, Jordan, Roll* to *American Exodus*, linking the photographs with the vernacular speech of the subjects portrayed is often the very thing that holds the narrative sequence together, however forced it may appear. In *LUNPFM*, however, Agee's commentary is antithetical to these attempts to

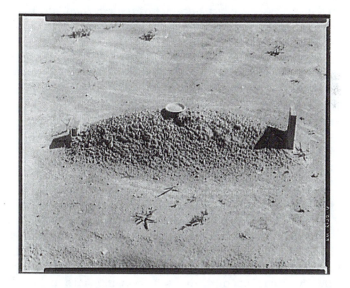

Fig. 4.2 'Sharecropper's Grave, Hale County, Alabama', in the photographic section of Walker Evans and James Agee, *Let Us Now Praise Famous Men* (Boston: Houghton Mifflin, 1941). Copyright © Prints and Photographs Division, Courtesy of the Library of Congress.

mimic a local vernacular. Here, Agee's articulation of the problems of documentary representation are distinctly literary, those of a Harvard-educated poet rather than a rural Southern boy (both of which, incidentally, Agee was). At some level, then, Agee's very personal voice can only destabilise the type of stereotypical representations of the sharecroppers seen in *You Have Seen Their Faces* by foregoing the pretence of speaking on their behalf. On another level, it is clear that Agee wants the writing to question the vexed issue of what photographs can do that writing cannot. If *LUNPFM* is marked by the problematic of representation, in terms of both its generic format and the difficulties of doing the sharecroppers justice, it is also a photo-text, which through his *own* utterance – at least for Agee – is still being written and revised. In this respect, *LUNPFM* does exactly what Agee wants it to do: namely, accentuate through the actual writing the tenuous line between self and other, between life and death, and between those doing the 'documenting' and those being 'documented'.

In this respect, the constant presence of death in *LUNPFM* ensures, paradoxically, another – necessary – form of communality, in some ways the exact opposite of the remedial, ameliorative nature of the work of Lange and, to some extent, Bourke-White. Rather than read death as an ending or void in *LUNPFM*, death becomes an invitation to remember the living. It is the proximity of death that allows Agee the opportunity to commune with us – the readers – and the sharecroppers on an equal level. There is much to be said about how the ontological nature of photography as a way to stop time aligns itself to this feeling of death but, subsequent theorisation aside, the very fact that Agee's version of documentary involvement touches on these ontological issues makes it a significantly different work from that of other documentary photo-texts.

The importance of, and problems surrounding, communication also lie at the heart of more ethnographically inspired readings of *LUNPFM*. In the many scenes in *LUNPFM* that take place on porches and other external spaces belonging to the sharecroppers, the threshold between life and death and between the perspective of the outsiders – in this instance, Agee and Evans – and that of the insiders, the occupants of the house take centre-stage. If *LUNPFM* metaphorically links the houses of the sharecroppers with Evans's camera eye and Agee's ethnographic gaze, these visual metaphors may invite the possibility of an 'unblinking' examination of the

sharecroppers, but they also prove in the process that such a thing is impossible. Agee, above all, is aware that there is no genuine objective eye, and indeed the camera lens, in this instance, can do no more than stress the play between interiority and exteriority, between going inside and becoming part of the families portrayed or remaining tentatively on the porch. Midway through the photo-text, the section aptly entitled 'On the Porch:' introduces the two authors, Agee and Evans, together trying to sleep in the sharecroppers' house. It is no coincidence that they are both close to and far away from each other. As Agee describes,

> We lay on the front porch to the left of the hall as you enter. One of us lay on the rear seat of a Chevrolet sedan, the other on a piece of thin cotton-filled quilting taken from the seat of a divan made of withes. We exchanged these night by night.[15]

Stressing the uncomfortable aspect and the fact that the visiting photographer and writer have to alternate between one and the other cast-off object, this scene constitutes one of the few humorous aspects of the systemic poverty at hand. Still, it also indicates how the liminal space of the porch is replete with the very material of past attainments and possessions. Like the shacks clad in advertisements in *YHSTF*, the 'threshold moments' in *LUNPFM* are often those moments where Agee the author co-habits the space he writes about with the photographer looking at it. Forced to occupy the relics of a more conventional notion of domesticity, Agee can only partially enter the interior space of the families investigated. As such, the seemingly insurmountable chasm between the culture of the sharecroppers and the 'investigators' is never downplayed; rather, it accentuates the ethical implications of cultural identity. If the measured eye of Evans appears to create a safety net between him, Agee and the sharecroppers, Agee's writing works hard to pull exterior reality into a more interior space, a movement that is equally mimicked in Agee's desire to get us, the readers, to enter the house and, by implication, the text with him.

If Agee uses the camera as a starting point in his Introduction to *LUNPFM*, it is because he is acutely aware that Evans's aesthetic lays not so much in a straightforward documentary ethos but rather in the co-mingling of recognisable facts, homes and faces that are clearly 'real', together with a form of poetic intervention.

This co-mingling, as seen in *American Photographs*, is not only intrinsic to *LUNPFM* but also a distinctive part of Evans's overall œuvre. In thinking about the South as an idea both constructed and envisaged rather than just a regional entity, Hale County, Alabama, becomes more than a site of destitution and economic collapse. Within Evans and Agee's representation of the vernacular life also lies the reinvention of a pastoral version of American agrarian culture, a reinvention that is very different from that of Ulmann and Peterkin, but a reinvention none the less.

Thus a form of pastoralism, albeit configured in distinctly modernist terms, has to be taken into account, and not considered just as an 'Ageean' trope in keeping with his romanticism but as something contained within Evans's work, just as it was in Doris Ulmann's vision of the South. In this respect, Evans's documentary gaze, as Kirstein pointed out in his Afterword to *American Photographs*, is, in reality, a far more complex and often oblique mechanism. If Evans came to the South with a particular 'cosmopolitan sensibility', it was one that had to reconstitute itself, faced with the demands of a Southern ethos, regardless of whether this was found or constructed. As with Erskine Caldwell's Southern vernacular in *You Have Seen Their Faces*, Evans may, in fact, have desired an affiliation with a certain Southern tradition: a renewed sense that regional affiliation could be more than just emblematic of a local vernacular culture – it could be an authenticating gesture in its own right. The issue, as in Ulmann's examination of territory in *Roll, Jordan, Roll*, is what happens when the act of photographing a specific place leads to a concurrent sense of both participation and detachment: in other words, when the Northern photographer has to embody a particular Southern gaze or, indeed, ventriloquise a particular Southern tenor.

This schism between participation and detachment is also played out in the relationship between Agee and Evans in *LUNPFM*. If the narrative implicit in the text of *LUNPFM* is often one of searching for an identity, Evans's photographs show a more detached and considered version of the sharecroppers as symptomatic of the bruised state of the nation in the 1930s. In this respect, it does not necessarily matter whether they themselves are looking towards a pastoral past, as long as the visual material renders a persuasive version of what that past might be.

As with many of Evans's images, the careful still-life arrangement shown in Figure 4.3 is meant to be artistic and 'realistic'

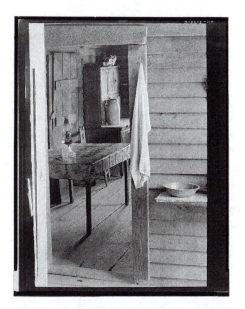

Fig. 4.3 'Part of the Kitchen', in the photographic section of Walker Evans and James Agee, *Let Us Now Praise Famous Men* (Boston: Houghton Mifflin, 1941). Copyright © Prints and Photographs Division, Courtesy of the Library of Congress.

simultaneously. If Agee's writing is constantly testing the limits of language, at times falling into a modernist form of solipsism, Evans's photography likewise struggles – or succeeds, depending on one's perspective – to be both recognisably documentary and lyrical, particularly in these 'still lives'. While the objects in Evans's photographs ironically parallel Agee's listings and descriptions in *LUNPFM* of clothing and kitchen utensils, the worn-out and used nature of the utensils also contrasts a corporate consumerist vision of the United States with the actual abject poverty of the sharecroppers. More paradoxical, but equally noticeable, is the fact that the abject poverty renders those objects worthy of being photographed.

Thus, in rendering the objects, houses and environments of the sharecroppers, Agee and Evans's promise of political and social concern for them appears as palpable and abstract at the same time. In section after section on the constituent parts of the sharecroppers' lives – the clothes, food, utensils and furniture – Agee weaves a discourse that

turns the vernacular and the everyday into the material of high art, just as the modest towel made out of sackcloth in Figure 4.3 becomes a constituent part of a still-life photograph.

However, if the objects and places described appear to provide the artists with a tenuous promise of permanence through and with their art, it is not necessarily so for the sharecroppers themselves. Agee himself may be able to move from the proverbial porch as the threshold place where the internal and the external meet, where both Agee and Evans position themselves seemingly at a vantage point, but the sharecroppers are often 'stuck' in their allotted places, cooking, sleeping, working and so on. No matter how much Agee articulates his understanding of the documentary process, he still needs the farmers literally and figuratively as a pretext for an exploration of his own psyche.

The issue of belonging, retraced in different ways by Peterkin and Ulmann, Lange and Taylor, and Bourke-White and Caldwell, is thus not so far removed from the basic question of what it means for an investigator/writer to want to 'get in' and 'fit in' at the same time. Agee, however, balks at this sense of documentary kinship and, in fact, spends a considerable amount of time towards the end of *LUNPFM* criticising Margaret Bourke-White as a shrewd self-promoter, a commercial photographer rather than an artist. For Agee, a genuine kinship between him and his subjects might be impossible, but by revering Evans's measured eye rather than what he sees as Bourke-White's intrusive one, Agee sees himself as operating on a higher moral ground.

While Agee may have been attuned to the visual on multiple levels, the idea that he was spellbound, to some extent, by Evans's expertise as a photographer is thus both true and false. For Agee, the photographs in *LUNPFM* should be seen more as a means towards an end, the desire to memorialise the Gudgers and at the same time prove the immeasurable weight of their 'actual existence'. Such tactics are nevertheless complicated by the ways in which the more descriptive passages within the text operate vis-à-vis the photographic material. What happens when Agee's process of visualisation deliberately aims for a sense of flux, as opposed to the more static and contemplative stance of Evans, is perhaps akin to the two of them alternating between uncomfortable positions on the porch. Striking a precarious balance between stillness and movement, between life and death in the Gudger home, Agee's writing

becomes a constant battle to keep the subjects alive and simultaneously memorialise them. Again, Agee's use of particular rhetorical devices situates the book between an impossible sociological premise and an equally impossible narrative one. Communality, for Agee, is about a great deal more than the successful ability to communicate with people across social, political and economic divides. Linking the interior life of the artist with his or her external subject, in this case 'the South' with all of its psychological and regional connotations, becomes once again a way to question the very foundations of documentary work.

In the end, Evans and Agee's collaboration was always based on producing a body of work that they themselves felt had integrity, rather than a successful *Fortune* article. Had *Fortune* magazine accepted the lengthy forty-two page article initially submitted by Agee, there would be no 'photo-text' in the sense that we see *LUNPFM* now. Compared to the other collaborative photo-texts that have been charted so far, the symbiotic nature of the relationship of Agee and Evans is also fundamentally different. Continuously revised by Agee for over four years after *Fortune* magazine turned it down, the book was finally contracted for publication, but even then, Agee's emotional involvement in it was such that he never considered it completed. It is possible, for example, that Evans's insertion of material in the second edition (years after Agee's death) is a response not only to changes in the ways in which the South was perceived, but also to certain narrative aspects he felt Agee had overlooked.

Whether Evans was more of a pragmatist, or chose to present himself as such years after the book's publication and the lamentable death of Agee, is a different issue. Their respective personas, regardless of how much we focus on the text itself, remain intrinsically linked to the book. Despite its verbose nature, *LUNPFM* is also about desire, joy and transfiguration in a bodily and metaphysical sense. Published at the cusp of a new decade, *LUNPFM* thus both breaks with the earnest endeavours of the other documentary photo-texts that were produced during the Depression and continues the belief in a particular photo-textual practice: a practice in which the co-mingling of writing and photography could render the true nature of the American people, regardless of circumstances, class or race. As the 1940s progressed, the photographer/ writer who would take up the mantle of Agee and Evans was, not

surprisingly, another regional visionary for whom the local and the immediate had immense connotations. In Wright Morris's Nebraska photo-texts, the aesthetics of Evans's examination of the quotidian returned in a renewed focus on rural lives and circumstances.

Notes

1. As quoted in *Letters of James Agee to Father Flye* (New York: George Braziller, 1962), p. 92.
2. James Agee and Walker Evans, *Let Us Now Praise Famous Men* [1941] (New York: Houghton Mifflin, 1988), p. xv.
3. Ibid., p. 7.
4. Alfred Kazin, *On Native Grounds. An Interpretation of Modern American Prose Literature* (New York: Reynal and Hitchcock, 1942), p. 495.
5. Lionel Trilling, 'Greatness with One Fault in it', *Kenyon Review*, 4 (1942), pp. 99–102.
6. Maren Stange, *Symbols of Ideal Life – Social Documentary Photography in America 1890–1950* (Cambridge: Cambridge University Press, 1989); William Stott, *Documentary Expression and Thirties America* (Chicago: University of Chicago Press, 1973).
7. As quoted in David Madden and Jeffrey J. Folks, eds, *Remembering James Agee* (Athens: University of Georgia Press, 1997), p. 110.
8. Keith Williams, 'Post/Modern Documentary: Orwell, Agee and the New Reportage', in Keith Williams and Steven Matthews, eds, *Rewriting the Thirties – Modernism and After* (London: Longman, 1997), p. 173.
9. Alan Trachtenberg, *Reading American Photographs: Images as History. Mathew Brady to Walker Evans* (New York: Hill and Wang, 1989), p. 247.
10. Agee and Evans, *LUNPFM*, p. 12.
11. Paula Rabinowitz, '"Two Prickes": The Colon as Practice', in Caroline Blinder, ed., *New Critical Essays on James Agee and Walker Evans: Perspectives on Let Us Now Praise Famous Men* (New York: Palgrave Macmillan, 2010), pp. 121–43.
12. Agee and Evans, *LUNPFM*, p. 102.
13. Rabinowitz, '"Two Prickes"', p. 127.
14. For more on this first-person perspective see: Jeanne Follansbee Quinn, 'The Work of Art: Irony and Identification in *Let Us Now Praise Famous Men*', *Novel*, 34:3 (Summer, 2001), pp. 338–68.
15. Agee and Evans, *LUNPFM*, p. 224.

CHAPTER 5

A Post-War Pastoral in Wright Morris's *The Inhabitants* (1946) and *The Home Place* (1948)

A remarkably prolific novelist, essayist and photographer, Wright Morris (1910-98) not only championed the very concept of the photo-text, but also wrote many essays on the intersections between text and photography that served to define the genre itself.[1] None the less, Morris has become increasingly overlooked within the larger canon of twentieth-century documentary photography and the reasons for this are partly indicative of the ambitious nature of his life-long project: namely, to synthesise photographs and text into a new creative format. For Morris, 'The mind is its own place, the visible world is another, and visual and verbal images sustain the dialogue between them.'[2] Morris claimed that he was merely 'a writer who very early saw the visible as a complement to the verbal' but in his actual photo-texts, written and with photographs taken by him during several journeys through the USA in the 1930s, 1940s, 1950s and 1960s, it is the vernacular mixture of recognisably regional settings and the documentation of the lives therein that constitute the heart of photographic practice.[3]

In this sense, Morris operates within the tradition outlined in the previous chapters, referencing not only the 1930s in photographic terms – in particular, Walker Evans's rural studies – but also a longer history of American writing in which the physical dimensions of the homestead, the familiar implements of farming and daily life, and the vernacular instruments of that particular life become the stepping-stone for a series of ruminations on the role of the artist. In his photo-texts, *The Inhabitants* (1946), *The Home Place* (1948), *God's Country and My People* (1968) and *Photographs and*

Words (1982), Morris's black and white photographs of his native Nebraska are united with a variety of textual formats, prose poems, quotations and first-person narrative, into an expansive image of a region ripe with both local and national implications.[4] Searching for the exterior and interior psychology of a rapidly vanishing America, Morris shares the same territory and motifs of small-town lives and rural existences as Evans, Lange and Bourke-White, and yet his projects are specifically designed to foreground the potential of the photograph as the starting point for a distinctly literary exploration. In Morris's photo-texts, the ethnographic impulse seen in Evans, Lange and Bourke-White is present, but strictly in the service of a larger literary effort. If Agee was seeking to approximate something photographic in his writing and yet maintain, in his own way, a division between the literary and the photographic, Morris was concerned with the possibility of the two adapting themselves to one another. Rather than supply us with portraits of the actual inhabitants, as Evans had done in Alabama, Morris's photographs show us the interiors and exteriors of the abodes of the people commemorated in his fiction and in his more autobiographical work. These are homes directly related to Morris himself, those of neighbours and acquaintances, and places from his past within a discernibly Nebraskan landscape.

In this respect, Morris's first photo-text, *The Inhabitants* (1946) – based in part on photographs taken whilst travelling on a Guggenheim grant (the self-same funding Robert Frank was given to work on *The Americans* a decade later) – pre-dates the more personalised versions of the documentary gaze to emerge in the 1950s as much as it harks back to 1930s photography.[5] Firstly, Morris does not share the political sensibilities of, for instance, Dorothea Lange or, as we will see, Paul Strand. Instead, Morris uses the aesthetic properties of the vernacular landscape to render a more introverted and more fluid arena for photography to coincide with a distinctly regional and personal form of writing. If the dialect and tone of voice in *The Inhabitants* are firmly set in the 1940s, the photographs, on the other hand, appear more timeless than those of Evans, marked primarily by the sober vernacular fronts of farms without ornamentation, and by landscapes that are untouched by contemporary industry or commodification. In fact, in *The Inhabitants*, most of the photographs appear to commemorate structures and buildings associated not so much with the Depression or the post-war era, but with

something that pre-dates it. Likewise, the dilapidation rendered – if there is any – is less overt and much less extreme than that found in Dorothea Lange's roadside shelters or Bourke-White's flood-ridden homes. For Morris, the vernacular landscape constitutes more of a wistful commentary on America than a visceral critique of its current state; what is at stake here is the intimate relationship between an artist and his subject.

In *The Inhabitants*, fifty-four black and white photographs of farms and outhouses, placed on double spreads (text on the left facing the photographs on the right), are accompanied by captions ranging from vernacular speech to local anecdotes and lyrical asides. In its form, it most closely resembles another overlooked photo-textual endeavour by Archibald Macleish, whose *Land of the Free* (1936) combined Macleish's own poetry with a selection of photographs from rural areas (Fig. 5.1).

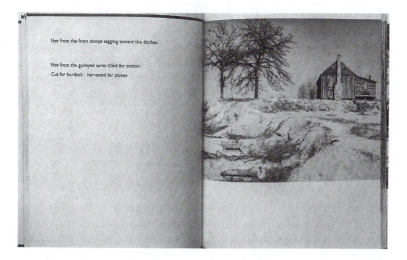

Fig. 5.1 Double spread from Archibald Macleish, *Land of the Free* (New York: Harcourt, Brace, 1938), p. 38. Courtesy of Houghton Mifflin Company.

> 'Not from the front stoops sagging towards the ditches:
> not from the gulleyed acres tilled for cotton:
> Cut for burdock: harvested for stones'

While Macleish's project provided an expansive Walt Whitman-like rendering of the landscape, and indeed strove for an epic quality in the accompanying poetry, *The Inhabitants* provides a more philosophical rumination on the idea of place itself, situating what appears to be random images of vacant streets and empty buildings side by side with single paragraphs of text.[6] The pairing of images of structures with the lively vernacular speech of the inhabitants places the book somewhere between more modernist experimentation and regional narrative. If Morris's photographs appear – at first glance – to be simply variants of the type of vernacular photography popularised by Lange and Bourke-White, the attempt at using colloquial speech in a poetic manner has more in common with Agee's high modernist moments in *Let Us Now Praise Famous Men*. Morris's use of photographs also carries some similarity to Evans's uncaptioned and untitled preliminary photographs in *Let Us Now Praise Famous Men*, asking the reader to make the connections internally rather than through exposition. However, as Raymond Neinstein points out in 'Wright Morris: The Metaphysics of Home', in reality, '*The Inhabitants* presents a series of unconnected prose fragments, each one accompanied, on the facing page, by a photograph which sometimes seems to have an unspecified "something" in common with the piece of prose.'[7]

This 'unspecified something' indicates both the absence of a specific link between text and image, and a desire none the less to use photographs in an illustrative manner (Fig. 5.2). Accompanying the figure, the 'caption' or 'title' consists of the two sentences listed below the image with a paragraph underneath:

> I've come to see the land is here for spreadin' me on. Never been in Ox Bow or Wahoo, never been in Wagon Mound or Steamboat Springs, but I can tell you I'm there – there's part of me there right now. Never owned a house or a piece of land, never owned a woman, no kids is mine. And if you ask me what kind of land that is, I'll tell you that too. Mister, the land is that part of me I can't leave behind. . . . [8]

Invoking the familiar American trope of the settler, the passage is at the same time a flashback to an earlier era, a reflection of current attitudes, and a soliloquy of sorts regarding the idea of belonging. The use of colloquial speech, as seen in Erskine Caldwell's Southern voice in *You Have Seen Their Faces*, is part of the 1930s documentary

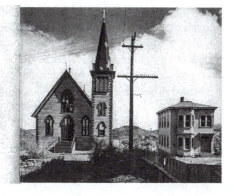

Fig. 5.2 'Church and House', in Wright Morris, *The Inhabitants* (New York: Charles Scribner's Sons, 1946), p. 72. Courtesy of the University of Nebraska Press.

'That was what I thought until I met Furman Young.
Hard to say where Furman's home is – or where it ain't.'

ethos that Morris has inherited, but Morris – rather than connect the fictitious quotation with the face of a presumed speaker – deliberately juxtaposes the vitality of the vernacular speech with the worn grandeur of the buildings. There is something wistful, even melancholy, at stake here that sets it apart from the urgency of Lange and Bourke-White's visions. As the paragraph ends, the first-person vernacular voice surmises: 'Where I've been is somethin' but it's nothin' beside where I've yet to go.'

Thus while Morris can be placed within a wider tradition of folk poetics, his use of vernacular speech and homespun philosophy is both similar and dissimilar to Agee's in *Let Us Now Praise Famous Men* and to what Erskine Caldwell and Julia Peterkin, for better or for worse, tried to ventriloquise in *You Have Seen Their Faces* and *Roll, Jordan, Roll*. By the late 1940s, however, and in the context of a post-war America seeking to look outwards rather than inwards in a domestic sense, the fascination with folk aesthetics was beginning to appear antiquated. The return to the sounds and cadences of Morris's native Nebraskan tongue may have been relevant to the Depression era but not necessarily to a post-war audience. If *Let Us Now Praise Famous Men* suffered from being read as a remnant of

the 1930s, published inopportunely at a moment when the American public wanted to forget the Depression and look ahead, *The Inhabitants* was another project that insisted on placing itself in an environment unmarked by modernisation. More crucially, both *The Inhabitants* and *The Home Place*, Morris's second photo-text, seem entirely unapologetic about doing so.

In this context, Morris is more comprehensively an artist influenced by the type of vernacular ethos that Lincoln Kirstein and William Carlos Williams recognised in Walker Evans. If Kirstein claimed that Evans's work was 'irrelevant unless fixed on its special subjects', then Morris's territory seems equally governed by a strong sense of purpose: a desire to locate essential truths within the everyday, be they national or personal.[9]

Accompanied by a mixture of dialogue and descriptive prose relating to the lives of *The Inhabitants*, the photographs none the less bear no overt traces of their presence other than the structures that they occupy. Again, it is in the strength of the vacated structures, their ability to emanate, that we find the crux of Morris's more ontological interest in photography. As with Evans's seemingly vacant churches and shops in *American Photographs*, similar questions about the nature of inclusiveness, of presence and absence, emerge. However, while *Let Us Now Praise Famous Men* is demarcated largely by the insistent voice of Agee, in *The Inhabitants*, the sounds of local vernacular speech are meant to dictate what narrative we create through the images. The photographs in *The Inhabitants* bear only the traces of human habitation but the accompanying speech, in fact, creates a veritable cacophony of voices.

The similarities to the landscape of Walker Evans's *American Photographs* (1938) may also be one of the reasons why *The Inhabitants* – when published in 1946 – seemed to not be quite of its time. In the references to small towns, Wahoo and Steamboat Springs, a post-war audience would have thought of places left behind rather than marked by modernity. Interestingly, in contemporary writing on Morris, *The Inhabitants* is also read more as a precursor for Morris's next book, *The Home Place* (1948), than as a seminal photo-text in its own right. As Raymond Neinstein points out in 'The Metaphysics of Home',

> What is seldom discussed . . . is the tension between text and photographs in *The Inhabitants* and *The Home Place*. The tension is not so apparent in *The Inhabitants*. Since the writing is free

of specific characters, plot, even place, since it is just writing, or speech, it is free, as the houses, barns, grain elevators, and so on are also set free, not intended to illustrate a story.[10]

For Neinstein, *The Inhabitants* is important, but only in so far as it acts as an investigation into what happens when text and images collide. In these terms, *The Home Place* is the more important photo-text that consolidates Morris's efforts at combining the two. There are a number of reasons for this. Firstly, *The Home Place* offers a more conventional first-person narrative: namely, that of an artist returning to his home town, the fictitious Lone Tree, on the Great Plains of Nebraska. In search of a house for his family during the Depression, the narrator, Clyde Muncie, describes a series of encounters with his past: ruminations on what it means to return, in both a visual and a more metaphysical sense, to one's birthplace. Again, as in Agee's writing in *Let Us Now Praise Famous Men*, the agricultural heartland is re-established as an almost pastoral sphere, an arcadia in spiritual, if not economic, terms. And like Agee, Morris is often fixated on the possibility of repossessing the very texture of childhood through the interaction between text and image. Whereas Agee describes in minute detail the daily lives of the sharecroppers, Morris's focus is squarely on himself and on those memories facilitated by the photographs he both takes and encounters on the way. Looking at a photograph that may be of his family, reunited in Lone Tree, the narrator Clyde Muncie/Wright Morris speculates on where he, as both author and photographer, fits into the frame:

There we all were, the clean-cut local boy, the farmer's beautiful unspoiled daughter, the town-character barber, and the old man with the horny hands of toil. And there I was. . . . Where did I fit in this picture? I didn't, that's the point. I was on the outside, in the control room looking in. On the one hand, I knew that what I saw was unbelievably corny; on the other hand I knew it was one of the finest things I had seen.[11]

Muncie/Morris's position as both outsider and insider is not dissimilar to the co-mingling of photographs and writing in the book itself. At the same time, though, it problematises a form of remembrance that is always at some level incomplete, looked at from 'the outside', and certainly at risk of idealising the environment and the

characters that populate it as 'one of the finest things' the writer has ever seen. The Proustian aspects of this fit neatly into Morris's writing, which seems to circle around the minute, its lyrical propensities and its ability to re-establish childhood as a pastoral antidote to a more grown-up, modernised and potentially alienating America. In this, again, Morris shares Agee's sense of photography as a form of representation in which documentary veracity is secondary to its emotional effect.[12] Morris consistently hints at the documentary aesthetic and its ability to transmute into something else, something timeless. In several essays on the intersections between writing and photography, here 'Photographs, Images, Words', Morris articulates how the dilemma between documentary veracity and fine art photography cannot be resolved:

> The explicitly documentary photograph makes the best, and the most, of its warring elements and its reluctance to be judged as a 'picture'. This conflict between the pictorial and the documentary gives many photographs a dramatic tension that seeks resolution in a 'decisive moment'. . . . The photographs by . . . Evans, Lange, and numberless others are unavoidably more than social comments. . . . Pictorial elements – we might say happily – both corrupt and enhance the most searing social statement. There is a remnant of the image in every documentary, and the leavings of the document in every image.[13]

As Morris's gaze shifts from the iconic exterior shots of *The Inhabitants* to a more intimate perspective in *The Home Place*, the use of photographs to render some event becomes more of an illuminative exercise than a plot device, as though Morris is attempting to unite the pictorial and the documentary elements more forcefully. In *The Home Place*, interior shots of bedrooms and the photographs and knick-knacks on display there signal the presence of, and at times diffusion between, private and public memory – between objects whose value is primarily mnemonic and objects whose value is still utilitarian. These are all subtle ruminations on the identity of the artist and his ostensible subject, one that relies on a meaning being generated even if the items shown seldom have any overt narrative context. If a secluded house in *The Inhabitants* signals the difficulty in understanding its actual inhabitants and the trajectory of their lives (Fig. 5.2), *The Home Place*, on the other hand, offers a closer, potentially revelatory view (Fig. 5.3).

Through the Glass Curtain, The Home Place 1947

Fig. 5.3 'Stove and Rocking Chair', in Wright Morris, *The Home Place* (Lincoln: University of Nebraska Press, 1999), p. 42. Courtesy of the University of Nebraska Press.

This is an accomplishment in itself, for Morris's combinations of images and text in *The Home Place*, although more descriptive and narrative in their direction than those in *The Inhabitants*, still signal the idea of photography as a curatorial exercise first and foremost. None the less, the curatorial exercise involved in examining the interiors of his aunt and uncle's home – the parlour glimpsed through the lace curtain is just one example – is marked out by a strong sense of being both a private space and a public display. These are inventories of actual lives and yet, at the same time, inventories strangely divorced from their social context in a manner not entirely dissimilar to Morris/Muncie's feeling of being 'outside looking in'. We need only look at the unhindered gaze of Evans's camera on the meagre possessions of the sharecroppers in *Let Us Now Praise Famous Men* to obtain a sense of how reverent Morris's gaze is by comparison. The thin lace curtain that separates the camera from the interior of his aunt's parlour indicates a step back in time to something more Victorian, more genteel, just as it indicates

how flimsy – like the lace curtain – the act of photography really is. For Neinstein, the photographs

> suggest or insist that something out there is real, really real, more real than the text. They intrude on the written text, which has to fight back to reclaim its pre-empted or usurped territory by the devious processes of fiction. The text has to try to subvert the photographs and insist on the right to reality of a character or a place in fiction.[14]

Neinstein's point, that photography will always have the upper hand in terms of the realism of the scenarios described, is a valid one. None the less, the fact that Morris's photographs somehow insist on the 'realness' of the photographic process does not necessarily place the text at a disadvantage. It may simply mean that both media have to work all the harder at truly representing 'a character or a place in fiction'.

While Evans and Agee, Lange and Taylor, Bourke-White and Caldwell all had to negotiate the issue of how to combine text and images synthetically in different ways, the insistence on the photo-text as indicative of wider social issues was still a common denominator. Morris, on the other hand, often insisted that the voice he answered to was only his: 'The voice of the social commentator, frequently shrill and insistent, is not the one to which I am listening. These are not documents of social relevance: they are portraits of what still persists after social relevance is forgotten.'[15] In this respect, while Morris's fascination with the vernacular and the importance of colloquial lives and rural environments relates very clearly to previous documentary work, it also stands out as a form of photo-textual memoir, one in which the hinterland of *The Home Place*, whilst populated by the townspeople of Lone Tree, is Morris's above all. Unlike Lange and Bourke-White, Morris does not pretend to be speaking on behalf of his disenfranchised subjects. He is more interested in 'what still persists after social relevance is forgotten', and photography is thus, first and foremost, an entry into something that supersedes the temporal – for Morris – than a useful critical apparatus in political terms. This does not mean that Morris's work seeks to be devoid of politics, simply that it gains its value from being the repository for something that he considers personal above all.[16]

This does not mean, however, that Morris's personal take on Nebraska precludes or even necessarily dilutes the social context of

the environment itself. If the beauty of Nebraska is rendered through a very personal gaze, Morris's interest in how we deal with the loss of a particular culture is just as prominent as it was in *Roll, Jordan, Roll*. Thus, while the pastoral elements in *The Home Place* may read as nostalgic, anxieties about a rapidly industrialising America are also present. Moving around the vacated house of his Uncle Ed in *The Home Place*, the house that Clyde Muncie is hoping to move into, the objects and things there seem to speak predominantly of a life lived away from modernity. In fact, Ed's left-behind objects are endowed with something sacred because of their ability to counter the encroaching materiality of post-war culture:

> For thirty years I've had a clear idea what the home place lacked, and why the old man pained me, but I've never really known what they had. I know now. . . . there's something about these man-tired things, something added, that is more than character. . . . That kind of holiness, I'd say, is abstinence, frugality, and independence – the home-grown, made-on-the-farm trinity. Not the land of plenty, the old age pension, or the full dinner pail. Independence, not abundance, is the heart of their America.[17]

The idea that photography is constituted as much by a form of abstinence and frugality as by larger societal concerns paradoxically again echoes the vision of Ulmann and Peterkin in *Roll, Jordan, Roll*. For Ulmann, as well as for Morris, the specifics of the historical moment – in other words, when the photographs were actually taken – is ultimately less important than what renders them timeless. Speaking in an interview from 1977, Morris looked back at the comparison between his own images and those of 1930s documentary in precisely these terms:

> The similarity of my subjects – abandoned farms, discarded objects – to those that were taken during the depression to make a social comment, distracts many observers from the concealed life of these objects. This other nature is there but the cliché of hard times, of social unrest, of depression, is the image the observer first receives. I do not have captions, but the facing text reveals the nature of the object that interests me. These objects, these artefacts, are saturated with emotion, with implications, toward which I am particularly responsive.[18]

While Morris's photographs of the exterior abodes in *The Inhab-
itants* speak of concealed lives and private existences, what cannot
be seen behind the boarded-up windows, the private material of an
interior life as described in *The Home Place* in some ways, most
clearly illuminates Morris's particular documentary style. Morris's
insistence on the minutiae of daily existence is not an excuse for
the mundane subject matter but a reconsideration of what actually
constitutes culture in the first place. By focusing on artefacts whose
value hinges on the fact that they pre-date a more commodified
society, it is the singularity of the past lives that they refer to that
gives them their value. As Morris puts it, while

> There is a diminishment of value in the artefact itself, and there is a
> limited way in which a photographer can deal with the diminished
> values of the contemporary artefact. There is a statement to be made
> about them, but it will be relatively shallow, soon exhausted.[19]

Instead, for Morris, it is 'the relative richness of the old and the lack
of it in the new' that are worth surveying and preserving.

This sense of the importance of photography as an outward sign
of authenticity, as well as inner truthfulness, partly explains why
Morris reused many of the photographs from *The Inhabitants* in *The
Home Place*. Determined not to adhere to a conventional definition
of documentary veracity, Morris recrops and configures his mate-
rial from the 1930s and 1940s in varying formats, using the textual
accompaniment instead to set the actual photographs apart. By reus-
ing images, Morris's writing on the permanence of the landscape and
the visible signs of lives lived there thus reflects on the permanence
of photography itself. When asked about the reuse of his images in
a later photo-text, *God's Country and My People* (1968), Morris set
out the importance of repetition for his vision overall:

> It was the quality of the repetition that was necessary. . . . I didn't
> know what problems I would have with readers who might . . .
> say, what is he doing in repeating himself? But I couldn't go out
> and make a new world for myself to photograph and it wasn't
> advisable. This is a revisitation. In fact, a repossession.[20]

Morris's interior shots in *The Home Place* situate these varia-
tions of repossession and reconstitution, allowing for something
that draws our attention to the creative process of the photogra-
pher/writer rather than to any conventional narrative. By calling it

a form of 'revisitation', objects and places become recurring meta-phors for how time marks us both materially and psychologically, and for how we negotiate these changes through careful observation. In Morris's descriptions, the everyday nature of the objects observed stands out:

> There's a pattern on the walls, where the calendar's hung, and the tipped square of a missing picture is a lidded eye on some-thing private, something better not seen. There's a path worn into the carpet, between the bed and the door, the stove and the table, and where the heel drags, the carpet is gone, worn into the floor. The pattern doesn't come with the house, nor the blueprints with the rug. The figure in the carpet is what you have when the people have lived there, died there, and when evicted refused to leave the house.[21]

The visual reference to the figure in the carpet relates, as is often the case in *The Home Place*, not to the item described but to something that, like the 'pattern on the wall', signals those things left behind. What concerns Morris, then, are those things such as Ed's worn-out jackets and cap that leave an indelible imprint on the place itself, despite their outward normality and the fact that they are no longer of any practical use.

The ability to render an imprint of something beyond its actual presence is thus one of the crucial tropes that bind *The Inhabitants* and *The Home Place* together and it is, of course, also an apt descrip-tion of the chemical process of photography itself. Morris's reference to the Henry James novella, *The Figure in the Carpet* (1896), in *The Home Place*, like the epigraph from Thoreau's *Walden* that first appears as a postscript to *The Inhabitants*, also constitutes a direct invocation of the photographer/writer as a transcendent poet/seer. As in William Carlos Williams's reading of Walker Evans's *Ameri-can Photographs*, it is the attempt to connect the representation of a thing with the essence of that thing that enables photography to move beyond mere documentation and into the realm of something transcendent. Thus Morris aptly starts the title page of *The Inhabit-ants* by quoting Thoreau directly:

> What of architectural beauty I now see, I know has gradually grown from within outward, out of the necessities and character of the indweller, who is the only builder – out of some uncon-scious truthfulness, and nobleness, without ever a thought for the

appearance and whatever beauty of this kind is destined to be produced will be preceded by a like unconscious beauty of life . . . it is the life of the inhabitants whose shells they are[22]

The Thoreau epigraph is about both fragmentation and cohesiveness, and about the importance of looking at exterior models as indicative of interior lives. In these terms, Morris's photo-textual œuvre continues the American version of nineteenth-century Transcendentalism, as set out in Lincoln Kirstein's reading of Evans's *American Photographs*. This acute sense of Thoreau's 'unconscious beauty of life' is similar to Morris's 'ability to be started by the relative richness of the old and lack of it in the new'. It mimics Thoreau's desire to go back to a life before industrialisation at Walden, just as Thoreau's 'indweller' bears more than a passing resemblance to Morris's *Inhabitants*.

If these references to Thoreau remind us of the idea of the camera as a transcendent practice with its roots in the nineteenth century, it also places the writer/photographer – that is, Morris – on a par with Thoreau himself. Thoreau's *Walden* is, amongst other things, the moment when the writer/reader's physical position within the landscape is made paramount. If Thoreau's sojourn at Walden Ponds constitutes an iconic moment, it is precisely because it inscribes into American culture the importance not only of being away from civilisation and modernity, but also of genuinely being in the space one occupies. For Morris, Nebraska offers the same possibilities.

Of course, it is not incidental that in James's *The Figure in the Carpet* the novella appropriately circles around the quest by one author to find the hidden message in the novel of another. Like James's main character in *The Figure in the Carpet*, Clyde Muncie in the *Home Place* struggles to realise that the hidden message may simply be that there is none – or, rather, that the most essential of meanings lies in what can be detected through time rather than through a sudden moment of realisation. James's metaphor for meaning (the figure in the carpet) is only in part visualised in Morris's interiors of his aunt and uncle's parlour, although both are, appropriately enough, remnants of a nineteenth-century sensibility. Much like a photograph, the worn-out pathways in the carpet of his aunt and uncle's house cannot be erased, and if they operate as a cipher for something homely, at the same time, they reveal hidden patterns and meanings, depending on the perspective of the viewer.

If a running theme throughout *The Home Place* is precisely how to navigate the material of past lives, most of Morris's commentary on photography's temporal quality simultaneously comments on its possible extinction. When Clyde Muncie returns with his family in the hope of moving into Ed's house, it is the encounter with the man's possessions, his worn outerwear and cap, that convinces them that they are not yet 'native' enough to inhabit the farm genuinely. There is a form of melancholia at stake here, an underlying narrative of loss, prompted not only by the nearness of Morris's own past but also by an anxiety regarding what is the best medium for rendering this 'nearness of the past'. Despite this anxiety, there must be no pretence about documentary 'truth'. As Morris argues,

if somebody says: Really . . . you're just trying to hang onto things that naturally have to be replaced; a kind of nostalgic mania . . . it really leads nowhere . . . I would have to say, Correct. Nostalgia is merely one ingredient. . . . Perhaps everyone in this century is insecure about the persistence of the past.[23]

The insecurity about the persistence of the past is the hazardous terrain of the documentary photographer, a risk as well as a reason to put into writing those emotional responses that the photographs themselves cannot capture. In this context, Morris's work is consistently marked by an acknowledgment that the two fields need one another. In this respect, the materiality of rural culture in Lone Tree has the same potential for Muncie/Morris as James's *Figure in the Carpet* has for his writer: both function as metaphors for how we inscribe memory in a meaningful way. In an attempt to synthesise form and content genuinely, it is perhaps more accurate to say that Morris's aesthetic constitutes an encounter with documentary practice rather than another example of it.

One of the things that bind *The Inhabitants* and *The Home Place* together is the fact that the photographs bleed into their adjacent pages without recourse to captions or titles other than those on the opposite page. In some ways, this instils in the viewer the sense that no photograph or sequence of photographs can ever tell the 'whole' story, in sharp contrast to, for instance, the continuous use of captions and quotations under Lange's photographs in *American Exodus*. Morris astutely points to how photographs resist being isolated, particularly in the context of the photo-text, because the reader will always search for an illustrative meaning. For Morris, the format of the photo-text,

rather than a story with illustrative material, is an opportunity to counter both literary and photographic conventions. Rather than establish narratives with conventional plots, the narratives – and the rather quirky passages in *The Inhabitants* can hardly be called that – always rely on the vernacular voices of his unphotographed subjects to situate and ground the images. In *The Home Place*, because we are conspicuously left without any portraits of the characters themselves, the vernacular voices are disembodied, are left floating in the landscape. In this sense, they are closer to the anonymous articulations first rendered in *The Inhabitants* than they may appear.

In *The Home Place*, for instance, photographs of the narrator's uncle, called 'the old man', bookend the work in its entirety. The first one is an image of him standing in the entrance to the barn, the last one a shot of his re-entry (Figs 5.4 and 5.5). In both photographs,

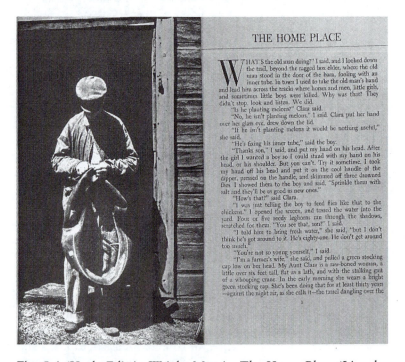

Fig. 5.4 'Uncle Ed', in Wright Morris, *The Home Place* (Lincoln: University of Nebraska Press, 1999), Introduction, p. xxii. Courtesy of the University of Nebraska Press.

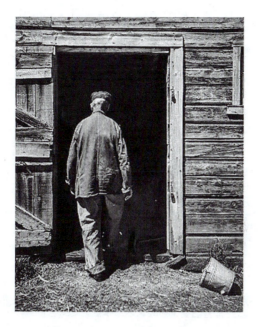

Fig. 5.5 'Back View of Ed', in Wright Morris, *The Home Place* (Lincoln: University of Nebraska Press, 1999), final page. Courtesy of the University of Nebraska Press.

the old man's face is hidden, covered by the shadow of his hat, turned away, intimated but barely glimpsed. This is as close to a conventional portrait as there is in *The Home Place*, although, paradoxically, in one of the final chapters, another photograph shows several faces, albeit from a distance. In what appears to be a nineteenth-century family portrait, a group of people present themselves in front of a house similar to the contemporary houses seen previously (Fig. 5.6).

In fact, there are several photographs of photographs in *The Home Place*. Usually nineteenth-century portraits inserted into the corners of mirrors, on tables or windowsills and in drawers, they remind us of previous photographic customs in which the sitter or sitters – not unlike Morris's stoic buildings – seem fixed in time, impervious to change. Morris achieves this sense of immobility partly by letting his photographs bleed edge to edge, a practice meant to avoid any neat framing or journalistic pretension whilst

Fig. 5.6 'Family Portrait', in Wright Morris, *The Home Place* (Lincoln: University of Nebraska Press, 1999), p. 154. Courtesy of the University of Nebraska Press.

still integrating them into the text. Without any bordering or captions to accompany the photographs in *The Home Place*,

> the camera image differs from all others in the way it resists isolation. The word 'bleed', used to describe a photograph printed without margins, accurately conveys the cutting off, the excision, the amputation, of the photograph from its environment. . . . The controlled conditions of studio portraits – the false environment of props and lighting – on the other hand – avoid the hard, bleeding edges and give the illusion of wholeness.[24]

Morris's critique argues that the more honest image foregoes any semblance of documentary cohesiveness by making it evident that it has been 'excised' from its natural environment. As in *Let Us Now Praise Famous Men*, the inclusion of anonymous vernacular photographs – the unnamed and uncaptioned photographs within the frame – is one way to stress how all photographs reveal *and*

conceal information about their subjects. The family portrait shown in Figure 5.6 also refuses any actual detail. We can glean the location from its similarity to other structures in *The Home Place*, but still we have no sense of who is who, or of what occasion prompted the taking of the photograph. As in the presence of anonymous vernacular photographs, what renders the architecture valuable is its typology, its tendency to repeat certain decorative motifs, rather than its ability to distinguish itself from other similar structures. However, rather than make the anonymity of the buildings a thing of beauty, which is arguably what Evans does in *American Photographs*, Morris sees them primarily as containers or vessels for what cannot be seen: namely, the unphotographable interior lives of their inhabitants. In other words, it is precisely by resisting the 'illusion of wholeness' that the photographs bleeding from edge to edge may intimate what paradoxically is not shown or explained.

The move towards something significantly more interior than the 1930s photographs of rural inhabitants seen in *You Have Seen Their Faces* and *American Exodus* does not mean that politics, in the sense of wider societal concerns, is absent from Morris's phototexts. The anxieties of the immediate post-war period, the loss of agrarian pride following the trauma of the 1930s, with all of its economic ramifications, play a pivotal role in the return of Clyde Muncie. In fact, without the Depression, the returning photographer desperate to find a home for his young family would not be there. In this context, Morris is acutely aware of the contradiction between his vision of the Midwest as protection from a rampant industrialisation, and a Midwest unable to insulate itself completely from post-war society's promise of material wealth.

This sense of the photograph as a landscape memorialised is partly conveyed through Morris's resolve to keep singular items and structures within the frame and to exclude the clutter of extraneous detailed material. This is done not simply through the practice of 'bleeding the image from edge to edge'. More often than not, Morris employs an even depth of field and a consistent range of grey tones, which deny special emphasis to particular details – again, not unlike some of Walker Evans's work from the 1930s. This has the effect of further flattening out an area that is already geographically flat – the Great Plains of Nebraska – ensuring that the only things visually disturbing the endless vistas are grain containers, farms and other local structures. In multiple ways, the straightforward application of the term 'documentary' is considerably more onerous for

Morris than for Bourke-White and Lange, despite their shared pastoral sensibility when it comes to agrarian culture. Not only does Morris share much of Evans's nineteenth-century sensibility when it comes to photographic aesthetics but also, as David Nye points out, the absence of people in Morris's work actually accentuates their presence in the structures photographed, something that one could argue runs through Evans's *American Photographs* as well.[25]

For the young narrator and father in *The Home Place*, it seems entirely appropriate, then, that it is the encounter with the possessions of Ed's dresser drawer (Fig. 5.7), rather than his house, that sets off a series of ruminations on the meaning of privacy and the camera's role in recording it:

> The camera eye knows no privacy, the really private is his business, and in our time business is good. But what, in God's name, did that have to do with me? At the moment, I guess, I was that

Fig. 5.7 'Dresser Drawer, Ed's Place, near Norfolk, Nebraska 1947', in Wright Morris, *The Home Place* (Lincoln: University of Nebraska Press, 1999), p. 140. Courtesy of the University of Nebraska Press.

kind of camera. Was there, then, something holy about these things? . . . I looked at the odds and ends on the bureau . . . there was not a thing of beauty, a manmade loveliness anywhere. A strange thing, for whatever it was I was feeling, at that moment, was what I expect a thing of beauty to make me feel. To take me out of my self, into the selves of other things.[26]

In asking 'What makes an image cohesive?', Morris questions not only the relationship between the artefacts that will 'tell' Ed's story, but also our preconceptions about the purpose of photographing them. It is, of course, Morris's belief in the sacred nature of these artefacts, not Ed's, that allows him to co-opt them into his own vision and then link them to something higher or more transcendent. In other words, it is the repossession of the artefacts that allows him to give us a collective, as well as private, vision of Lone Tree. Insistent on his emotional connection to these artefacts, Morris writes:

Perhaps all I'm saying is that . . . some things, these things, have that kind of character. That kind of passion has made them holy things, that kind of holiness, I'd say, is abstinence, frugality, and independence, the home grown, made-on-the-farm trinity.[27]

The idea of frugality and of living through a spirit of independence rather than material accomplishments is, in many ways, a traditional one. It pays homage to a notion of stoicism and resilience in the face of economic hardship, but more crucially, it forms a direct link to the spirit of Thoreau that pervades the text. According to Morris, 'the simultaneous existence at different times of the same sensibility' proves that 'we are merely the inheritors of a sensibility that moves among us'.[28]

Such an ethos is not vastly dissimilar to that of James Agee in *Let Us Now Praise Famous Men*, nor is it coincidental that Agee in that photo-text spends considerable time philosophising about the private contents of the sharecroppers' drawers. None the less, Morris – unlike Agee – is entirely comfortable in his co-ownership of the artefacts photographed. This sense of entitlement, for lack of a better word, has a curiously conservative edge to it, as though the artefacts are an inheritance to be cherished rather than something indicative of social circumstances that need to be overturned, as is clearly the case in *Let Us Now Praise Famous Men*. As Nye puts it,

Morris's vision is more akin to a 'conservative version of modernist aesthetics' than to a radical rethinking of material culture.[29] The result is that what Nye designates as 'the ineffable particularity of the domestic landscape' is made heroic and permanent, even if it consists of just 'the odds and ends on the bureau'.

Morris's homage to Ed, whilst connected to his personal situation, is thus predominantly elegiac, in that it rests on his absence rather than his continued presence in the house. For Alan Trachtenberg, the elegiac is no less than 'the defining mode of his (Morris's) pictures'.[30] This elegy, 'which is closer to a sacramental embrace of objects', implies that the artefacts pictured are primarily there to indicate time passing, that they constitute ciphers for past events and memories.[31] But Morris's awareness of 'the field of time' implies that the act of looking outwards into the world engenders its opposite, which is not really its opposite at all: namely, the act of looking inwards. By using the term 'sacramental', Trachtenberg indicates an almost ritualistic aspect to the act of photographing, even if it is not necessarily a mournful one.

If there is any melancholia in Morris, it is also because the idea of Nebraska cannot exist without the concurrent danger of its demise. Aware of this, Morris admits:

> If somebody says: Really . . . you're just trying to hang onto things that naturally have to be replaced; a kind of nostalgic mania . . . it really leads nowhere . . . I would have to say, Correct. Nostalgia is merely one ingredient. . . . We're dealing here with the zeitgeist . . . the persistence of the past. . . . I think there is present in any construction an effort to replace what is disappearing.[32]

While nostalgia partially explains the photograph's ability to function as a form of repossession, as Morris puts it, the text also has to emote some truth about 'the life of the inhabitants'. The fact that it inevitably attempts to replace what is disappearing in cultural terms is partly a testament to the photograph's ability to visualise certain emotions: emotions that are not always rational but are none the less valuable. In this respect, Morris shares James Agee's tendency to excavate the past through its most indirect route, even if it is a circuitous route of material possessions, external habitations and vacated interiors.

Morris may have chosen not to define his own photographic process as a salvage operation in the vein of 1930s documentary but this does not mean that his work did not contain many of the tropes and concerns of the 1930s. If he gravitated towards a particular aesthetic in *The Home Place*, it was because the intrinsic fabric of life there was conducive to such an aesthetic. Ultimately, Morris's photo-texts are both an extension of the 1930s documentary project and an attempt to synthesise form and content genuinely through a narrative that relies equally on text and photography. For Morris, the camera's ability to render how memory really works, with all of its inconsistencies and narrative tendencies, became the creative impetus for an exploration of how we read photographs and how they, in turn, inform our reading of text. Above all, it was a way to ensure that the vernacular voices of *The Inhabitants* of Nebraska would remain living entities rather than static objects emblematic of a bygone era.

Notes

1. Amongst Morris's books on the interaction between writing and visual arts are: *The Territory Ahead* (New York: Harcourt Brace, 1958); *God's Country and My People* (New York: Harper and Row, 1968); *Love Affair – A Venetian Journal* (New York: Harper & Row, 1972); *Structures* and *Artifacts: Photographs 1933–1954* (Lincoln: University of Nebraska Press, 1976); *Earthly Delights, Unearthly Adornments: American Writers as Image-Makers* (New York: Harper and Row, 1978); *Photographs and Words* (Carmel: Friends of Photography Press, 1982); and *Time Pieces: Photographs, Writing, and Memory* (New York: Aperture, 1999). He was awarded the National Book Award in 1957 for *The Field of Vision* (Lincoln: University of Nebraska Press, 2002) and the American Book Award in 1981 for *Plains Song: For Female Voices* (New York: Harper & Row, 1980).
2. Wright Morris, 'The Romantic Realist', in *Time Pieces*, p. 26.
3. Morris, *Structures and Artifacts*, p. 120.
4. In *God's Country and My People*, a selection of Morris's previous photographs reappear, together with a mixture of lyrical commentary, snippets of folklore and tales indirectly linked to the Nebraska images as a way to cross-reference many of the people and events introduced in his two previous books. Most of Morris's notable fiction is also set on the Great Plains of Nebraska.
5. Wright Morris was awarded two Guggenheim fellowships in 1942 and 1946 for photo-textual studies.

6. For more on the interaction between text and images in Archibald Macleish's *Land of the Free* see: Louis Kaplan, '"We don't know": Archibald Macleish's *Land of the Free* and the Question of American Community', in *American Exposures: Photography and Community in the Twentieth Century* (Minneapolis: University of Minnesota Press, 2005).

7. Raymond L. Neinstein, 'Wright Morris: The Metaphysics of Home', *The Prairie Schooner*, 53:2 (Summer, 1979), pp. 121–54 (Omaha: University of Nebraska Press), p. 124.

8. Wright Morris, *The Inhabitants* (New York: Charles Scribner's Sons, 1946), p. 71.

9. Lincoln Kirstein, 'Foreword', in Walker Evans, *American Photographs* (New York: Museum of Modern Art, 1938), p. 194.

10. Neinstein, 'The Metaphysics of Home', p. 124.

11. Wright Morris, *The Home Place* (New York: Charles Scribner's Sons, 1948), p. 107.

12. The children of the main narrator, Clyde Muncie (a stand-in for Morris himself), play a pivotal role in *The Home Place*. It is from the children's perspective that we see another version of Morris/Muncie's documentary camera eye.

13. Wright Morris, 'Photographs, Images, Words', in *Time Pieces*, pp. 53–67, 57.

14. Neinstein, 'The Metaphysics of Home', p. 125.

15. Wright Morris, 'Structures and Artifacts: Interview with James Alinder', in *Time Pieces: Photographs, Writing, and Memory* (New York: Aperture, 1999), p. 145. In *God's Country and My People* (1968), as well as in *Photographs and Words* (1982), a selection of Morris's previous photographs reappear, together with a mixture of lyrical commentary, snippets of folklore, interviews and tales as a way to cross-reference material introduced in the two previous books. In each instance, the photo-text becomes another moral return to his home roots for Morris, as well as an aesthetic experiment in rendering a very agrarian vision of the heartland of America.

16. Robert E. Knoll, *Conversations with Wright Morris: Critical Views and Responses* (Lincoln: University of Nebraska Press, 1977), pp. 147–8.

17. Ibid., p. 150.

18. Ibid., p. 149.

19. Ibid., p. 150.

20. Ibid., p. 151.

21. Morris, *The Home Place*, p. 143.

22. Henry David Thoreau, *Walden*, Ch. 1, 'Economy', Section 7, 'Modern Improvements', as quoted in *The Inhabitants*, p. 1.

23. Morris, *The Home Place*, p. 141.

24. Ibid., p. 143.
25. David E. Nye, *Narratives and Spaces: Technology and the Construction of American Culture* (New York: Columbia University Press, 1998). For more on the connections between Morris's nineteenth-century aesthetics and nineteenth-century paintings of vernacular artefacts see Caroline Blinder, 'The Bachelor's Drawer: Art and Artefact in the Work of Wright Morris', in *Writing with Light*, ed. Mick Gidley (London: Peter Lang, 2010).
26. Morris, *The Home Place*, p. 144.
27. Morris, *The Home Place*, p. 145.
28. Morris, quoted in Trachtenberg, 'Wright Morris: American Photographer', in *Distinctly American: The Photography of Wright Morris* (London: Merrell, 2002), pp. 9–33, p. 9.
29. Nye, *Narratives and Spaces*, p. 55.
30. Trachtenberg, 'Wright Morris: American Photographer', p. 12.
31. Ibid.
32. Knoll, *Conversations with Wright Morris*, pp. 143–4.

Hardboiled Captions and Flashgun Aesthetics in Weegee's *Naked City* (1945)

If Wright Morris's return to the photo-textual format in his Nebraska books constituted the tail end of a distinct fascination with rural America, other photographers took urban life as a measure of a new identity in the immediate post-war era. Published in the same year as Wright's *The Inhabitants*, Weegee's massive bestselling photo-text *Naked City* (1945) constitutes an antithesis to the nostalgia and reverence of Morris's look at small-town America, despite being conceived, like Morris's, as a photo-text both written and photographed by one person. Designed to bring his massive archive of street photography to a wider audience, *Naked City* was marketed predominantly as a brutal, unflinching collection of photographs of New York in the late 1930s and 1940s. The book consists of eighteen chapters preceded by an introduction, 'A Book is Born: Weegee', with subsequent chapters charting various disasters – 'Fires', 'Murders', 'Sudden Death' – as well as places 'The Bowery', 'Harlem' and 'The Opera'. However, it is the former category, the images of the aftermath of crime and violence, for which the book is famous. Allegedly connected to the Ouija board's predictive characteristics, Weegee's pseudonym as a news photographer (his real name was Arthur Fellig) was an apt metaphor for his uncanny ability to appear at the scene of a crime or accident only seconds after its occurrence. While Weegee himself played up this persona as an unflinching photographer of the seedier aspects of urban life, the very fact that *Naked City* was designed as a photo-text, and not simply a collection of sensationalist images, allows a crucial insight into Weegee's considerable abilities as a commentator on city life beyond that of tabloid photographer.

Because of Weegee's reputation as a crime photographer, the innovative nature of how his images and text operate together in *Naked City* is often overlooked. In reality, the book itself constitutes one of the most synthetic photo-textual experiments of the era. Put simply, the graphic nature of Weegee's photographs of accidents, murders and other spectacular urban occurrences, from fires to the arrest of gangsters and car crashes, has meant that the accompanying writing in *Naked City* is seen as incidental compared to the photographic material, much of which has since reappeared on the covers of crime fiction in various mutations. Nevertheless, Weegee's captions and the design of *Naked City* overall are, in fact, engaged in a complex dialogue with the meaning and repercussions of the photographic act itself. As the images are accentuated by and duplicated in the adept use of text and captions, Weegee's photographs are rarely – to coin a phrase – allowed to speak for themselves.

In the Introduction, Weegee presents *Naked City* as the charting of his love affair with the city, one born out an innate sense of belonging to his subjects:

> For the pictures in this book I was on the scene; sometimes drawn there by some power I can't explain, and I caught the New Yorkers with their masks off . . . not afraid to Laugh, Cry, or make Love. What I felt I photographed, laughing and crying with them.[1]

Presenting himself as an insider, Weegee's persona is introduced from the outset as a constituent part of the overall structure of *Naked City*. Unlike Morris, who used Claude Muncie and a variety of other local figures as stand-ins for the concerns of the photographer/writer, Weegee stresses his own presence and his own hand in the process of putting the book together. Capitalising the words 'Laugh, Cry, or make Love', he promises a book that is literally big on emotions, emotions that are heightened by his own participation, both voluntary and involuntary, 'drawn . . . by some power' he 'can't explain'. In this and in other ways, Weegee's participation in the layout and structure of the book is established as a crucial part of what will make the ensuing material enticing. In other words, here is a text – Weegee insinuates – that will expose himself as much as his subjects.

Like Margaret Bourke-White in *You Have Seen Their Faces*, Weegee includes a separate section at the end of *Naked City*, 'My Camera', in which he outlines the equipment used, stressing the importance of instinctive know-how in the process. If Bourke-White was sharing tips regarding how to be the most efficient ethnographer in the field, Weegee's expertise, on the other hand, relies on his ability to empathise with the heightened emotional landscape surrounding him. For Weegee, the process is, above all, about belonging to, rather than objectively surveying, the landscape surrounding the photographer.

One of the ways in which the text in *Naked City* establishes this more personal and emotive language is by aligning the intrepid photographer with the investigative detective, the outcome of which is that the accompanying writing is often more reminiscent of such contemporary hardboiled writers as Dashiell Hammett or Raymond Chandler than of anything journalistic. The backward glance at events beyond his control, the scripted voice-overs of Hollywood crime procedurals, are all standard tropes that Weegee gravitates towards knowingly. None the less, given the documentary parameters of the book and its promise to provide the city 'naked' and exposed, Weegee's aesthetic still has to combine his more emphatic perspective with a sensationalist vision. While Weegee's often jocular, occasionally sentimentalising descriptions of the urban evidence the hardboiled detective fiction and cinema that influenced his work, it is the actual everyday reality of New York life that he takes as a starting point. As Weegee argues, his forte as a writer lies in the very fact that he is not a writer or journalist per se, simply a misunderstood purveyor of human interest stories; what constitutes a human interest story is ultimately his overriding subject.

In the very first chapter of his autobiography from 1961, Weegee writes: 'My typewriter is broken. I own no dictionary, and I never claimed that I could spell. . . . Everything I write about is true . . . and I have the pictures, the checks, the memories and the scars to prove it.'[2] One of the defining factors of *Naked City* is thus that it presents its material as veritable proof of Weegee's ability to 'see' what others ignore, despite the fact that many other tabloid photographers were engaged at the time in producing similar images.[3] What distinguishes *Naked City* is thus not so much the nature of the material: it is the way in which Weegee sets out to prove not only that is he himself part of the city he photographs, but also that photography itself can somehow bear the 'scars' of the crimes witnessed.

Weegee's presentation of himself as emotionally entangled with his project is thus vastly different from Morris's personal engagement in the rural communities of Nebraska. Not only does it become a way to establish the photo-book's potential as a form of disclosure that extends beyond the city, but also it reconstitutes the photo-book as a very self-conscious probing into the things we seldom see in public. The images of the undressing of the inhabitants of New York (and it is no coincidence that Weegee loves photographing mannequins being dressed or undressed in New York shop windows) are examples of a form of disclosure unabashedly based on Weegee's own voyeurism. Happy to share his predilections for people who are exposed and vulnerable, Weegee never pretends to be engaged in a form of investigative journalism and instead focuses on his own emotive response to the material at hand. In an image of a shop owner removing three white mannequins from a broken storefront in Chapter 13 of *Naked City*, Weegee positions himself nearly on a par with the man holding the mannequins, choosing a sense of proximity for the camera rather than a more advantageous position from which to capture the shop window in its entirety (Fig. 6.1).

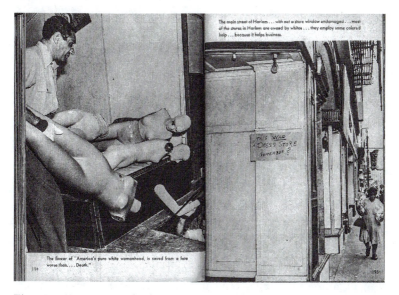

Fig. 6.1 Weegee, *Naked City* (New York: Da Capo Press, 1985), p. 194. Copyright © Hawthorn Books Inc.

Under the photograph is written: 'The flower of America's pure white womanhood is saved from a fate worse than . . . Death.' While the caption appears humorous, it also has a political point: a point that is reiterated in the next image of a boarded-up shop in the same location. Here the caption states: 'The main street of Harlem . . . with not a store window undamaged . . . most of the stores in Harlem are owned by whites . . . they employ some colored help . . . because it helps business.'[4] In the style of a shorthand report, Weegee's tongue-in-cheek commentary on the intersections between racism and commodification deliberately mimics and then undercuts the rhetoric of white superiority. Unlike Erskine Caldwell's rendition of an African–American vernacular in *You Have Seen Their Faces*, designed to give a sense of authentic regionalism, Weegee adopts the superior attitude of someone who not only 'knows better' but also expects his audience to do so as well. In other words, the photo-text operates on the premise that its audience understands the ironic subtext enabled by the captions. With their use of punctuation to indicate omissions, as seen in the previous example, the style seems more akin to a form of shorthand than a polished report. It is no coincidence that Weegee gravitates towards internalised captions in the form of signs as well. In the same section, a handwritten piece of paper on a looted shop in Harlem states: 'This WAS a Dress Store – Remember?', admonishing the passer-by, the photographer and the reader to look closer at what might be the image's *true* caption.[5] These captions, then, provide an added commentary on the social context of the period through a discourse entirely different from that seen in *American Exodus*, for example. If Dorothea Lange and Paul Taylor went to some lengths to give a voice to the subjects photographed by allegedly quoting them directly, it is the writing on the wall in *Naked City* that here stands in for the voices of the subjects – who themselves are rarely quoted.

Unlike the journalistic traditions of the broadsheets, with which Weegee was familiar, *Naked City*'s compartmentalising of the material is thus less about journalistic structure and more about tracing the habits and haunts of the photographer himself. The sequencing of the chapters, from Chapter 1's 'Sunday Morning in Manhattan' to Chapter 16's 'Odds and Ends', indicates that the city is somehow organised through specific neighbourhoods or types of people,

when in reality it is structured according to what Weegee finds photogenic. Just as the writing and captions constantly remind us of the photographer's familiarity with the episodes witnessed, no matter how anarchic or bizarre, the landscape is always approached from the ground up rather than from a more elevated vantage point. In a famous one-page sequence, Weegee's caption once again reminds us that the photographer is operating at ground level. The caption 'For the first time, an accident is photographed before and after it happened' accompanies three images of a street pedlar being hit by a car and subsequently dying, almost as though the photographer's predictive powers caused the actual accident to occur (Fig. 6.2).[6]

In this harrowing recording of a death, the street becomes a staging area for a complete collapse between the private and the public, as the last rites are performed by a priest simply passing by. The first caption, 'A man is seated on the sidewalk taking it easy', indicates that victim could be everyman, not a vagrant or bum necessarily, but a person just taking a break. The second caption then tells us that he was a 'peddler of pencils' – someone on the lowest rung of

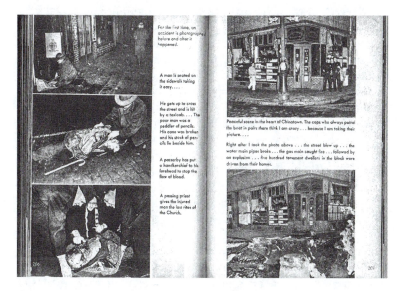

Fig. 6.2 'For the First Time', in Weegee, *Naked City* (New York: Da Capo Press, 1985), p. 206. Copyright © Hawthorn Books Inc.

the economic ladder – and yet despite his 'stock of pencils [lying] beside him', there is no sense that social indignation has motivated Weegee to take the picture. When a 'passing priest gives the injured man the last rites', the gist of this three-image 'story' is that Weegee just happened to witness 'the before and after' of a death.[7] As is often the case in *Naked City*, rather than provide a more distanced bird's-eye view of the accident, Weegee makes us privy to something that we are not meant to see. While this is different from the photo-textual aesthetic witnessed in such work as *American Exodus* and *Let Us Now Praise Famous Men*, it does share certain characteristics with aspects of Margaret Bourke-White's work. Weegee's alternative guidebook to New York – like Bourke-White's alternative guidebook to the South – is not adverse to the potential of the photo-text as a form of titillation, as well as shock. Like Bourke-White, Weegee also understands that the idea of a place is often as powerful as the actual place itself.

In more ways than one, then, the mapping of the city that occurs in *Naked City* is filtered through a conceptual framework rather than a purely documentary one. To a large extent, this is facilitated by Weegee's use of the investigative photographer as a figure of detection more akin to something fictitious than simply journalistic. For Weegee, this becomes, crucially, another way to remain on the margins of the city as a liminal figure capable of stepping in and out of the environment portrayed. It is no coincidence that the many images of gutters, pavements, doorways and windows in *Naked City* are always used as peripheral entrance points between the private and the public, a domain that Weegee appropriates as his own.

Despite the sense of a proprietorial eye surveying New York, *Naked City* does not end with an image of the typical New Yorker or of Weegee himself. In fact, Chapter 17, 'Personalities', culminates tellingly with the image of a forlorn and bedraggled Alfred Stieglitz, the photographer most famous for introducing modernist art and photography to a twentieth-century public. This is not simply Weegee congratulating himself on capturing a cultural icon; it is as much a sly commentary on what type of photography is relevant to the new age, and to the post-war era that Weegee occupies. The caption states: 'Alfred Stieglitz, in his cubby hole in the back of an [sic] Madison Avenue office bldg. He sits here lonely & forgotten. . . . He has destroyed over 30.000 priceless platinum photographs of his works.'[8] The 'downfall' of Stieglitz becomes – within the larger

landscape – a memento mori of a soon-to-be-dead photographer and presumably, according to Weegee, a soon-to-be-dead photographic movement, the platinum prints superseded by Weegee's use of ordinary film. Weegee's nod to the photographic aesthetic of another era thus becomes a way for him to acknowledge his familiarity with this existing cultural territory, as well as to intimate its imminent collapse. Stieglitz, as the caption states, has destroyed his priceless platinum photographs, leaving space for another type of photography, another type of photographer.

The image of Stieglitz alone, despite a lifetime of artistic endeavours, also fits into another one of the main themes of *Naked City*: namely, the inherent loneliness of modern urban life. Contrary to what one might expect, *Naked City* presents the urban as more about solitude than overcrowding. However, if modern life is about inevitable alienation, it is an alienation that also mirrors that of the photographer. In this environment, the social documentarian shares the general problem of modern humanity: no matter how talented or successful, one is ultimately alone.

The possibility of *Naked City* being reflective of a darker postwar philosophical ethos is none the less one that critics, in their eagerness to read Weegee as an extension of a particular social documentary style, tend to neglect. For Miles Orvell, for instance, Weegee's voyeuristic eye actually continues the aesthetic found in the documentary work of the 1930s, both of them capitalising on – and to some extent misusing – an idea of social concern. According to Orvell,

> the public's habituation to a photography of ritualistic social sympathy during the Depression, [was] created partly by the celebrated work of the Farm Security Administration, who with good conscience manipulated their subjects in the name of social betterment. Anyone looking at the destitute through the eye of a camera, by definition had a heart. And Weegee himself went so far, on one occasion in *Naked City*, as to advertise his own sentiment: 'I Cried When I Took this Picture'.[9]

While Orvell is right to point to how 1930s documentary often 'manipulated their subjects in the name of social betterment', he none the less misreads Weegee's captions by defining them as mere extensions of this form of 'documentary' manipulation. By taking

Weegee's caption at face value, Orvell reads it as a persuasive tactic similar to those of the Farm Security Administration and presumably the work of such photographers as Dorothea Lange. This, however, neglects Weegee's canny use of captions, both externally and internally, as seen previously, and in the form of variations of urban signage that is vernacular and yet mass-produced. By adding an extra layer to the inscriptive nature of the image itself through the self-reflexive use of irony, such as in the images of the Harlem riots, any 'social sympathy' is problematised and questioned. In Orvell's example, Weegee's presence is accentuated by the accompanying caption, 'I Cried When I Took this Picture', but the proximity of horror on the faces of a mother and daughter watching the burning building in the actual photograph is equally important. It is the combination of text and image, in this instance, that prevents any sense of 'social betterment' taking place. It is with the horror of witnessing a moment of death that Weegee is concerned.

The fact that the issue of social betterment operates in fundamentally different ways in *Naked City* does not mean, of course, that it is devoid of any political charge. It simply means that the politics of the book operate more opaquely in the intersections between image and text. In one iconic photograph from Chapter 4, 'Murders', entitled 'Their First Murder', a group of unruly children intermingled with adults rush towards the scene of a crime, their collective faces charged with both joy and horror. Despite the ages of the participants, the photograph carries the same hostile charge as the grainy black and white shots of gangsters, accidents and witnesses to crime throughout *Naked City*. In other words, these children are not paradigms of an innocence lost – in fact, they are the exact opposite of Dorothea Lange's mournful sharecropper children. Not only are they shown as having a form of agency, albeit rather anarchical, but also they are interesting to Weegee because they are enacting a version of later adult life rather than childhood play. This feeling is accentuated by the caption underneath the image: 'A woman relative cried . . . but neighbourhood dead-end kids enjoyed the show when a small-time racketeer was shot and killed' [10] Nevertheless, despite the aggressive posture of the children, a certain urban lyricism is at play here as well: a lyricism in keeping with Weegee's fascination with the 'street' as a natural habitat for a form of desire as well as violence (Fig. 6.3).

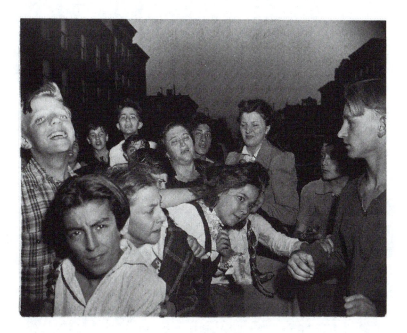

Fig. 6.3 'Their First Murder', in Weegee, *Naked City* (New York: Da Capo Press, 1985), p. 86. Copyright © Hawthorn Books Inc.

This is a sphere in which ordinary play is circumvented in favour of something brutal and, in Weegee's case, in favour of witnessing a childhood in which violence is an everyday occurrence. As Weegee's deadpan captions insinuate, the witnessing of a crime committed and the witnessing of the photographer documenting the crime cannot be so easily divorced. Not only are these children aware of the presence of the photographer at work, but also they are inadvertently enacting some of the gestures of hostility and voyeurism obliquely present in the process of documentary photography itself. Despite these alignments, it is too easy simply to read Weegee's images as a critique of the photographer 'at work'; nor can they be read as straightforward examples of how children return the photographic gaze in different, more direct ways than adults. What we have instead is a complex example of how text influences the politics of Weegee's photography. In 'Their First Murder', the children

clearly represent the natural desire to witness violent events, a desire accentuated by the presence on the following/adjacent page of the image of the dead man himself. As Weegee states matter of factly: 'Here he is . . . as he was left in the gutter. He's got a D.O.A. tied to his arm . . . that means Dead On Arrival.'[11] Like the voice-over in a 1940s crime film, Weegee's caption appears to provide a privileged entry into the urban, and yet nothing about the murdered man provides any detail on how he 'was left in the gutter'. In fact, the tag around his arm, reading 'D.O.A.', accentuates the anonymous nature of his death and the fact that it is his death and not his identity that is of interest to both Weegee and the people rushing towards his corpse.

In political terms, 'Their First Murder' is, of course, situated within very particular social and economic circumstances, but to a large extent these circumstances still pale in comparison with the sheer force of the children portrayed. The group dynamics point to something indescribable here, even if it is visualised by the camera's ability to capture moments of rapture, violence and pain. The ironic captions thus often mask a more emphatic purpose: namely, to query photography's ability to capture genuinely the essence of a specific place and/or time through Weegee's overtly subjective rather than journalistic insight. While it may be tempting to see in Weegee's photographs a form of love affair with the city's children, for example, such readings are constantly disturbed by his use of captions such as 'Their First Murder'.

Weegee's role, then, as private eye in a visual as well as a linguistic sense may mimic popular dime store novels and tabloid headlines but it also reflects the manipulative and didactic strategies employed by the photographer as voyeur in a perilous urban environment. These captions not only fundamentally direct the meaning of the images in specific directions, but also they diffuse what is essentially very uncomfortable viewing, bringing the act of representation itself to the forefront, despite the sensationalist nature of the content. Not coincidentally, one of the first documents reproduced in *Naked City* is a receipt from a newspaper in the form of a payment of $35 for photographs of two murders. The photographs shows a receipt in the amount of $35.00 from Time, Incorporated, New York.

Within the overall remit of *Naked City*, beginning with this image diffuses the possibility of a nostalgic or sentimentalised reading of the events to follow. More importantly, it immediately reminds us

that an economic transaction lies at the heart of Weegee's practice. In the images that follow the 'Murders' section, the sense of Weegee being emotionally distanced from the events photographed is accentuated by the fact that nearly all of the photographs are lit with a hand-held flashbulb – a cumbersome, loud and intrusive accessory that ensures no discretion on the part of the photographer. Thus, despite Weegee's alleged desire to become one with the subjects photographed, the use of a large hand-held flashbulb at some distance from his Speed Graphic camera, usually held around the neck at stomach level, not only would be immediately noticeable to those photographed, but also it would direct the subjects' gaze towards the flash rather than the lens of the camera itself. As such, the use of the large flash – not dissimilar to Margaret Bourke-White's use of flash in the darkened interiors of her Southern subjects – draws attention to the photographer's presence rather than vice versa. It also accentuates the sense of *Naked City* as, above all, a series of fixed images of life in motion, of people rushing towards or away from something, as the flash tends to darken the background, adding more contrast between the figures in the foreground and the buildings behind. The children rushing towards the victim in 'Their First Murder', a woman finding her boyfriend dead in a car crash, are all rendered through an aesthetic device suited as much to a forensics team as to a street photographer.

In this sense, the pictures, although recognisably realistic, tend to render people oddly unreal and ghost-like. By using the flash in the foreground, any attempt at rendering a more naturalistic-looking scene is dispensed with. For the French critic André Laude, such procedures are a deliberate aspect of Weegee's aesthetic, proof of his

> unique knowledge of darkness and gloom, an art of approaching the backside of things, of crossing through the looking glass, . . . a faculty of resurrecting death out of each particle of life . . . an obsession with rigor mortis, a grasp of the agony of being.[12]

Laude's commentary positions Weegee as an *enfant terrible*, oblivious to photographic niceties, in touch with the primal nature of the city and somehow existentially connected to its very being. On the one hand, such a reading is in keeping with Weegee's self-created persona as a connoisseur of 'the backside of things'; on the other hand, it aligns the fascination with 'darkness and gloom' with something

much more morbid: an 'obsession with rigor mortis' and 'the agony of being'. Pre-empting Roland Barthes's alignment between photography and our foreknowledge of death in a physical and metaphorical sense in *Camera Lucida* (1980), another French critic and writer, Pierre Mac Orlan, in 'Elements of a Social Fantastic' (1929), considered 'photographic knowledge of the world as cruel ... because the power of photography consists in creating sudden death'.[13] What Mac Orlan described as the photograph's ability to condense the uncanny correspondence between photography and death is precisely Weegee's speciality: in this case, eyewitness photographs of murder scenes. As Mac Orlan states:

> To be able to create the death of things and creatures, if only for a second, is a force of revelations. . . . It is thanks to this incomparable power to create death for a second that photography will become a great art. . . .[14]

This positioning of Weegee as a photographer in tune with the darker forces of human nature is also, for Mac Orlan, a way to connect the properties of the camera apparatus itself with its subject matter. For Mac Orlan, the 'priceless tool' of 'the photographic lens' is therefore particularly effective when used at night, as 'black and white, colours of night and principles of the photographic image, illuminate it with a fire as inhuman as it is intelligent. The camera's click suspends life in an act that the developed film reveals as the very essence.'[15]

Mac Orlan's focus on night photography aligns the properties of the camera, its illuminative capabilities, with Weegee's role as a form of detective, something echoed by André Laude, who sees Weegee as acting out 'his internal theatre in the night time streets of N.Y. with the spontaneous complicity of others unknown, anonymous people, hoodlums, misfits'.[16] This sense of complicity creates an art in which the detached eye of the camera provides only the illusion of distance. If 'private eye' is a euphemism for the detective as well as the photographer, the irony is that the photographer is never private but works in an exclusively public domain. Laude's analysis of Weegee as comfortable with 'hoodlums, misfits' aligns his photography with a pulp aesthetic in which the lines between reportage and fiction are often blurred. Weegee may have intended to illuminate the harshness of urban life but, according to Laude,

the overriding impulse in *Naked City* is a performative rather than an ameliorating one.

The issue, whilst partly to do with the ethics of documentary photography as a form of photojournalism, is also about what happens when the 'archetypal hard-bitten tabloid photographer' becomes a 'modern master of the art of photography'. As Allan Sekula points out in 'On the Invention of Photographic Meaning' (1975, reprinted 1982), 'We see this happening repeatedly. The anonymously rendered flash-lit murder on the front of the Daily News is appropriated by the Museum of Modern Art as an exemplary moment in the career of the primitive freelance genius Weegee.'[17] Sekula's choice of Weegee as an example of tabloid photojournalism in the service of art photography is apt in this respect, but as interesting is his use of the word 'primitive' to describe Weegee's practice, as though any overt professionalism would diminish the quality of his work.

The idea of primitive behaviour as an intrinsic part of the cityscape is certainly present in 'Their First Murder', where the angling of the lens, as well as the use of the flash, adds a sense of uncontrollability to the scene. The camera aim, slightly below the heads of the children, and the fact that we cannot perceive how close they are to the murder victim deny us an overview; we become accomplices to the frenzy portrayed rather than detached observers. The deliberately darkened background of the city – created largely by the flash – itself becomes a menacing backdrop for a violence accentuated by the absence of homes and recognisable thoroughfares.[18]

Upon closer inspection, Weegee's use of the flash, the predominance of the captions and the careful angling of the lens all directly impose on the aesthetic and political, as well as thematic, quality of his images. The use of the flash, in particular, accentuates the fact that a photograph is, in its essence, an emanation in terms of luminosity. In 'Their First Murder', the black and white contrast acts to give us a sense of division between the looked at and the onlookers, just as, on a basic level, it provides the pigmentation necessary for the image to appear in the first place. In fact, in Weegee's case, an intrinsically black and white aesthetic is born out the flash's ability to provide contrast as a main mode of representation. More importantly, the excessive use of flash also breaks with the 1930s tradition of photographic idealism outlined by Orvell. If the role of 1930s documentary photography, according to Orvell, was to sell a certain hopeful version of realism (notwithstanding Bourke-White's overtly

dramatic style), Weegee's version is very different. By letting the use of lighting be evident in the shot, the flash becomes instrumental in creating a particular form of 'realism' that, in a sense, is not particularly realistic. Flash photography, in this context, is not merely about capturing night time as a reversal of civilised daytime but is also a way to accentuate photography's ability to provide a glimpse of something that is both frightening and yet socially recognisable.

Playing around with preconceived notions of what childhood represents in terms of innocence and agency is thus just one of the themes in 'Their First Murder' and throughout *Naked City*. Even when children are not central to the narrative, the issue of who the actual victims are within *Naked City* is deliberately vague. As such, Weegee appears acutely aware that victimhood is as much an idea as an actual state of mind, something we can bestow as well as remove. Using children in photographs as tropes for a particular kind of innocence, and how this 'innocence' is acted out in spaces usually reserved for adults, say a great deal about subjecthood (and not merely that of children) in general. In 'Their First Murder', the faces of the children rushing to see the dead body are no more or less humane than many other portraits in *Naked City*. To augment this sense that identities are fluid rather than static, the architecture that surrounds Weegee's characters is often deployed to render a sense of performativity and play-acting rather than stability and security. The streets of New York – whilst clearly flanked by typical residential brownstones or shop-fronts – are never merely passageways between the private and public. They are always sites of observation and witnessing, places of tenuous protection and, as such, useful literal and metaphorical frames for human existence.[19]

The ascendency of Weegee in the post-war era as a photographer with a distinct 'look' is not, however, promulgated *only* on the fact that he appears to counter a 1930s documentary ethos. The way in which Weegee was and continues to be written about also demarcates the desire to define a certain type of photojournalism in artistic terms. Weegee's use of the flash, for example, may have been facilitated by the war period's advances in photography but the ways in which his prints are unleavened by tonal graduations and the conspicuous use of the flash are clearly a deliberate form of manipulation and not just done out of necessity. Encoding the image with the subjects caught off guard and 'naked', flash photography becomes a deliberate aesthetic choice for Weegee in ways

that it was not for Bourke-White in *You Have Seen Their Faces*. Put simply, the fact that Bourke-White's use of the flash is explained as being out of necessity, rather than aesthetic choice, is in itself a crucial difference.

Just how instrumental the flash is for 'Their First Murder' is discernible in the contrast between black and white. In 'the image, the flash appears to create a luminous face in the foreground, whilst leaving much of the surrounding upper field and background dark. Rather than isolating the children's movements, a continuous sense of implied movement is created, as though the group operates first and foremost as a tribal unit or a force of nature rather than a number of individuals. Likewise, the predatory nature of the observers is accentuated by a sense that space has been violated, and the close cropping of the image provides no edge, no frame to contain the events shown. By seeing the image of the onlookers before that of the actual corpse, we are allowed to focus instead on the urgent nature of looking and on the conflict between the different gazes.

Such manœuvres accentuate the fact that there is no unmediated relationship between the photographer and his subject. Weegee presents himself as a professional above all, a man whose mercantile relationship to the denizens of the city – regardless of whether they are dead or alive – is primarily commercial. Similarly, Weegee's images of corpses are – as seen in the caption regarding the D.O.A. – surprisingly detached from the gory subject itself. Thus, if *Naked City* begins with the promise of disclosure, the distancing ability of the camera as it confronts, amongst other things, unexplained death ensures that this never really happens.

This notion of absence – both on an informative level, journalistically speaking, and in terms of a full disclosure of the city – is a recognisable part of Weegee's aesthetic. Paradoxically, this may seem out of place in the work of a photographer who prides himself – as seen in his Introduction – on inclusiveness, his ability to capture a wide array of people from all walks of life. Nevertheless, some of the most disturbing shots of violence are precisely those that *do not show*, which, in a sense, belie the photojournalist's aim. As Alain Bergala points out in 'Weegee and Film Noir', it is often 'as if the equilibrium of the picture is waiting for something off-screen to enter the shot'.[20] Citing Weegee's taste for reverse shots and his tendency to diverge from traditional set-ups of crime scenes, Bergala believes that 'the chalk outline that describes the absence of the body' is indicative of

an uncanny alignment between the aesthetic of film noir and Weegee's urban vision.[21] The absent body can also be seen from a different perspective, however: that is, as a device that allows Weegee to focus on the act of looking itself.

To reintroduce Barthes would be pertinent here for, above all, Barthes's melancholic reverie vis-à-vis the photograph stems from having to look for those signs that appear not to be there. In other words, it is precisely the photograph that reluctantly gives away its clues, that hides them in unaccustomed places that contain the possibility of illumination. If Barthes confirms the importance of absence as a phenomenological trope within photography, Weegee's work in this respect both proves and disproves this. For Barthes, images of humans essentially mourn their absence, both past and future, rather than their presence, and yet Weegee's crowded frames give us an onslaught of onlookers, as opposed to conventional subjects. In other words, it is hard to decipher whose presence or absence we are meant to mourn as viewers. Likewise, if photography seeks to certify the presence of what is visible within the frame (whilst unavoidably pointing to its future disappearance), the presence certified in Weegee's case is ultimately that of the photographer: that and the body that cannot move, the corpse.

This is more obvious in the many photographs in which Weegee directly inserts himself, either by having a subject look directly at him or by having other photographers by proxy within the frame. The ostensible subject – the missing body of 'Their First Murder', for instance – tells only part of a story. Instead, Weegee banks on the dialectic between the actual content of the image and the often rather oblique cultural codes that surround that content. This is not to say that clues are not present in these images of children: they are poor, life is rough on the streets, and so forth. Nevertheless, the Dionysian aspect of many of the photographs, what makes them genuinely uncomfortable in terms of sheer aggressiveness, remains what we cannot comfortably explain. Why are some of the observers at 'Their First Murder' anguished and others joyful? Why are they in close proximity to a crime scene in the first place?

Again, what has generally been read as a realistic version of the *Naked City* could also be seen as an entirely subjective view of the 'mean streets' of both childhood and adulthood. Hence, the possibly psychotic behaviour of these children is not – as we would like it to be – the opposite of acceptable liberal culture but its apotheosis.

Weegee may be acknowledging that photography both duplicates the anxieties of an increasingly media-led culture, and condenses certain rituals and psychic processes inherent in that culture, but it is the ways in which we look at things that are paramount. Rather than provide a neatly cropped image of the scene of the crime, Weegee will, then, always opt for a heightening of the theatrics. The theatrical aspect is emphasised because the images focus so blatantly on crime as the modus operandi of a multiplicity of looks rather than a straightforward relationship between the photographer and the object, the perpetrator and the victim.

This is crucial, for it points to another disturbing aspect of Weegee's photography: the absence of a recognisable catalyst for the movement captured. If Weegee's urban representations, on one hand, fit into our ideas of crime fiction in the 1940s, they disturb what the more conscious documentary photography from the 1930s seemed to capitalise on: namely, a concern for its subjects. Even when the subject matter is recognisable enough, the way it refers back to an event that we will never know – who killed the small-time racketeer, who drove into the vagrant, for example – signals an uncomfortable absence: an absence confirmed by the lack of any detailed information in the accompanying caption.

Just as the exact predatory nature of Weegee's images is not clear-cut, neither is that of the captions. There seems, ironically enough, to be a nervousness contained within the highly charged captions, as though Weegee is afraid that readers may read a hidden agenda within them, as though they might read his bluff. In this respect, *Naked City* often over-determines the image retrospectively by adding a caption to give it meaning (rather than actual information). In this way, it appears to safeguard the image's thematic context from any accusations of deeper motives. Such procedures say something about the contemporary rhetoric of crime in the period, the photographer creating his own hardboiled persona, but an ironic caption is also a convenient way to distance the image from being overtly political. This does not mean, of course, as previously mentioned, that the images are apolitical: far from it. And yet, the aggression that Weegee, for example, insists is part of childhood could be read as both inherent and socially inflicted; the children could be read as ciphers of an innocence corrupted or an innocence that is simply non-existent. This is a major difference between Weegee and previous documentary material that focused on children as markers of

various societal ills. For Agee and Morris, for instance, childhood was a way to allegorise a lost state – both nationally and in more personal terms – whilst Lange's images of children at labour or visibly hungry are clearly meant to work as indictments of a social system gone wrong.

Because of these contradictions, Weegee tends not to be read as a social critic. Instead, he is likely to be seen as intuitive rather than intellectualising, a human interest photographer rather than a polemicist. In this context, comparisons are often made between Weegee and Diane Arbus (who staged one of the first major retrospectives of Weegee's work in New York). Nevertheless, the differences between them are telling. Although both are preoccupied with documenting the uncomfortable, the awkward, with Weegee it is the moment, rather than the portraiture of pain, that interests him. Caught in extreme situations, Weegee's victims never appear grotesque; what is grotesque are the situations occurring in front of us, on the streets, in front of cinemas, rather than the people involved.

In similar terms, Weegee's obsessions with the notion of culpability in the photographic process itself make for a very different form of portraiture: a portrait, in a sense, of the photographer at work. The mug-shot, as mentioned before, is disconcertingly close to being as succinct a definition of Weegee's expertise as any. Again, it seems crucial that the image of a receipt for 'two murders' is positioned early on in the overall sequence of the photo-text.

The fact that Weegee's portraits of the city constantly return to death becomes, then, one way to align the photograph's spectrum, to use Barthes's phrase, with Weegee's favourite subject matter. As Barthes argues, the spectrum 'contains, through its root, a relation to "spectacle" and adds to it that rather terrible thing which is there in every photograph: the return of the dead'.[22] The horror at hand here is the alignment, of course, between the 'return of the dead' and those acting as witnesses to this 'return'. We have, then, something infinitely bleaker: a spectacle in which the arrested subject (dead or alive) coincides with that of the people in *Naked City*. These are often people occupied with the frenzied intent of 'seeing', whether it be accidents, criminals or the exposed underwear of girls in the cinema – another unsavoury mainstay of Weegee's voyeuristic aesthetic. In its double meaning, the arrested subject is thus the criminal, the corpse and those criminalised by their environment, as well as the frozen moment of the image itself.

Photography thus shares the innate qualities of the spectacular, the theatrical and the deadly. Nevertheless, Weegee does a great deal more than simply make personal tragedy fit for public consumption by photographing it. Weegee's astute sense of photography as a commentary on seeing, and the ways in which he employs written captions to reflect on voyeurism and documentary aesthetics on a wider level, cannot be divorced. Contrary to the argument that *Naked City* is about the indifference and, at times, the rage that inhabitants feel towards other inhabitants in urban environments, the photo-textual devices in *Naked City* argue for something more akin to a type of calculated chaos in which the use of writing – both within and external to the image – points to the precarious co-existence of humanity. It is, then, about spectatorship as subject, but also about paying homage to the city's violent dynamism in the form of an unmediated desire to look. This means that, in Weegee's New York, the social bond is an extremely tenuous, unreliable one; the looks we are presented with, often within the same frame, oscillate, after all, between fear and tenderness, joy and anguish. What makes the images harrowing is the consistent way in which this violence is 'looked for' and then accentuated in the faces of those portrayed.

It is precisely because Weegee's locations and thematics are conveniently over-determined that we can begin to discern the more complex procedures enacted in the photographic process itself. In this respect, Weegee's commentary on voyeurism aligns itself conveniently to a critique of news photography's predisposition towards violent images: perhaps too conveniently. The violence in the faces of the children in 'Their First Murder' is Dionysian in its excessiveness. Thus, the violence of these images is not so much the subject matter, but the image's ability to fill the sight by force with something that cannot be transformed or refused. Weegee's photographs confront the viewer with something that, in its essence, cannot be disavowed. In this context, the deliberate use of the flash is more than just another way to question a crucial part of the vocabulary of tabloid photography. Together with the flash effect, Weegee's captions accentuate the inevitable loss of neutrality that occurs when a photograph is taken. We may want to believe in the photograph's ability to discern an unmediated reality but in *Naked City* this is impossible.

In the end, *Naked City*'s strength relies on the text's relationship to the images, and it is this that ensures the self-reflexive nature of

the book. Weegee took the subject matter of urban photography and turned it in a markedly more contemporary direction, collapsing the boundaries between journalistic objectivity and authorial manipulation. We can trace a post-war cynicism in operation here, but the desire to become one with the subjects photographed was a fundamental part of the photo-textual projects of the 1930s as well. This collapse between the objective nature of the camera and the subjective nature of the writing is fundamental to all subsequent photo-textual collaborations of the post-war era. As the paranoia of the Cold War began to have an impact on the rhetoric of social betterment that had pervaded the pre-war period, photo-textual collaborations became more rather than less oblique in their use of politics and ideology. In the following chapter, an example of a photographer trying to trace the meaning of American democracy through a 1930s documentary aesthetic in a post-war context proves just how problematic this can be.

Notes

1. Arthur Fellig (also known as Weegee), *Naked City* (New York: Da Capo/Essential Books, 1945), p. 11.
2. Arthur Fellig, *Weegee: The Autobiography* (New York: Ziff-Davis, 1961), p. 7.
3. See: William Hannigan, *New York Noir: Crime Photos from the Daily News Archive* (New York: Rizzoli, 1999).
4. Weegee, *Naked City*, p. 195.
5. Ibid., p. 196.
6. Ibid., p. 206.
7. Ibid.
8. Ibid., p. 232.
9. Miles Orvell, 'Weegee's Voyeurism and the Mastery of Urban Disorder', *American Art*, 6:1 (Winter, 1992), pp. 18–41.
10. Weegee, *Naked City*, p. 86.
11. Ibid., p. 87.
12. André Laude, 'Introduction', in *Weegee* (London: Thames and Hudson, 1989).
13. Pierre Mac Orlan, 'Elements of a Social Fantastic' [1929], in Christopher Phillips, ed., *Photography in the Modern Era – European Documents and Critical Writings, 1913–1940* (New York: Aperture, 1989), p. 32.
14. Ibid., p. 32.
15. Ibid.

16. André Laude, 'Introduction'.
17. Allan Sekula, 'On the Invention of Photographic Meaning', in Victor Burgin, ed., *Thinking Photography* (London: Macmillan, 1982), pp. 84–110, p. 91.
18. In his autobiography, Weegee tells of his use of contrast in the developing process as a way to 'whiten' the faces of the poor immigrant children he used to photograph. Weegee quickly realised that a slightly altered racial image would sell to those parents for whom the buying of a photograph represented a gesture of upward mobility and integration.
19. In other famous Weegee shots the doorway is a tenuous home for vagrants and bums, nearly always a precarious meeting point and a far cry from the architecturally majestic or melancholy frontage of, say, Walker Evans or Berenice Abbott.
20. Alain Bergala, 'Weegee and Film Noir', in Miles Barth, ed., *Weegee's World* (New York: Little Brown & Co., 1997), p. 23.
21. Ibid., p. 76.
22. Roland Barthes, *Camera Lucida*, trans. Richard Howard (London: Vintage, 1993), p. 27.

PART III
THE 1950s

Ideology, History and Democracy in Paul Strand and Nancy Newhall's *Time in New England* (1950)

In 1950, the publication of *Time in New England*, a collaborative venture between the photographer Paul Strand and the writer, critic and curator of photography Nancy Newhall, was met with little critical attention. Despite Strand's existing reputation as a photographer, *Time in New England* (abbreviated as *TINE* in the following) was seen largely as a quaint homage to New England life, a coffee table project rather than a complex exercise in photo-textual collaboration. As Alan Trachtenberg puts it in his Introduction to *Paul Strand: Essays on His Life and Work* (1990), the pairing of landscapes and portraits of local inhabitants with a cross-section of historical and fictional accounts of New England from 1630 to 1950 seemed to present a relatively straightforward 'concept of New England rectitude, individualism, and perseverance'.[1] None the less, *TINE* not only constitutes the first in a series of photo-textual projects instigated by Paul Strand, but also marks the beginning of a more complex interaction between documentary photography and the use of captions and text as a way to create particular narratives. Rather than use text as an explanatory device designed to 'explain' or steer the illustrative material, *TINE* utilises a carefully edited selection of previous writing to provide a specific backdrop to Strand's photographs. In another setting, and with other forms of writing, Strand's beautiful measured shots of New England architecture, local inhabitants, flora and fauna might have provided a predominantly historical overview of a region. Instead, Nancy Newhall's chosen textual extracts both overtly and obliquely turn Strand's photographs into a discourse on what democracy may mean for America as a nation beyond the regionalism of New England.

In addition, *TINE*, or rather the concept of New England that it provides, whilst in keeping with an idea of the region as the cradle of American democracy, also operates as a critical, and even potentially subversive, commentary on US post-war politics. If Weegee's versions of life on the streets of New York were manifestly for and about the people, and thus political in terms of their very subject matter, for Strand, and for Nancy Newhall, *TINE* was more than an attempt to synthesise images and writing into a coherent narrative relating to a specific place and time. For them it was a way to re-examine – in a time of increasingly domestic political strife – the unresolved schisms and fractures within that narrative. Similarly, even though Strand's photographs, at first sight, appear to be primarily timeless images of locations and people from New England devoid of any political context, the intersections between text and photography tell a different story.

The book is structured in four parts, part one dealing with the first settlers, the second the revolutionary period, the third Abolition and Transcendentalism, and the fourth nineteenth- and early twentieth-century responses to New England. As such, it moves from the original settlers, with their religiosity, superstitions and attempts to set up a workable society (William Bradford: 'Arrival Plymouth November 1620', facing an image entitled 'Storm and Sea'), onwards to civil strife, disobedience, slavery and suffrage (Margaret Fuller: 'A Man's Ambition with a Woman's Heart', preceded by an image entitled 'Dried Seaweed') to the book's very last image, prefaced by Van Wyck Brooks's 'New England: Indian Summer' (1940), in which Brooks concludes: 'Americans had a stake in New England . . . as a palladium of truth, justice, freedom and learning.'[2]

The texts, ranging from affidavits from the Salem witch trials to John Winthrop's diary entry, were chosen and edited by Nancy Newhall and set up adjacent to the photographs. Although the extracts appear to complement the subject matter of the photos, they also constitute a counterpoint to Strand's images in ideological terms. If the subjects photographed by Strand seem primarily to be a series of symbolic landscapes, replete with church steeples and fallen tombstones, other images – landscapes of looming clouds and close-ups of the local flora and fauna – do not immediately present themselves as indicative of or relating to the iconic nature of the accompanying texts. Added to this is the fact that, with over ninety photographs and more than a hundred textual extracts, the

juxtaposition between the static images of buildings, plants and inhabitants and the textual evidence of an often violent American history is far from transparent. If New England symbolised the cradle of democracy for many Americans, the narrative presented here seems to capitalise on this and to question it simultaneously. In fact, at regular intervals throughout the book, anecdotal material detailing Indian massacres, cruelty to runaway slaves and the horrifying narratives of witch hunts markedly set themselves apart from the placid images. If anything, it is as if the chosen extracts counter the visual iconography of Strand's photographs. The darkened tombstones and the faraway gazes and static postures of the inhabitants show them as calm and ennobled, rather than as the inheritors of regional strife and violence.

A paradox is thus at work in *TINE*. On the one hand, the book clearly does not function as a well-illustrated travel guide through the history of New England, just as Nancy Newhall's chosen extracts cannot be read simply as a collage of famous New England writings. On the other hand, in political terms, the inscription of a democratic heritage into the very fabric of New England is far from ideologically transparent. If William Carlos Williams and Lincoln Kirstein sought to define Walker Evans as a photographer capable of rendering the essential nature of America through a particular iconography – from vernacular architecture to home-made implements – Strand's images of similar subjects point to just how problematic this iconography had become by the end of the 1940s. This does not mean that the concept of democracy is not present in *TINE*, simply that the persistence of the native, of the indigenous and the local, takes on added meaning when it is paired with writing spanning several decades and a multitude of voices. In this sense, *TINE* continues the tradition that we have seen previously of aligning the vernacular voices of local inhabitants with images of their surroundings, but it refuses to restrict the documentary format to one genre or period. Gone is the insistence on the familiar and the domestic, as seen in *Let Us Now Praise Famous Men*, or the tracing of a recognisable path by a particular group of people, as in *American Exodus*. The voices we encounter, through diaries, poems, letters and other documents in *TINE*, are all indicative of their relationship to New England, but at the same time, they indicate wider national issues. In other words, the documentary premise is widened in ways that are very different from a pre-war

documentary aesthetic, and Strand – whilst capitalising on those traditions – is also circumventing them.

This complicates any claims that *TINE* is simply an arena for a particular form of realist photography or that it constitutes a straightforward extension of what critics usually focus on: that is, Strand's leftist politics of the 1930s. Unlike Strand's critique of domestic politics in films such as *Native Land* (1942) and *The Plow that Broke the Plains* (directed by Pare Lorentz, 1936), *TINE* is a much more subtle investigation into the hopes and aspirations of a nation caught between a pre-war belief in collective democracy and post-war anxieties concerning the erosion of civil liberties. If Weegee's version of New York appeared to circumvent these concerns through an obsessive focus on crime and disaster in the here and now, *TINE* uses the New England vernacular as an ideological and aesthetic mechanism capable of rendering something distinctly timeless. In other words, crossing the border between the textual and the visual is not meant to question the value of documentary photography; on the contrary, it consolidates its value as something more than simply an informative tool.

Thus, if *TINE* did not provide a comforting 1950s vision of New England as the cradle of democracy, it compensated for this through its use of the vernacular, in the voices of the New Englanders and the 'look' of their surroundings as a fundamentally lyrical version of America. The presence of the vernacular is also there in the tenor and urgency of this lyricism, rather than in the use of certain colloquialisms or patterns of speech, as seen, for instance, in *You Have Seen Their Faces*. Again, this makes for a very different type of exercise. As in Morris's *The Home Place*, the textual extracts in *TINE* impose various meanings on the photographs, but these meanings are more oblique, less governed by a type of narrative impulse. Compared to the tone of voice rendered in the Nebraskan photographs, the stress here is on extracts of writing by famous New Englanders, not the anonymous farmer or farmer's wife. In the section entitled 'Foothold', two extracts from Captain Edward Johnson's 1654 *Wonder Working Providence of Sion's Saviour* bookend the image of a latch on a wooden door (Fig. 7.1).

The photograph of the latch, an item nearly unchanged from the fifteenth to the twentieth century, is cropped to foreground the simplicity of the mechanism itself. Unlike in similar architectural studies in *American Photographs*, where Walker Evans is equally

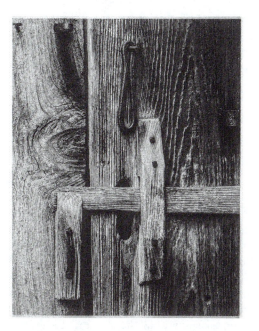

Fig. 7.1 'Latch', Gelatin silver print, 1944, in Paul Strand and Nancy Newhall, *Time in New England* (New York: Aperture, 1980), p. 39. The Paul Strand Collection, Philadelphia Museum of Art, Accession no. 1969-83-23.

fascinated by the vernacular aspects of façades, artisanal decorations and other indicators of craftsmanship and local labour, the meaning of Strand's latch appears more symbolic largely because of the accompanying text. In the latter, an extract from Johnson's diary describes Boston as 'the center town and metropolis of this wilderness' and yet it is on 'constant watch to foresee the approach of foreign dangers'.[3] The latched door thus connotes both a barrier against the presence of the wild in historical terms, and a more contemporary desire to close off the region, to bar it against foreign and undesired influences. In this instance, despite the photo-text's occasional use of homely allegory, seascapes often accompany narratives of journeys, for example, the alignment provides a more complex vision of the book's agenda. Rather than chart the progressive nature of democratic values, such images seem to question, if not directly contradict, it. In the example of the latched door,

the approach of foreign dangers – whilst historically reasonable in 1654 – also operates as a reminder of the anti-leftist anti-foreign rhetoric of the post-war era.[4]

If *TINE* questions the problematic reliance on a visible connection between democratic values, as set out in Newhall's textual extracts, and Strand's photographs of a more 'timeless' New England, it is also an investigation into the use-value of documentary photography itself. How do Strand's photographs maintain a potentially reductive version of New England as the cradle of American democracy *and* render it a distinct living regional location? And how does the fact that the camera places itself both in opposition to – and with – the textual material make us read Strand's use of 'time' in New England? Of course, the title *Time in New England* indicates a deliberate conflation of the regional and the photographic, but the conflation is so obvious, in a sense, that the connection is often overlooked. By referencing the vernacular and the photographic, 'time' in New England is an essential component both in exposing the 'essence' of New England and in the mechanical process of photography itself. In other words, it is not just politics but 'time' itself that reflects *and* inflects its regional subject. In these terms, the integration of text and imagery, rather than illuminating the book's aesthetic and philosophical undercurrents, also questions the mimetic qualities and purposes of the camera itself.

To look at *TINE* as a book about the mimetic properties of the camera does not, of course, preclude a consideration of the project in political and historical terms. As indicated in the image of the latch, numerous photographs can also be read as post-war responses to the trauma of fascism in Europe, establishing *TINE* as an attempt to – amongst other things – confirm the idea of America as a haven for democratic principles in an increasingly volatile political climate. It is not coincidental that in 1950, the year *TINE* was published, Strand was driven out of the USA because of increasingly aggressive right-wing politics. None the less, in reviews of the time, *TINE* was seen predominantly as a clear-cut confirmation of America as a site for democratic principles. Thus the importance of regionalism as an *internal*, as well as external, landscape was used primarily to bolster New England as a site of honour, rectitude and perseverance, rather than as a way to articulate ideological anxieties about the state of America on a larger scale. In this context, *TINE* not only responds to the

anti-leftist sentiment of the post-war years, but also constitutes an investigative process – particularly by Strand – into the limitations, as well as possibilities, of the documentary aesthetic in a post-Depression era.

John Rohrbach's '*Time in New England*: Creating a Usable Past' links the structure and concerns of *TINE* with Strand's earlier projects, such as his film *Native Land* (1942), a mixture of documentary and staged footage about labour unrest and racism, and, according to Rohrbach, about the importance of 'free and open dissent' as 'the core of American democracy and moral culture'.[5] Rohrbach's reading of *TINE* as essentially an ambitious commentary on the 'fortitude central to New England's settlement' none the less underestimates the importance of the schisms between the textual material and the images. Rohrbach argues that the images, presenting a predominantly 'symbolic' landscape rather than 'specific places', 'become metaphors for the surrounding text', designed to synthesise a vision of New England as a site for freedom – contested, but a site for freedom none the less. By indicating that a form of restitution and, indeed, containment is delivered, Rohrbach's notion of the photo-text is as something neatly homogeneous. However, in Strand's Foreword to *TINE*, 'the freedom of the individual to think, to believe, and to speak freely was' – according to Strand –

an issue fought out here more than once. ... Men gave their lives in the struggle against political tyranny, and when it took courage to speak out against human slavery ... and the threat of mob violence, they spoke out. ... It was this concept that ... gave the clues to the photographs ... and brought them into relationship with the text.[6]

Strand's commentary, whilst about a certain American idealism, unity and coherency, is, on a more oblique level, also about the outward manifestation of an inward movement: a movement spurred on by ideology as much as by historical necessity. Not only does this movement begin in the seventeenth century, emphasising the original settlers, but also it introduces a theme that, in several ways, links the collaboration to previous photo-textual interactions. In *TINE*, the concept of a transcendental faith and its resulting cultural and literary tradition is established from the outset as a fundamental part of the landscape of New England and the voices that inhabit that landscape.

Extracts from Emily Dickinson, Herman Melville, Nathaniel Hawthorne, Cotton Mather and Jonathan Edwards are all infused by a faith configured in transcendental terms. Despite the book's mixing of genres, the use of travelogue, historical narrative and factual documents, the overall gist is that a Transcendentalist ethos binds these various voices together. By moving from more overtly Puritan doctrine to later Transcendentalist thought, Newhall, in particular, seems to re-establish the foundations of American culture, religion and philosophy in one place: New England.

The artistic remit for the project, according to Newhall, supports such a reading: a reading that, in numerous ways, echoes that of Lincoln Kirstein and William Carlos Williams in relation to Walker Evans. In Emersonian terms, the linking between the thing seen and its most accurate linguistic representation lies not in ornate language or sophisticated metaphors but in the creation of alignments both believable and true. In a section entitled 'EBB' in *TINE*, Emerson is quoted directly: 'It is the age of severance, of disassociation. . . . Instead of the social existence, which all shared, was now separation.'[7] In many respects, Newhall's task is thus to prove the persistence of the opposite in New England, a vision of a region that still carries something integral to American culture, even if 'separation' rather than 'social existence' now permeates. This desire to establish a safe haven of sorts in a domestic and regional sense is something that permeates *Let Us Now Praise Famous Men* as well, although in *TINE*, according to Newhall, the historical thrust of the project supersedes that of any political critique. According to Newhall,

> Neither of us was looking for illustrations. Independently, following the twists and turns of our material, we set out for our common goal, the definition of the New England spirit. . . . We wanted an integration so complete that either medium could state or develop a theme. The emotional and intellectual clarity of each passage was our goal. . . .[8]

Newhall's desire for emotional *and* intellectual clarity, like the Transcendentalist idea of transparency *and* immediacy, requires a compelling connection between the photographs and the textual extracts. Even if those connections are far from obvious, Newhall is none the less aiming for a sense of complete integration between text and image, a concept she named 'the additive caption' in an essay entitled the same:

In the Additive Caption, the basic principle is the independence –
and interdependence – of two mediums. The words do not parrot
what the photographs say, the photographs are not illustrations.
They are recognized as having their own force. . . . The additive
principle at this stage looks like a whole new medium in itself. Its
potential seems scarcely explored, like a continent descried from
a ship.[9]

At first sight, Newhall's use of 'independence and interdepend-
ence' simply describes text and imagery as distinct and yet symbioti-
cally aligned. Nevertheless, setting up her collaboration with Strand
as an exploratory one, in line with that of the Pilgrims embarking
on a voyage to a new continent, Newhall also signals an almost reli-
gious enterprise at the heart of the project. In her Editor's Foreword,
Newhall writes:

Could language – not captions, nor the usual pseudo-poetic
phrases, but language intimate, alive, and often of real intensity,
extend and clarify the condensed meaning of these photographs?
Even more important, could words and images from different
authors in different periods become an integral whole? The temp-
tation was irresistible.[10]

With Newhall's description of the irresistible temptation of abol-
ishing conventional captions and 'pseudo-poetic phrases', having
little sense of the 'political tyranny or mob violence' referenced in
Strand's Foreword, she thus renders *TINE* more of an aesthetic than
a practical exercise. And yet, reviews such as the *Boston Sunday
Post*'s 'The True Christmas Spirit Survives in New England' placed
its emphasis not on the novel use of text and images, but on New
England as the 'symbol of spiritual hardihood'. In such reviews, the
focus is not so much on the experimental nature of the relationship
between image and text, but on New England itself as a place where
a 'precious loveliness has been captured'. In this context, the struc-
ture of the photo-text is left aside in favour of a sentimentalised
reading of the regional affiliation of Newhall herself:

None of the pictures is captioned, and Nancy Newhall's text
consists entirely of original documents – letters, poems and dia-
ries, all the way from governor Bradford to Robert Frost, with
lots of little people in between. Nancy is a New England girl,

born in Swampscott and educated in Boston and at Smith College. Paul Strand is one of the three or four greatest living photographers. Here . . . the faces of New Englanders . . . are carved out of granite. . . . In their eyes is eloquence no pen can express; in their features is the kind of courage Americans need today.[11]

Emphasising the native credentials of the book and Newhall as a born and bred 'New England girl', the review asserts that the book contains the courage that 'Americans need today' (a reference to the Cold War) and a stoicism 'carved out of granite' like the presidential faces at Mount Rushmore. The fact that 'little people in between' have been included indicates that, despite its lofty purpose, the book takes an emphatic and human approach. Here is a work, in other words, with a recognisable iconography; an impression of a New England as welcoming prevails.

The sense of New England as a refuge of sorts could, then, be seen as a result of Newhall's toning down of the more radical implications of the Puritan legacy, the very implications foregrounded in Strand's Foreword to the photo-text. However, in Newhall's original version of the Introduction, later changed for publication, a sharper tone regarding New England politics is in evidence. Here Newhall makes the direct link between the politics of previous generations and post-war anxieties by stating:

The source of New England character lies in the seventeenth century – in the puritan, arch revolutionary and archconservative. It lies in . . . family and the burning immediacy of god (or truth, or liberty, or his own special revelation). . . . Again and again in his humanity and his inhumanity he is born into the centuries, . . . called forth as persecutor and apostle by issues essentially unchanging – hanging of Quakers or electrocution of Sacco and Vanzetti, rebellion against Britain or crusade against slavery.[12]

In contrast, the later published version takes a decidedly softer approach:

The source of New England character lies in the seventeenth century. But the great music of seventeenth century prose that led pilgrim and puritan across the ocean and sustained them in

the wilderness was for our ears choked by obscurities and redundancies. Yet in those cadences was the sound of the sea and in their thought the germ of a nation. The sound of that lost time was essential; so were the brisk, bright marching tunes of the Revolution and the dark-bright music of America beginning to sing in its own voice in the nineteenth century.[13]

When the two versions are compared, Newhall's original stress on the revelatory nature of New England, in terms of both humanity' and inhumanity, persecutor and apostle alike, is the darker one. By omitting the 'hanging of Quakers' and the electrocution of political prisoners, and instead focusing on the 'brisk, bright marching tunes of the Revolution', an undeniably more patriotic version emerges. This is not to say that all contemporary reviews were entirely oblivious to the presence of a more complex narrative. For instance, according to the *Christian Science Monitor*:

> The book is roughly chronological in concept; with headings and subheadings; almost one might say plots and subplots; Wilderness, Savages, Witchcraft, Revolution. And later, Hill and Town, The Sea, Protest, Abolition, Ebb, and ultimately, Affirmations. Puritanism merges imperceptibly into rationalism, rationalism into 'the age of severance, of disassociation, of freedom, of analysis, of detachment' (the description is Emerson's). . . . If the text then tells of the past, the dirt-root past as well as the flowering, the photography tells us of the past in the present.[14]

Unlike Owens's review, Chapin's acknowledges a link between the layout of the book and its thematic approach. It also acknowledges the idea of *time* in New England as having a philosophical as well as constructive purpose, of essentially being a way for photography to '[tell] us of the past in the present'. More importantly, Chapin links the Puritan legacy to a wider philosophical lineage in which the merger between Puritan ideals and American rationalism mutates into a desire for freedom: a freedom distinctly described – as in William Carlos Williams's writing on Evans – in Emersonian terms. Chapin's demarcation between the tasks of the text and that of the images is perhaps a bit too neat, but it indicates *TINE*'s potential as a sort of secular scripture that carries the emotional resonance of the past into the future. Acknowledging how 'Puritanism merges

imperceptibly into rationalism', Chapin acknowledges that the book's genuine agenda may be the tracing of a wider ideological history as much as a regional one.

Indeed, the layout of *TINE* provides a sense of the complex arrangement that in ideological terms indicates the complex history of American democracy: Part I has seven different sections, starting with 'New World' and ending with 'Witchcraft'; Part II has three sections, starting with 'Native Earth' and ending with 'Revolutions'; Part III has five sections, starting with 'Hill and Town' and ending with 'Abolition'; and Part IV has three sections, starting with 'EBB' and ending with 'Affirmations'. Despite a potentially uplifting trajectory, Newhall's subheadings are extremely messy if one takes her edict, that the additive caption 'extend and clarify the condensed meaning of these photographs', as a ground rule. For example, the 'Protest' section contains a selection of Thoreau's freedom manifestos and Susan B. Anthony's 'Rights of a Woman', and yet the sense of political urgency is diffused in the following 'EBB' section, in which Emily Dickinson's funeral coincides with Robert Frost's melancholy poem, 'An Old Man's Winter Night'. In this sense, *TINE* – as indicated in the sub-captions – is governed by its own ebb and flow, by a sense of flux that complicates a reading of the text as straightforwardly progressive.

If narrative and historical continuity is less seamless than it first appears, the ideological fissures within the sequencing of the textual extracts illuminate how Newhall – despite her own protestations – also had a vested interest in the political aspects of *TINE*. Although Newhall's position in terms of the House Un-American Activities Committee – the organisation charged with exposing so-called communist sympathisers during the period – was less volatile than that of Strand, her immersion in the New York Photo-League, later targeted because of its alleged leftist sympathies, meant that she was also under examination. During World War II, Newhall's more famous husband, Beaumont Newhall, the curator of photography at MOMA who was responsible for Walker Evans's 1938 show and the eventual publication of *American Photographs*, was ousted from his position. This was taken over by Edward Steichen shortly thereafter. Beaumont Newhall's autobiography, *Focus: Memoirs of a Life in Photography* (1993), elaborates on the political machinations behind his ousting in 1945, and tells of the museum's reluctance to allow Beaumont to curate officially with his wife Nancy, despite the fact that she had effectively been in charge whilst her husband was in the army.[15]

In this respect, *TINE* responds to a changing of the guard in the photographic establishment of post-war America and it indicates Nancy Newhall's desire to pursue projects outside of the museum environment, to cement her position as a proponent of photography, irrespective of institutional support.[16] Whether Newhall's investment in the publication of the book meant that she downplayed any overt criticism of American values is hard to gauge. Newhall may have felt that she, too, was a potential victim of current antidemocratic forces. Bound by her role as the editor/facilitator of *TINE*, Newhall also had a somewhat different role from that of Strand, whose reputation was firmly established. In an essay written four years earlier for the catalogue *Paul Strand: Photographs, 1915–1945*, Newhall – who had not yet persuaded Strand to do the project – none the less introduces some of the images that will later appear in *TINE* and more specifically describes how Strand's images speak to a more complex vision of the region:

> Where generations of painters and photographers have found only the superficial and the picturesque, Strand reached into the essence of New England. The shuttered white church stands on patches of snow like the terrifying grip of an ideal. In the worn doorlatch, the tar paper patch, the crazy window among rotting clapboards, appear the ancient precision and mordant decay of New England.[17]

The 'terrifying grip of an ideal' and 'mordant decay' of New England signal the presence of several tropes that will reappear in *TINE*: tropes that partially explain the melancholy nature of Strand's photographs. It is a testament to Strand's expertise that he can take objects such as the modest decoy duck, whose unassuming demeanour is matched by its sparse background, and make it synonymous with a particular vision of New England life. Such an object appears at first glance as the antithesis to earlier Strand images from the 1920s, in which Machine Age objects, such as Strand's own Akeley camera, pay homage to photography's place within modernism more generally. In *TINE*, however, architectural decorations, furniture and tools appear animated precisely because of their pre-industrial vernacular context, because of their 'ancient precision' – as Newhall puts it – and not despite it. Thus, the objects, implements and vernacular ornaments, contrary to the Machine Age objects of modernism, signify not only handicraft and singularity of design,

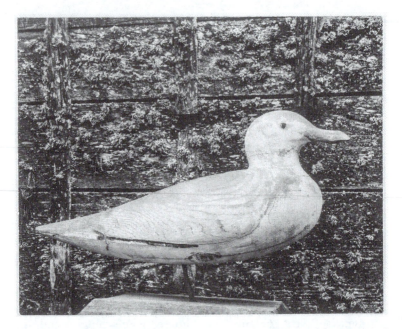

Fig. 7.2 'Decoy', Gelatin silver print, 1946, in Paul Strand and Nancy Newhall, *Time in New England* (New York: Aperture, 1980), p. 29. The Paul Strand Collection, Philadelphia Museum of Art, Accession no. 2010-14-139.

but the passing of time as well. To enable this, objects in *TINE* are photographed more as conventional portraits; the decoy presents itself with some pride, the tombstone with a sense of purpose. The upward angle gives many of the subjects a nearly heroic quality, as though they too – like the original immigrants to New England – are survivors from an earlier time (Fig. 7.2).

While the 'heroic' quality of certain vernacular items can be traced back to Evans's use of objects in *Let Us Now Praise Famous Men*, here they rely heavily on their aesthetic qualities in a slightly different way. These qualities – political as well as aesthetic – are not simply regional; if they signify an unmistakable American individualism, it is because they come across as survivors, as valuable objects despite the passing of time.

Residing somewhere between melancholy resignation and an affirmation of American values, it is no wonder, then, that *TINE* occupied unfamiliar territory and therefore did not do very well.

Despite the outward narrative of progress and democracy, a poten-
tially uncomfortable narrative of colonisation can be read between
the lines: a narrative that might have put off patriotic readers at
the time. Strand had lived periodically in New England but *TINE*
is also a book that navigates Strand's own integration into a land-
scape both familiar and alien to him. The issue is not necessar-
ily that Strand considered himself another 'settler', simply that he
considered the Puritan experience as an antecedent for something
quintessentially American. Like the original settlers, Strand is also
engaged in a struggle to integrate and appropriate foreign terri-
tory – albeit photographically. In this respect, it makes sense that,
despite the affirmative value of many of the textual extracts, other
excerpts indicate a long history of internal strife, from the subjuga-
tion of Native Americans to the return of runaway slaves. While
such histories are blatant examples of the effects of a ruthless colo-
nisation, other extracts throughout *TINE* – the self-effacing poetry
of Dickinson, Melville's anxious letters to Hawthorne – are more
subtle examples of self-doubt and fear. If the desire to appropri-
ate territory is a fundamental part of New England history, the
inevitable anxiety that accompanies it – *TINE* seems to say – has
both regional and psychological ramifications. By choosing New
England as his American swansong before permanently moving to
Europe, Strand thus both implicates and distances himself from the
profoundly ideological ramifications of appropriation and coloni-
sation on a wider level.

It is no coincidence that Strand will later choose a series of loca-
tions for his collaborative photo-texts, such as the Hebrides in
Tir a'Mhurain (1962), *Ghana: An African Portrait* (1976) and *Living
Egypt* (1969), for whom a colonial past colours the present. In *Un
Paese: Portrait of an Italian Village* (1955), Cesare Zavattini's inter-
views with the locals contextualise Strand's photographs, linking the
issue of regional identity directly to a collective history of territorial
strife.[18] The fact that Strand's photographs of the people marked by
these events seem strangely placid in the face of historical turmoil and
aggression none the less says as much about his own limitations as an
ethnographer as it does about his abilities as a photographer. Despite
Strand's self-professed interest in the politics of documentary pho-
tography, his tendency to render his subjects as universally dignified
and timeless in their beauty inevitably places certain restrictions on
the images as complex ethnographic studies. Even though Strand had
an uncanny ability to collaborate with writers conversant with the

culture portrayed, the regional studies remain problematic in terms of what may or may not constitute documentary verisimilitude.

If ethnography is not the chief impetus behind *TINE*, a type of photographic colonisation is yet present, and it provides an additional and crucial link to the legacy of seventeenth-century immigration signposted throughout. With its overly Puritan contextualisation of a region and its people, *TINE* is also a narrative about finding oneself metaphorically in the wilderness. If we take the colonising effect of photography as enabled by the appropriation of its subject matter, by the reorganising of places and people in terms of typography and sections, *TINE* itself continues a process that goes back to the originators of the American dream centuries before, despite the fact that it visually owes a great deal to the modernisation of documentary photography in the twentieth century. Likewise, while the Transcendentalist desire to merge the thing seen with its proper name and designation is given a distinctly visual angle in *TINE*, it is also a marker for a more subtle form of appropriation, a linguistic version of the documentary impulse that Strand was familiar with: the impetus to own one's surroundings by naming and photographing them, as witnessed in several of the earlier photo-texts charted here. In this context, the belief that underpins *TINE* – namely, that an essential quality in ideological terms can indeed be captured through visual means – shares a great deal with both *American Photographs* and *Let Us Now Praise Famous Men*. James Agee may have approached the issue of documentary truthfulness with more trepidation than both Strand and Newhall, but the impetus behind *Let Us Now Praise Famous Men* shares a fascination with how the immediate and the everyday signify larger national concerns. What links *TINE* with something like *Let Us Now Praise Famous Men* is the fact that Strand's response to the environment is always both social and in large measure philosophical.

In Part III of *TINE*, 'Fine Auroras', an Emerson quotation combines the lyrical qualities of the vernacular with a more philosophical outlook reminiscent of Agee's ruminations in *Let Us Now Praise Famous Men*. Here, Emerson articulates how the urge to name and identify is linked, as always, to nature and place:

> Adam in the garden. I am to new name all the beasts in the field and all the gods in the sky. I am to invite men drenched in time to recover themselves and come out of time, and taste their native immemorial air.[19]

Emerson's invitation to 'come out of time' gives us a sense of *TINE* as a spiritual rather than ethnographic vision of New England. Transformed through Emerson's delight in renaming his surroundings, the sacred and the secular combine here through a distinctly vernacular vision; it is the 'native immemorial air' that allows Strand's unassuming church front to be as sacred or secular as the entrance to a cottage, the voice of the minister as holy or profane as that of his neighbour. Similarly, Newhall's description of 'the shuttered white church' and the 'worn doorlatch', rather than being signs of dilapidation, indicate the potency of vernacular architecture. In Strand's photograph of a framed doorway of a house, it is the distinctive façade, and not the fact that someone has just entered or left, that is crucial (Fig. 7.3).

Leaving the door ajar for multiple interpretations is another indication that the photographs in *TINE* are as much about intimated as actual presences. If the door is literally left ajar in New England,

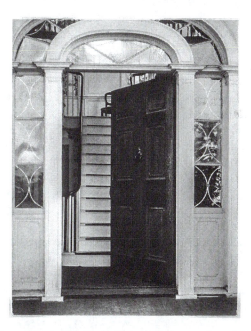

Fig. 7.3 'Open Door, Maine', Gelatin silver print, 1945, in Paul Strand and Nancy Newhall, *Time in New England* (New York: Aperture, 1980), p. 102. The Paul Strand Collection, Philadelphia Museum of Art, Accession no. 2010-14-130.

it opens up a series of interpretations, of which the political is merely one possibility. In the last section of *TINE*, the private letters of Sacco and Vanzetti are followed by the image of a large plant closely cropped, the texture of the leaves matt and silvery. The letters are preceded by a gravestone from 1868: a not so subtle harbinger of the execution awaiting the two correspondents.

Such symbolic alignments of text and imagery enable something other than a 'history' of New England, and while the photographs are fixed here by the writing to an actual political context (in this case, Sacco and Vanzetti as 'honorary' New Englanders), the images themselves move away from the specifics of the text. By bookending the letters with images of plants and gravestones, Sacco and Vanzetti are taken 'out of time': they too are somehow timeless in New England. According to the cinematographer and artist Hollis Frampton, Strand's regional studies were always about time and the ontological nature of photography itself. In 'Mediations around Paul Strand' (1972), he writes:

> Strand has returned often to his accustomed sites, and two adjacent photographs, from Vermont, for example, may be dated thirty or forty years apart. Predictably, they differ from one another no more than they might if made on consecutive days. . . . Still photography has, through one and another stratagem, learned to suspend or encode all but one of our incessant intuitions: I refer to what we call time. Paul Strand seems consciously intent, in his presentation of his work as in the work itself, on refuting time.[20]

The twin strategy that Frampton refers to – the suspension and encoding of photographic material through a lack of information – touches the heart of Strand's enterprise and possibly the limitations of Newhall's. For Frampton, a strange cancelling-out effect takes place in Strand's photographs. Objects are suspended in time – and maybe this is what *TINE* really implies – and simultaneously imbued with symbolic meaning; the decoy in Figure 7.2 exemplifies this. None the less, the attempt to stop time in New England is doomed to failure: meaning will always regenerate, much like the photographs of plants that survive changing times and political regimes, only to re-emerge. Even if, as Frampton points out, 'Strand might photograph the whole terrain of the world', the issue

of change cannot be circumvented. In this respect, Strand's use of objects that are emblematic of continuation and survival make him, paradoxically, very different from Newhall.[21] Like a still painter, Strand is interested in the timeless aspects of the objects photographed, whereas Nancy Newhall's textual choices are all about change, about liberation and ideology, even if that ideology is occasionally problematic or outmoded, given the political circumstances of the 1950s.

For other critics, Strand's attempts to create a politicised narrative with an aesthetic that illuminates some essential timeless truth poses a serious moral problem: a problem that is both antithetical and similar to the one in *You Have Seen Their Faces*, as well. In the attempt to render a timeless essentialist version of the South, Caldwell's text tried to outline the economic and cultural context for agrarian mismanagement, a narrative that, for better or worse, Bourke-White also sought to duplicate photographically. In *TINE*, Strand's work is so markedly timeless, so consistently of one perspective, that it simply cannot be taken as a straightforward illustration of the accompanying text. This deliberate disjunction between the two media, paradoxically, is what some critics consider Strand's forte, while for others such as Allan Sekula, this is a major problem that permeates documentary photography of the American scene. For Sekula, this type of photography inevitably continues to be 'caught between the conditions of a kind of binary folklore', in which the rendition of specifically regionalised subjects – regardless of whether they are termed folkloric or vernacular – is always 'embroiled in an expressionistic structure'.[22] In other words, no matter how much the documentary aesthetic pretends to be neutral, to be 'real', it inevitably ends up empathising with its subject, a limitation of which James Agee – for instance – was all too keenly aware.

Even if, in this case, Strand operates within the limits of an acceptable level of empathy, his aesthetic masks, according to Sekula, an often untenable celebration of abstract humanity divorced from any real political agency – a vision of abstract humanity not dissimilar to that of Dorothea Lange's mournful mothers and hungry children in *American Exodus*. One could argue that, in *TINE*, the celebration of a New England doomed to extinction is mourned but not countered in any way: a charge one could levy against many of Strand's later regional studies, as well. While, for Sekula, this amounts to a depoliticisation of the documentary process, for some Strand scholars

Strand's ability to render a palatable version of abstract humanity, in which the regional is made synonymous with authenticity and truth, proves that he is, indeed, a great photographer. According to Milton Brown's essay in one of the seminal collected works of Strand, *Paul Strand: A Retrospective Monograph, 1971,*

> Strand believes in human values, in social ideals, in decency and in truth. These are not clichés to him. That is why his people, whether Bowery derelict, New England Farmer, Italian Farmer, French artisan, . . . are all touched by the same heroic quality – humanity. To a great extent this is a reflection of Strand's personal sympathy and respect for his subjects. But it is just as much the result of his acuteness of perception, which finds in the person a core of human virtue and his unerring sense of photographic values.[23]

For Brown, Strand's subjects are heroic figures – mythologised to such an extent that their actual social and economic backgrounds become inconsequential. The Brown quotation exemplifies the paternalistic camera that Sekula is weary of, a vision in which the subjects ultimately do not need their own subjecthood as long as they are discernibly Strand's 'people'. However, in simply looking at Strand's images in isolation, Sekula ignores the fact that the photographs compete at some level with Newhall's extracts, and that this, in turn, unsettles both the editor's and the photographer's authorial status in ways that inherently politicise the photographic process.

Strand's morose heroism (a term coined by his long-term collaborator in the 1930s, Harold Clurman) is another reason why he shies away from creating any overtly emotive alignments between the images and text. There are, for example, numerous textual extracts that deal with the issue of slavery and emancipation (W. E. B. Du Bois's 'I Dream of a World' is one of the penultimate extracts), but no images that portray actual African–American faces, an issue that seems all the more of an anathema, considering Strand's work on *Native Land*, in which the blight of racism is a central issue.

There is, of course, a fine line between what we might call Newhall's more cautious optimism and Strand's 'morose heroism': a heroism that seems suited to the puritanical context of the

book overall. The signposting of a religious history in the very last image of an austere-looking New England church is no coincidence in this respect. The white wooden church, manufactured by and for the people, signifies a respectful homage to vernacular culture in nearly every documentary project of the 1930s, but contrary to similar photographs (by Walker Evans or Wright Morris, for example), Strand's church is ominously decentred; the dark sky, contrasted with the whiteness of the church, fits with Newhall's description of it as a 'terrifying ideal'. As is usual for Strand, we have no sense of whether this church is in temporary repose or long abandoned (Fig. 7.4).

To end *TINE* with an image of a church is, of course, to acknowledge the religiosity inscribed into the very fabric of New England. Nevertheless, even in something as visually canonical as a church,

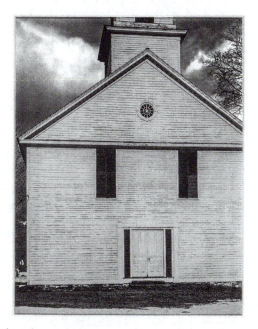

Fig. 7.4 'Church', Gelatin silver print, 1946, in Paul Strand and Nancy Newhall, *Time in New England* (New York: Aperture, 1980), p. 250. The Paul Strand Collection, Philadelphia Museum of Art, Accession no. 1980-21-164.

the issue remains oblique. Is this the funereal end of *TINE*? Is it an image that embodies a sacred rather than a secular vision of the 'spirit' of New England? In the section entitled 'Foothold', a biblical New England primer from 1648 for the instruction of children is reprinted from A to Z:

> A In Adam's Fall We sinned all
> B Heaven to find The *Bible* Mind
> C *Christ* Crucified For Sinners died.[24]

Here the alphabet is defined in terms of a sacred discourse: one cannot learn the building blocks of language without going through an instructive rota of biblical material. In the same way that a biblical primer constitutes the foundations for a later, more secular American discourse, Strand's images, paradoxically, also seem to hark back to a time when the sacred was present in the everyday. After the primer there is an image of a fern, partly shaded and lit by diffused sunlight. Thus, while Strand's plants mimic Emersonian marvelling at nature, the plants themselves, while native to the region, are by no means exclusive to it. Their true impact lies not in their regionalism but in their continued survival. Man may be temporal but time in New England is the same for these organisms, regardless of historical change and political exigencies. In fact, the images of nature, the sense of an organic design throughout the photo-text, makes it difficult to delineate the divide between the vernacular designs on wooden implements, doors and hinges, and the natural forms that have inspired those designs. Once again, an Emersonian alignment between word and image, tool and environment, is in some ways re-enacted here, even if it is curiously devoid of the artisans who created that alignment in the first place.

If we return to Sekula's argument, that Strand's documentary aesthetic creates a potentially problematic form of folklore, then *TINE* could be critiqued for presenting a defunct idea of a democratic America, an America trying to prove that fascism cannot encroach on its territory. As readers, we want Strand's version of New England to be more than an idyllic construction, but the question remains: what is the book's actual intention, then? The combination of text and photographs is simply too politically obtuse, too questioning of its own iconicity, to make for something entirely legible in an ideological sense.

As previously mentioned, there is an argument to be made that Strand's later regional studies are perfected examples of a photographic attempt to arrest time, an attempt commenced but never completed in *TINE*. In studies of the Sudan and the Hebrides, Strand's aestheticism is largely left unchecked by the text that accompanies it. For all of Newhall's gentility in terms of acquiescing to Strand's superior abilities as an artist, it is worth noting – in comparison – just how instrumental the textual extracts are in *TINE*. One such example is the extract from Anne Bradstreet's poem, 'Spirit to Flesh' (1650), toward the end of the 'Wilderness' section. In this Puritan poem, flesh, 'the unregenerate part', is admonished to 'disturb no more my settled heart, for I have vowed, and so will do, thee as a foe still to pursue. Sisters we are, yea, twins we be, yet deadly feud 'twixt thee and me.' For Bradstreet, the unregenerate soul is the soul who has not yet conquered the material world, whose spirit – as she puts it – remains twinned with the worldly. The dichotomy also lies at the heart of a Puritan poetic and it is this duality, between the spiritual and the worldly, between a discernible past and an uncertain future, that is expressed through the synthesis, as well as ambiguity, of image and text in *TINE*.

In the end, then, *TINE* must be seen as an indication of Newhall's desire to merge the past with the present, and to present the culture of New England as a truly collective, democratic *and* personal experience. In Strand's photographs, attempting to stop time, to exist outside and beyond the texts accompanying them, we discern a fittingly puritanical form of 'morose heroism' and a growing sense of nostalgia for an America he was soon to leave behind. As we will see in the next chapter, even something as urban as Harlem is capable of eliciting a similar sense of nostalgia as it too – under the photographic gaze – becomes indicative of various political and cultural schisms. In a rapidly changing post-war society, change seems nearly to supersede the abilities of the camera to capture things as they really are.

Notes

1. Alan Trachtenberg, 'Introduction', in Maren Stange, ed., *Paul Strand: Essays on His Life and Work* (New York: Aperture, 1990), p. 2.
2. Paul Strand and Nancy Newhall, *Time in New England* (New York: Oxford University Press, 1950), p. 248.
3. Ibid., p. 24.

4. For more on the layout and history of *TINE*'s publication see: John Rohrbach, 'Time in New England: Creating a Usable Past', in *Paul Strand: Essays on His Life and Work* (New York: Aperture, 1990), pp. 161–77. A brief summary of how the text in *TINE* has been examined, or overlooked, can be found in Laura Wexler, 'The Puritan in the Photograph', in Nan Goodman and Michael Kramer, eds, *The Turn Around Religion: American Literature, Culture and the Work of Sacvan Bercovitch* (London: Ashgate, 2011).

5. Rohrbach, 'Creating a Usable Past', p. 162.

6. Paul Strand, 'Introduction', in Strand and Newhall, *Time in New England*, p. vii.

7. Ralph Waldo Emerson, 'Historic Notes of Life and Letters in New England', *Atlantic Monthly*, October 1883, as quoted in Strand and Newhall, *Time in New England*, p. 187.

8. Nancy Newhall, 'Editor's Foreword', in Strand and Newhall, *Time in New England*, p. VI.

9. Nancy Newhall, 'The Caption: The Mutual Relation Between Words/ Photographs', in *From Adams to Stieglitz: Pioneers of Modern Photography* (New York: Aperture, 1999), p. 136; originally printed in *Aperture 1* [1952].

10. 'Notes for the Introduction', Nancy Newhall Files, Center for Creative Photography, Tucson, Arizona.

11. Olga Owens, 'The True Christmas Spirit Survives in New England', *Boston Sunday Post*, 3 December 1950.

12. Nancy Newhall Files, Center for Creative Photography, Tucson, Arizona.

13. Ibid.

14. Ruth Chapin, 'Which Lives In All That Is Free, Noble, and Courageous', *Christian Science Monitor*, 18 November 1950, quoting Ralph Waldo Emerson, 'The Spirit of the Times' [1850].

15. By moving from a regional perspective to a humanistic worldview, Steichen – according to his critics – made photography subservient to an American ideology of good neighbourliness across continents and cultures. Steichen's position at MOMA was instrumental in putting precisely this perspective at the forefront, an irony that would not have been lost on Nancy Newhall.

16. See Nancy Newhall's later collaborations with Ansel Adams: *Eloquent Light* (New York: Aperture, 1963) and *Fiat Lux* (New York: McGraw-Hill, 1967).

17. Nancy Newhall, *Paul Strand: Photographs, 1915–1945* [New York: MOMA, 1945], reprinted in Nancy Newhall, *From Adams to Stieglitz: Pioneers of Modern Photography* (New York: Aperture, 1999), pp. 71–7. Beaumont Newhall's version of an American history of photography was undoubtedly a formative influence on Nancy Newhall's

version, as seen in Beaumont Newhall, *The History of Photography* (New York: MOMA, 1937).

18. Paul Strand and Cesare Zavattini, *Un Paese: Portrait of an Italian Village* [1955], in English (New York: Aperture, 1997). For more on the interaction between text and images in *Un Paese* see: Elena Gualtieri, ed., *Paul Strand Cesare Zavattini: Lettere e Immagini* (Bologna: Bora, 2005).

19. Strand and Newhall, *Time in New England*, p. 136. Originally delivered as a lecture on 'Education' in 1847 and reprinted in Ralph Waldo Emerson, *The Journals and Miscellaneous Notebooks*, ed. Alfred R. Ferguson and Ralph H. Orth (Cambridge, MA: Harvard University Press, 1960–82), vol. 4, p. 41.

20. Hollis Frampton, 'Mediations around Paul Strand' [1972], in *Circles of Confusion: Film, Photography, Video: Texts, 1968–1980* (San Francisco: Visual Studies Workshop, 1983), p. 134.

21. The persona of Strand as a politically concerned activist sits rather uncomfortably with his argument with Ansel Adams in the 1960s about artists and elitism. Strand insisted that Adams's choice of large print runs, a decision in line with Adams's desire to democratise photography, was unethical. By taking high prices for his own limited editions, Strand felt that he was signalling unequivocally that photography was, indeed, art.

22. Allan Sekula, 'On the Invention of Photographic Meaning', in Victor Burgin, ed., *Thinking Photography* (London: Macmillan, 1982), p. 87.

23. Milton Brown, 'Photography Year Book 1963', in *Paul Strand: A Retrospective Monograph, 1971* (New York: Aperture, 1971), p. 370.

24. Strand and Newhall, *Time in New England*, p. 25.

Visions of Harlem in Langston Hughes and Roy DeCarava's *The Sweet Flypaper of Life* (1955)

In stark contrast to Doris Ulmann and Julia Peterkin's 1933 *Roll, Jordan, Roll*, Langston Hughes's response to Roy DeCarava's photographic studies of Harlem life in the 1940s (unpublishable until Hughes agreed to write an accompanying text) solidifies a distinctly African–American voice through a vision of authenticity and belonging.[1] DeCarava and Hughes's poetic homage to Harlem in *The Sweet Flypaper of Life* (1955) seems an apparently effortless homage to the resilience and beauty of an African–American neighbourhood in the face of economic adversity, and yet the historical timing of the project renders its politics far from transparent. On one hand, *The Sweet Flypaper* uses the African–American vernacular of Hughes's fictionalised first-person narrator, the elderly black Harlem resident Sister Mary Bradley, as a way to fuse text and imagery into a poetic vision of togetherness in the face of urban discord. On the other hand, the narrative also complicates the dynamic between writer and photographer by allowing for competing messages to occupy the same space. If Chapter 1 of this present book dealt with Ulmann and Peterkin's collaboration as an act of preservation, an attempt to represent the Gullah slave descendants of South Carolina as fixed photographically and politically in time, Hughes and DeCarava's animated vision of Harlem is driven by another act of preservation: a desire to illuminate the daily life of an otherwise overlooked part of New York. In the process, it shines a light on the schisms and contradictions of contemporary African–American life in the context of a changing documentary perspective.

This penultimate chapter will look closer at the respective politics and aesthetic backgrounds of Hughes and DeCarava for an understanding of *The Sweet Flypaper of Life*'s ambivalent love affair with

Harlem. Under-rated and out of print until recently, the combination of DeCarava's more subtle photographic aesthetic with Hughes's fictional vernacular narrator, Sister Mary, has meant that the book is mentioned only occasionally within African–American studies and almost never as a seminal photo-text in its own right. One of the reasons for this, as we will see, is that the competing messages in DeCarava and Hughes's photo-text have been read primarily as a measure of the book's awkward status. What this chapter proposes is that the photo-textual aspects of the book are, in fact, a measure of the work's astonishing complexity. On a basic level, the paradox of *The Sweet Flypaper of Life* lies in its unorthodox rendering and coupling of a fictitious African–American voice with what appears to be more straightforward documentary photographic material. However, on other levels, the book presents a series of internal contradictions that are also thematic and narrative-driven.

In structural terms, *The Sweet Flypaper of Life* consists of 140 of DeCarava's black and white photographs, selected, sequenced and with an accompanying text over a hundred pages by the then already famous Harlem Renaissance writer Langston Hughes. Hughes, whom DeCarava approached in order to get his photographs in print, immediately realised the potential of the images. In previously published stories, Hughes had perfected a type of folksy narrative in which invented dialogue provided the framework for various ruminations on daily life in Harlem. A cross between drama and ethnographic observation, *The Sweet Flypaper of Life* follows the immediate family and life of its narrator, Sister Mary, whose running commentary on the accompanying photographs indicates a life of toil as well as pleasure.[2] Following Hughes's advice, Simon and Schuster agreed to publish *The Sweet Flypaper of Life* in an inexpensive pocket-sized format, enabling its initial print run of 25,000 to sell out quickly. The book was favourably reviewed, mostly as an ethnographic study, with *The New York Times Book Review* critic Gilbert Millstein arguing that the book should 'be bought by a great many persons and read by a good many more'.[3] In line with his sociological angle, Millstein promised 'the chances are it could accomplish a lot more about race relations than many pounds of committee reports'.[4] Millstein's review is indicative of the commentary at the time. By focusing on the photo-text as 'a delicate and lovely fiction-document of life in Harlem, told with astonishing verisimilitude, in the words of an elderly Negro woman . . . and seen

with a corresponding truth through her bright old eyes', Millstein's reading provides a comfortable, non-subversive version of the book as 'fiction-document'.[5] By calling the book a 'fiction-document', he allows it to have both documentary appeal, tempered if necessary by its fictional context, and something more essential – namely, truth and empathy. Oddly enough, both initial and subsequent reviews neglect the unorthodox look of the first edition; setting aside Simon and Schuster's desire to keep costs to a minimum, which meant low-quality prints, the paperback's layout and design were unusual in themselves. Rather than have a separate cover, a frontispiece, a dedication page and so on, the book – images *and* narrative – starts on the cover and continues seamlessly without any break on the first page (Fig. 8.1).

The cover design gives the photo-text an almost journalistic feel, and at the same time, the opening sentence, with its vernacular cadence and colloquialisms, is more reminiscent of Hughes's poetry.

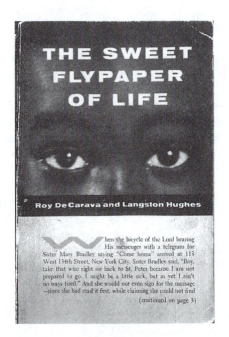

Fig. 8.1 Roy DeCarava and Langston Hughes, Cover Image of *The Sweet Flypaper of Life* (New York: Simon and Schuster, 1955).

These stylistic quirks were left unnoticed by critics upon the book's publication and continued to be so, even by 1970, when the photography critic A. D. Coleman publicly berated a 'white' arts establishment for failing to recognise DeCarava's talent as a photographer. None the less, for Coleman and others, *The Sweet Flypaper of Life* was still mentioned as an aside rather than as an important part of Hughes's or DeCarava's overall œuvre.

One of the reasons for this, apart from the low-key design of the paperback, was DeCarava's more toned-down photographic aesthetic, comparatively speaking: a discrete look compared to the work of other urban photographers such as Weegee, or indeed other members of the New York Photo League, whose projects relating to Harlem were more overtly didactic and polemical.[6] Unlike Weegee, for instance, DeCarava turned his attention to the stoops, doorways, window frames and other areas where an insight into the private lives of urban residents is made visible, foregoing the more dramatic gestures of human interaction in favour of something quieter and more intimate.[7]

If the images in *The Sweet Flypaper of Life* come across as more meditative, it is not simply because of the many shots of people sitting on chairs, at tables, in bedrooms and loitering on city streets; it is in large part due to the measured cadence of Sister Mary Bradley's fictional voice that accompanies them. The portraits of the inhabitants of Harlem, compared to Weegee's angry children and mobsters, for instance, unavoidably present an inward sense of stoicism, a stoicism accentuated by Sister Mary's resigned wisdom. As a man perches on the steps in front of a house, the caption reads: 'It's too bad there're no front porches in Harlem.'[8] From Sister Mary's language, it is clear that the narrative relies on something more intimate, something filtered through the patient glare of Sister Mary, as much as through the outward masculine gaze of the photographer. This sense of duality runs through the photo-text in its entirety and it provides us with a vision of Harlem as a place where overlapping sensibilities are allowed to play out without the usual restrictions of gender or age.

Thus, if the post-war era became a time when the idea of documentary veracity was increasingly under scrutiny, as seen in Weegee's use of puns and *double entendres*, Sister Mary's perspective constitutes another shift from the use of captions and text as primarily descriptive. By focusing on internal thoughts and ruminations, the

tone becomes more personal, even melancholy. It is no coincidence that most of the residents photographed often appear to be standing still, to be – as it were – in the process of occupying the neighbourhood rather than going somewhere else. In this sense, *The Sweet Flypaper of Life* provides a vernacular vision both marked and unmarked by earlier types of documentary work. Just as the poor white sharecroppers in *Let Us Now Praise Famous Men* seemed to have sprung from the same environment as their dried-out crops and livestock, the inhabitants of Harlem are rendered as natural extensions of their environment. The issue is not simply one of ethnographic focus, here on one community as opposed to a whole region as in *American Exodus*; it is also about proximity and distance in moral terms, about how close one can come to the subjects investigated without becoming overtly intrusive.

In this context, the very title, of course, is indicative of some of the contradictions within the text. *The Sweet Flypaper of Life*, on a very obvious level, implies that the Harlem residents are somehow stuck geographically and socially, despite the contentment articulated at the beginning by Sister Mary, who claims to be 'so tangled up in living. I ain't got time to die.'[9] If the text is partly about moving away from racial stereotypes *and* about moving away from the formatting of previous photo-textual collaborations, then Harlem is none the less registered as a place of social enclosure, even imprisonment. Most writing on *The Sweet Flypaper of Life* neglects this angle, perhaps because of the politics of the location itself, but also because of the difficulty in categorising the resigned attitude implied in the vernacular 'folkish' discourse of Sister Mary. If the way in which she speaks is disarmingly naïve, then what does this do to the politics at play in DeCarava's photographs?

For Sherry Turner DeCarava, Roy DeCarava's wife and co-curator, the issue of racial empowerment is always, even if obliquely, present in the work of her husband. As Sherry DeCarava argues, DeCarava's photographs of black urban life in the twentieth century always 'show an inward eye trained on an outer reality, . . . a personal vision that finds resolution more in the realm of metaphor than in the photographic particular'.[10]

This focus on the realm of metaphor rather than documentary veracity indicates a particular post-war sense of what documentary photography should be doing, rather than what it was perceived as having done previously. If the 'photographic particular', as Sherry

DeCarava intimates, belongs to the 1930s, the new 'realm of metaphor' acknowledges that the documentary process can be more overtly political *and* more visibly personal in the post-war era. Of course, these demarcations in terms of pre- and post-war are not so neat, as previous chapters have shown, and in many ways, DeCarava's attempts not to be pigeonholed as a documentary photographer are similar to Walker Evans's more nuanced concept of the documentary aesthetic, as outlined in Chapter 3. For both Evans and DeCarava, the role of photography is to be representative of a particular time and age, and at the same time, able to transcend it.[11]

For Sara Blair, 'the changing contract between the documenting camera and its subjects, particularly in Harlem . . . promised a newly iconic Harlem, at once metonymic of America's modernity and revelatory of its social failings'.[12] This vision of Harlem as a site of both political strife and urban vigour enables *The Sweet Flypaper of Life* to emblematise an on-going struggle within documentary photography. As a microcosm of wider regional issues, Harlem facilitates a lyrical image of the American landscape, whilst showing an increased awareness of its social and political context.[13] In this regard, it is not incidental that DeCarava slots himself into a longer lineage of Guggenheim grant recipients for whom photography – above all – was a way to illuminate regional specificity, lyrical potential *and* social injustices. As with Walker Evans and Wright Morris – both of whom received Guggenheim grants – DeCarava's application uses a language in which the vernacular is made poetic rather than overtly scientific or ethnographic. Nothing less than the entirety of everyday life constitutes the subject matter for the photographer: 'Morning, noon, night, at work, going to work, coming home from work, at play, in the streets, talking, kidding, laughing, in the home, in the playgrounds, in the schools, bars, stores, libraries, beauty parlors, churches etc.'[14]

This listing of the constituent pieces of a working-class landscape is not dissimilar to Weegee's obsession with all of New York's residents, rich and poor, but it is also conspicuously devoid of any overt references to race. DeCarava deliberately presents himself, just as Evans, Morris and Frank did in their respective Guggenheim applications, as a working photographer interested, above all, in the changing ontology of the photographic image. In this way, DeCarava does not remove himself from previous documentary efforts; he simply continues an investigation into the merits of vernacular culture,

regardless of race or location. All the stranger, then, that Langston Hughes's focus on Sister Mary in some ways redirects the perspective outlined by DeCarava in his grant application into something fairly different. By using her singular perspective, Hughes creates a distinctly black voice, one that has moved beyond the national fears and ideological schisms of the 1930s, and one that is more private in some respects than the all-encompassing list established by DeCarava. To what extent Hughes is altering the environment in order to make it more palatable to a white audience, packaging it through a recognisably 'folkish' vernacular, is another crucial question.

On a wider level, then, the photo-textual interaction in *The Sweet Flypaper of Life* puts centre-stage different notions of agency and self-representation, ideas that the preceding chapters have charted throughout other photo-textual collaborations. This does not mean, of course, that DeCarava is engaged in fundamentally the same exercise as, for instance, Doris Ulmann and Julia Peterkin. In fact, comparing DeCarava's images of African–Americans to those of Ulmann indicates a perspectival change on race that far surpasses the twenty-five years or so that lie between them. If DeCarava and Hughes's response to political disenfranchisement and social marginality is made through a combination of fictional experimentation and documentary experience, it is vastly different to that of Peterkin and Ulmann. As seen in Chapter 1, Peterkin and Ulmann created a vision of an already lost pastoral and feudal version of African–American life. *The Sweet Flypaper of Life*, on the other hand, seems set on making the contemporaneous come alive: in fact, to illustrate how alive it actually is.

Setting aside their different attitudes to race, the issue of what Sara Blair defines as 'the problem of the look and the look back' within documentary practice remains.[15] For Blair, documentary photography invariably has to deal with the vexed issue of how to represent the disenfranchised without submitting them to a gaze that inadvertently re-establishes the victimisation that made them disenfranchised in the first place. As such, while Sister Mary's perspective and narrative come from a place of marginalisation – she is black, she is a woman, she is old – she none the less carries with her the task of filtering DeCarava's images, of applying some sort of knowledge to them; in this sense, she carries a form of entitlement or agency that might counter such 'victimisation'. Thus, DeCarava's visual awareness of how his subjects are both cloaked in anonymity

and meant to be representative of Harlem life, how they are looked at and look back, is complicated by Sister Mary as named narrator. For instance, in certain situations, Sister Mary's outlook seems to accentuate the realist nature of the book. She does not sugar-coat the domestic and familiar patterns that mark the hardships of Harlem life. Her grandson is at risk and there are other indicators that the conventional nuclear family is under economic and social duress. Nor is Sister Mary – although she articulates the realist terrain verbally – always able, or allowed, to mediate fully the social implications of her surroundings (Fig. 8.2).

Sister Mary's socially conscious voice is thus both charged with providing an accurate sense of life in Harlem and at times allowed to transcend that life through a photographic bird's-eye view of her surroundings. Hughes's writing is – in this way – charged with creating a persuasive voice for Sister Mary, whilst providing enough space for the images to render a sense of authenticity *and* empathy. The ways in which these two movements, the realist landscape

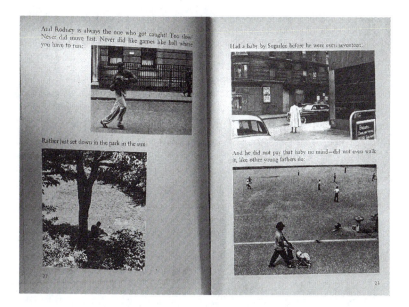

Fig. 8.2 'Four B&W Images of Harlem Residents', in Roy DeCarava and Langston Hughes, *The Sweet Flypaper of Life* (New York: Simon and Schuster, 1955), pp. 22–3.

and the emotive text, operate in union is fundamental to the crea-
tive tenor of the project. Hughes, in removing his voice to another
generation and another gender, may appear, then, to create a safer
distance for observation, a sort of safeguard against the accusation
that any stereotyping of Harlem is inadvertently taking place. In
fact, Hughes is engaging in a form of ventriloquism that complicates
the book's politics on several levels.[16] According to Sonia Weiner in
'Narrating Photography in *The Sweet Flypaper of Life*', the

> words of Hughes's narrator provide a way of reading the images
> without actually seeing their subjects in all their complexity. . . .
> However, to read the text only on its literal level is to overlook a
> crucial aspect. Hughes's narrator presents a double-edged text.[17]

Weiner argues that a double bind exists at the very heart of the
representational mode in *The Sweet Flypaper of Life*. On the one
hand, a racially segregated sphere is presented in such a manner
that readers unfamiliar with Harlem may understand it better. On
the other hand, the authenticity of Sister Mary's vernacular voice
depends on the presence of this segregated sphere as a place made
by and for African–Americans. In other words, if the photo-text
is critical of the insularity it portrays, this very insularity is also,
to some extent, what guarantees its authenticity. Acutely aware
of this, DeCarava shows his subjects as both individualised and
anonymous simultaneously (with no proof, for example, that the
images actually reflect what Sister Mary narrates). In this way, the
uncaptioned photographs, similar to those of Walker Evans in *Let
Us Now Praise Famous Men*, both facilitate and question just how
much we *can* empathise with the subjects portrayed. Because the
photographic material in Harlem and *Let Us Now Praise Famous
Men* is deliberately left uncaptioned, it has the formidable task of
providing an intimate *and* universal sense of the subjects portrayed.
 This awareness of the potential of the photo-text to render
a universal vision of daily life, through the specifics of a local
population, constitutes another link to many of the earlier photo-
texts. Like Millstein's review of *The Sweet Flypaper of Life* in *The
New York Times*, reviews of *Time in New England*, as seen in the
previous chapter, often stressed an upbeat version of American
life rather any implicit political critique. In not dissimilar terms,
Millstein's 1955 review commends *The Sweet Flypaper of Life*

for its representation of Harlem as a homely rather than crime-ridden environment. As seen in several instances of contemporaneous reviews, the focus for reviewers was on the resilience of the citizens portrayed rather than on those factors that so clearly disabled them socially and economically.

In this context, Hughes's Sister Mary – precisely because of her fictional status – seems particularly suited to counter some of the tropes of previous documentary vernacular first-person accounts. If reviews of the time tend to read her narrative as predominantly factual and therefore sociologically sound, her fictional status none the less presents a version of truthfulness, which, strictly speaking, is as trustworthy (or untrustworthy) as Erskine Caldwell's vernacular quotations in *You Have Seen Their Faces*. As Weiner puts it, 'The fact that Hughes had engaged with the documentary genre in the past enhanced the inclination to read his text as factual and grant credibility to its narrator.'[18] Weiner is right to note that Hughes's previous interest in documentary projects is crucial in this respect, partly because DeCarava knew of and empathised with Hughes's continuing and well-known interest in African–American music, from blues to jazz, just as Hughes was familiar with DeCarava's earlier attempts to articulate a jazz aesthetic through his photography.[19] Both artists linked the improvisational aspects of African–American music to a more performative and playful, rather than everyday utilitarian, form of vernacular speech and sound. By ventriloquising Sister Mary, Hughes is – in effect – not only performing a different version of black identity, but also responding to the lyrical impetus (in this case, one that is feminised through Sister Mary) of DeCarava's images. One of the many surprises of *The Sweet Flypaper of Life* is that, despite DeCarava's visualisation of black culture in terms of sound, rhythm and tonal quality, a platform traditionally occupied by male musicians and performers, we now have that platform occupied by Sister Mary.

Langston Hughes also gave much consideration to how this vernacular tenor, the rhythm of speech and intonation, could be accentuated by the sequencing of the photographs. Not only did Hughes and DeCarava take the 'sound' of 1950s New York and add it to the photographs, but also they combined it with certain design and illustrative practices gleaned from advertising: practices that belonged as much in the realm of magazines as they did in the world of music and art. The design of Edward Steichen's 1955 catalogue for the

'Family of Man' photographic exhibition was likewise hugely influential in terms of its layout and use of variously sized frames.

Rather than duplicate the austerity and clean lines of Walker Evans or Wright Morris, the images in *Family of Man* – the most sold photo-text of its era – alternate dynamically in size and in terms of their positioning on the page. A few – crucial – images by DeCarava appear in the *Family of Man*: a portrait of a young woman playing an instrument in a nightclub within a larger spread of images about musicians accentuates various forms of performativity and of the importance of motion and sound. *The Sweet Flypaper of Life* mimics, in this respect, the more fluid form of layout of the *Family of Man*, not only as a way to provide a sense of engagement with the materials at hand but also as an indicator of the project's modern credentials. What we see *and* hear in *The Sweet Flypaper of Life* is thus a desire to draw in the viewer/reader through devices designed specifically to be emphatic rarely than purely aesthetic.

Apart from the design and layout in *The Sweet Flypaper of Life*, DeCarava's print techniques also differ from those of his photographic predecessors, although there are inklings of this more improvised style in *The Family of Man*. The use of grey tones and blurring is vastly different from, for instance, Paul Strand's clarity and use of high contrast, or Walker Evans's symmetry and frontal directness. In several ways, DeCarava's 'look' is closer to that of Robert Frank, whose efforts to define an 'anti-documentary' aesthetic are considerably better known, despite the fact that he too appeared in Steichen's *Family of Man* catalogue as a 'conventional' documentary photographer. Committed to not using flash, even in dark interiors, DeCarava considered his printing a more important and intrinsic aspect of the artistic process. Not unlike Frank, he aimed to explore social and public situations in a more intimate way, without the sense that subjects were posed or lit for specific purposes (the very thing that Bourke-White unashamedly excelled at in *You Have Seen Their Faces*). At the same time, DeCarava wanted to manipulate his prints so they would be what he considered most expressive. In an interview with Ivor Miller in 1990, DeCarava speaks at length about the importance of printing and lighting as being intrinsically expressive rather than necessarily realistic:

> For example, I don't try to alter light, which is why I never use flash. I hate it with a passion because it obliterates what I saw. . . .

The reason why my photographs are so dark is that I take photographs everywhere, light or not. . . . I alter not so much the light, but the image. Whatever is necessary for me to express the feelings I have.[20]

DeCarava's articulation of his own practice is valuable, not merely because it indicates a more complex form of documentary work, but because it provides an insight into what was considered an unconventional form of documentary photography at the time. Through print technique, DeCarava stresses the emotional gist of the scene portrayed, and instead of compensating for the darkness of bars, nightclubs, badly lit interiors and so on, DeCarava experiments with shading and various tonal qualities in order to 'express the feelings' of the photograph. Because of this, some critics have since situated DeCarava as one of the instigators of the post-war meta-documentary form, a more appropriate term, possibly, than the 'anti-documentary' definition used to convey Frank's work. Regardless of these 'anti-documentary' or 'meta-documentary' aspects, both Frank and DeCarava – as evidenced by their inclusion in *The Family of Man* – were recognisable enough to be part of the established art world by the mid-1950s. DeCarava was one of the few black photographers to be included in this new canon at MOMA, with a selection of his photographs chosen – as were Frank's – for the exhibition.

Neither does situating the photographs in *The Sweet Flypaper of Life* as exemplary of a 'meta-documentary' art form fully explain the interaction between text and images. On the contrary, given the at times sentimental tenor of Sister Mary's voice, one might query to what extent she contradicts DeCarava's darker, more melancholy images, and whether – more importantly – this contradiction is a deliberate 'meta-documentary' choice. According to Sara Blair, the book seeks 'to displace the documentary rhetoric of objectivity with an affective complexity understood as the product of subjective response'.[21] Blair's reading, a very condensed articulation of DeCarava's more 'emotional' aesthetic, presupposes a 'rhetoric of objectivity' within documentary photography. For several reasons this is problematic. As we have seen in the preceding chapters, one of the underlying premises in the work of Evans, for instance, was to align documentary practice with the subjective vision of the photographer, to move away from any semblance of a 'rhetoric of objectivity'.

In *The Sweet Flypaper of Life*, the idea of Harlem as a boundary, a liminal space in terms of both racial and economic disparity, in fact enables it to become a particular type of testing ground for a more subjective vision. Like Weegee's urban backdrops, where houses become staging areas for social interaction, as well as the aesthetic backgrounds for a distinctly narrative form of photography, Harlem becomes a site *designed* to be a place for photographic interrogation, as well as documentation.

One example of how DeCarava's use of space takes on particular interrogative aspects lies in the differences between his use of locations and that of, for instance, Weegee in New York. DeCarava's photographs from demolition zones in Harlem, ostensibly targeted for urban renewal but in reality occupied by local children, portray them as creators of their own world rather than – in Weegee's terms – interlopers into an adult one. In interviews, DeCarava himself expressed a desire for his photographs to stand alone, as if they too could create their own world without any textual accompaniment, as though one might endanger the meaning of the other. According to Maren Stange in '"Illusion complete within itself": Roy DeCarava's Photography', DeCarava wrote to the photographer Minor White whilst working on *The Sweet Flypaper of Life*, expressing the hope that 'the time will come when photography will cast aside its literary crutch' in order to 'stand on its own feet as a legitimate means of expression'.[22]

The ambivalence felt by DeCarava regarding the use of text is not just about the status of his own images and whether they need the 'literary crutch'; it is about contextualising the work in the right way too. In interviews, DeCarava was consistently uncomfortable with the very definition of his work as documentary:

A lot of people have identified me as a documentary photographer, because documentation uses a straight, honest approach. Well, I do have that straight approach, I do try to be honest, that is, basically true to myself and to the subject, but I'm not a documentarian, I never have been. I think of myself as poetic, a maker of visions, dreams, and a few nightmares.[23]

Defining himself to the interviewer Ivor Miller as a poet and 'a maker of visions', DeCarava distances himself from previous documentary projects, even though he also wants to solidify his role as an

insider in terms of Harlem's social and cultural history. The representation of this history – DeCarava maintains – can be rendered in ways that are reflective both of the photographer's personal eye and of wider collective anxieties and problems. When asked by Miller, 'How would you compare your notion of community survival with that of Walker Evans and other Farm Security Administration photographers who seemed concerned with community survival?', DeCarava sets himself apart from their 'documentary' gaze:

> They (the photographers) were concerned too, but it was an issue of the time. Photography was just coming into its own. It was also a time of economic scarcity. . . . When you're hungry it's very hard to be aesthetic. It's very hard to set aside time and money for materials, hard to think about 'loftier' ideas.[24]

The 'luxury' of thinking aesthetically rather than simply 'politically' is crucial and in some ways supersedes issues of class or economics for DeCarava. It also questions the assumption that African–American artists always have to be 'political' firstly and artistic secondly, and – more crucially – enables them to be both at the same time. For DeCarava, this relates directly to his experience as an African–American artist. When asked whether his so-called 'anti-documentary' aesthetic is similar to that of Robert Frank, DeCarava again responds in terms that directly refer back to his identity as an African–American:

> Frank saw the U.S. as a white person. If I had gone through the same towns side by side with Frank I would have seen something entirely different than he did. He is incapable of seeing what I see. But I can see what he saw. Because I have this duality, I am like a person with two languages. Most black people are. The reason his work was so well received was it showed just what the curators and critics wanted to see. He was critical of America. But only slightly critical. Not enough to upset the culture. . . . Whereas there is no doubt that my work reflects life as it is in the black community. . . . Frank saw one America, I see another.[25]

Unable to focus on the 'interpersonal relationships that grow out of social values', DeCarava sees Frank fundamentally as an outsider. He insinuates, in other words, that his own forte as a photographer

of Harlem lies in something more intimate, the ability to capture certain nuances that would not be tangible to a 'white' photographer. By re-establishing himself as 'a person with two languages', an African–American whose sense of duality is instilled in him or her through persistent social and cultural patterns, a larger metaphor emerges: one that extends itself in interesting ways to the co-existence of text and images in *The Sweet Flypaper of Life*.[26] Sister Mary may not fully articulate the schism of living within white society as an African–American and yet she is clearly representative of Langston Hughes and Roy DeCarava's 'two languages', and certainly representative of their desire to render a discourse both faithful to their individual artistic visions and representative of African–Americans in general.

In this context, DeCarava's reluctance to define the book as genuinely collaborative makes sense if we consider his images as vying for attention against two persuasive discourses: the authorial notoriety and distinction of Langston Hughes and that of his emphatic fictional character, Sister Mary. For Hughes, on the other hand, the political impact of *The Sweet Flypaper of Life* lies primarily in its ability to act as an antidote to contemporary reports of Harlem as a place of poverty and crime: 'We've had so many books about how bad life is, what it would seem to me to do no harm to have something along about now confirming its value.'[27] While Hughes's optimistic spin on *The Sweet Flypaper of Life* may have made the project acceptable to Simon and Schuster in 1955, it could also be a way simply to confirm the value of daily life in Harlem. Despite this, DeCarava later stated that adding text to his photographs was no more than 'a slight detour in his development'.[28]

Such comments by DeCarava interestingly contradict the relatively few readings of *The Sweet Flypaper of Life* to emanate from within African–American Studies. For Sonia Weiner, the strength of the book as a photo-text relies heavily, in fact, on the collaborative process of the two artists. As she argues, this process is thematically consistent and yet deliberately subverts the established norms of African–American representation. According to Weiner,

> the two media are linked and interrelated by a passion for subversion: the images created by DeCarava deviate from and subvert standard portrayals of black Americans in the mainstream media, while the text created by Hughes resorts to trickster tactics, articulating a double-edged message of compliance and subversion.[29]

Weiner's argument – in line with the problematics of the 'look and the look back' – relies on the assumption that 'the place of the documentary subject' is 'given in advance'. In these terms, 'a double act of subjugation' always occurs for the African–American artist, 'first in the social world that has produced its victims; and second, in the regime of the image produced within and for the same system that engenders the conditions it then re-presents'.[30] While she acknowledges the ways in which *The Sweet Flypaper of Life* tries to counter this 'regime of the image', the possibility that African–American artists themselves might reproduce such a 'regime', whether willingly or subconsciously, is left unexplored. Instead, she proposes that *The Sweet Flypaper of Life* is mostly a lyrical poetic exercise in photography, an exercise that thus tends to 'eclipse or obscure the political sphere, whose determinations, actions, and instrumentalities are not in themselves visual'.[31] In *The Sweet Flypaper of Life*, Sister Mary's tendency to sentimentalise her environment might mean, for instance, that the issue of equal rights is subsumed in a form of pathos rather than effective change.

Despite her trepidation regarding documentary photography as a 'double act of subjugation', Weiner concedes that a clever 'conceit' runs through the structure of *The Sweet Flypaper of Life*: a conceit 'that implies that the text was read differently by different audiences'. Thus dual readings are possible 'because Hughes crafted a dynamic text that accommodated two diverse audiences'.[32] According to Weiner, these dual audiences, black and white, would have read the book in vastly different ways: a valid assumption, given the segregated nature of Harlem at the time. None the less, whilst dual readings are a measure of the interaction between text and image in terms of its racial politics, they also reflect the difficulty in anchoring specific meanings to images, and vice versa, within the photo-textual format. For instance, African–American audiences might have seen a recognisable Harlem in DeCarava's photographs but not all African–American audiences would necessarily have seen Sister Mary Bradley as the most obvious proponent of such a vision. In other words, we have to consider if the appeal to both white and black audiences at the time is as deliberate and well thought out a mechanism as Weiner and other critics would like it to be.

For Weiner, though, the double-sided strategy of *The Sweet Flypaper of Life* is located not in the complexity of the images but

in the stereotypical aspects of Sister Mary's voice. In this respect, Weiner argues,

> the mammy's prose is perceived . . . to be simple and unassuming and forecloses other possible levels of meaning suggested by the images. Contemplating the photo-text, the reader/viewer could privilege the surface level of words spoken by a stereotypical mammy over the possible meanings conveyed by the accompanying images. Thus, the potential of the images to create affect, to be really seen, . . . is neglected or overlooked.[33]

By making the assumption that the 'voice and tone of Sister Mary's narration' will automatically overwhelm the accompanying images, Weiner does DeCarava's photographs a disservice. Even if *The Sweet Flypaper of Life* suffers from a form of pretend 'documentary verisimilitude', in which the voice of the mammy figure carries the traits of 'the hyper-ethnicised narrator', the fact that it differs from the faces in DeCarava's portraits has an impact on how we read the narration. Weiner's claim that Sister Mary's voice is designed to reflect a stereotype rather than validate it, to create an exaggeration in order eventually to 'further a positive representation' of the racial group, thus cannot adequately convey the interaction between text and image.[34]

This way of engaging in social critique, by delivering through speech the very figure of derision one attempts to overturn, is deemed by Weiner to be a form of 'refracted intention' – a way to create a clash between the outward statement, often made in vernacular dialect, and a deeper underlying complexity of meaning. In other words, 'the stereotype is evoked, only to be refuted'.[35] Interestingly, the concept of the 'refracted intention' may be more pertinent to other forms of photo-textual interaction than the one traced in *The Sweet Flypaper of Life*. The presence of exaggerated racial stereotypes, as we have seen, may indicate an inherent racism at the heart of the photo-text, as in Ulmann and Peterkin's *Roll, Jordan, Roll* and Margaret Bourke-White and Erskine Caldwell's *You Have Seen Their Faces*, but many of the same mechanisms – the linguistic ventriloquism, the vernacular simplicity of first-hand accounts – are similar to those in *The Sweet Flypaper of Life*. Such comparisons prove, then, just how difficult it is to define what really constitutes photo-textual 'sincerity'. At what point does an unintentional irony

in the representation of dispossessed people, regardless of colour, become a 'refracted intention'?

The problem with such readings, as DeCarava surmised in his attempts to move beyond a definition of himself as a 'black photographer', is that the photo-text's potential in lyrical terms always becomes secondary to its political efficacy. In the case of *The Sweet Flypaper of Life*, a disavowal of Sister Mary as just another instance of the placating mammy voice ignores the power of the photographs themselves to overturn such stereotypes. The risk is, then, that the photographs are seen by association as potentially sentimental and stereotypical, the very thing that DeCarava sought to counter aesthetically by relying on a more subjective rather than documentary approach.

In *You Have Seen Their Faces*, the discrepancies between the naïve commentary by the local population and the horrors of regional poverty in the photographs clearly created a schism. In *The Sweet Flypaper of Life*, the discrepancies between Sister Mary's optimistic narrative and DeCarava's more melancholy and introspective images have the potential to do more than simply undercut each other. Weiner's point, that Sister Mary's vernacular dialect and outwardly unsophisticated, stereotypical observations might identify her as a 'mammy', is complicated by DeCarava's images, which provide us with something fundamentally different. In other words, the photographs are designed to provide an insight into the ambiguities of Sister Mary's language rather than confirm them as a form of absolute 'truth'. Similarly, the narrator/Sister Mary's words not only engage with the images, but also count on them in the signifying process, inviting them to 'have their say' as well. The final page of *The Sweet Flypaper of Life* is, in this respect, crucial for an overall reading of the book (Fig. 8.3).

According to Maren Stange, 'Using the most verisimilitudinous of mediums and always referential rather than nonobjective, DeCarava ... makes form, rather than subject alone, convey his meanings.'[36] The idea that form, rather than subject alone, is instrumental is crucial to how we read the structure of *The Sweet Flypaper of Life*. The unusual design of the first edition paperback, with its narrative text beginning on the cover rather than after the title page, signals something both insistent and casual, just as the final page, with its portrait of Sister Mary, brings Hughes's narrative and DeCarava's photography univocally together. Far from the 'mammy' figure, the

ever so once in a while, I put on my best clothes.

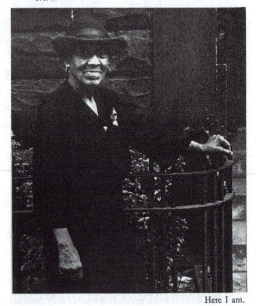

Here I am.

Fig. 8.3 'Portrait of Sister Bradley', in Roy DeCarava and Langston Hughes, *The Sweet Flypaper of Life* (New York: Simon and Schuster, 1955), p. 98.

last image presents us with a confident Sister Mary returning the gaze of the photographer rather than acquiescing to it. If the photos up to this point have worked to legitimise the fictional narrator's point of view, the returned gaze here is a way to legitimise that of the photographer too. The photo-text comes full circle in this sense, both structurally and emotionally, as the final illustration constitutes the disclosure of the narrator by finally showing us Sister Mary and closure of the book itself.

Whether DeCarava's reluctance to have his images 'thematically' tied to text – as he put it – was due to a desire for a more emotive 'musical' form of photography or a way to accentuate the authorial role of the photographer is another question. Interestingly, DeCarava – even after having established his reputation as a photographer – returned to the photo-textual format late in his

career. This culminated in the 2001 publication by Phaidon of *the sound I saw*, with text and photographs by DeCarava himself.[37] A mixture of poetry, commentary and quotations, and variously formatted images, *the sound I saw* – as DeCarava writes in the Preface – 'tries to present images for the head and for the heart, and like its subject matter is particular, subjective and individual . . . which is as it should be and was so intended'.[38] This quotation from the *sound I saw* reminds us of DeCarava's faith in a subjective vision. Here, photography is both uniquely individual, regardless of subject matter, and multifarious in its meanings to different people. If *the sound I saw* constitutes an extension of the lyrical vernacular landscape instigated in *The Sweet Flypaper of Life*, it also consolidates what was already present: namely, the symbiotic nature of the visual and the oral as something intensely subjective and personal.

What makes *The Sweet Flypaper of Life* a remarkable phototext is ultimately that it does not shy away from the dissonance inherent in the photo-textual interaction. This may be a strange phrase, considering the importance of rhythm and lyricism in the work of both Hughes and DeCarava, but it proves ultimately that the real charge of the photo-text lies as much in the awkward nature of the marriage between Hughes's Sister Mary and the gravitas of DeCarava's vision. Between formal beauty and mundane subject matter are discernible links to the documentary aesthetic of previous decades, but also an extension of the on-going belief in the camera as an instrument of cultural response as well as verification. Ultimately, *The Sweet Flypaper of Life* is more than a text that confirms Harlem's iconic status. It enables Harlem to become a site for a variety of encounters: an encounter between two forms of media, and an encounter between a photographer reticent to put himself forward as a visual spokesperson for the African–American experience, and a writer adept at doing so as a literary spokesperson for Harlem. *The Sweet Flypaper of Life* can be read as one of the seminal beginnings of a more meta-documentary form that will culminate in Robert Frank's *The Americans*, but above all, it allows us to consider DeCarava and Hughes as examples of a photo-textual practice already instigated in the pre-war era: one in which the emotional aspects of the documentary gaze were absolutely paramount.

Notes

1. According to Sonia Weiner: 'The images, it appeared, had no market. In representing the daily life of family and community in Harlem in an artistic and humane way, they dramatically departed from the general public's embedded conceptions of black Americans instilled by previous photographic efforts. As such, they were deemed politically subversive and far too liberal. Publishers felt that mainstream America was not yet ready to see these pictures.' Sonia Weiner, 'Narrating Photography in *The Sweet Flypaper of Life*', *MELUS*, 37:1 (Spring, 2012), p. 4.

2. According to Maren Stange, it was Hughes's Jesse B. Semple (often spelled Simple) sketches that made DeCarava contact Langston Hughes, the 'humorous conversations between two harlemites, one educated and northern and one southern and "semple"'. Maren Stange, '"Illusion complete within itself": Roy DeCarava's Photography', in Townsend Ludington, ed., *A Modern Mosaic: Art and Modernism in the United States* (Chapel Hill: University of North Carolina Press, 2000), p. 290. The sketches appeared as a column in the *Chicago Defender* and blurred the distinctions between 'fiction and the kind of vernacular reportage associated with WPA [Works Projects Administration] fieldwork'. Sara Blair, *Harlem Crossroads: Black Writers and the Photograph in the Twentieth Century* (Princeton: Princeton University Press, 2007), p. 52.

3. Gilbert Millstein, 'While Sister Mary Sticks Around', *The New York Times Book Review*, 27 November 1955.

4. Ibid.

5. Ibid.

6. Mason Klein and Catherine Evans, eds, *The Radical Camera: New York's Photo League 1936–1951* (New Haven, CT: Yale University Press, 2011).

7. The similarities between DeCarava and later meta-documentary work is noted by Richard Ings in '"And You Slip into the Breaks and Look Around": Jazz and Everyday Life in the Photographs of Roy DeCarava', in Graham Lock and David Murray, eds, *The Hearing Eye: Jazz & Blues Influences in African American Visual Art* (Oxford: Oxford University Press, 2009), p. 330.

8. Langston Hughes and Roy DeCarava, *The Sweet Flypaper of Life* (New York: Simon and Schuster, 1955), p. 66.

9. Ibid., p. 3.

10. *Roy DeCarava: A Retrospective January 25th–May 7th, 1996*, Press Release, Museum of Modern Art, New York, p. 2.

11. DeCarava started his career as a painter but by the late 1940s he was taking photographs of Harlem and other neighbourhoods, both journalistic

and personal. Having studied painting and lithography for two years at Cooper Union, he continued to study art at the Harlem Art Center in the mid-1940s. Subsidised by the Works Projects Administration, DeCarava embraced the opportunities of the New Deal arts programmes, did free-lance work for various foundations and became familiar with documentary photography, in journals and elsewhere.

12. Blair, *Harlem Crossroads*, p. 5.
13. Roy DeCarava was the first African–American artist to receive a Guggenheim grant in 1952, and the photographs he submitted to Langston Hughes within the following two years were largely done through this funding.
14. As quoted in 'Sunday Salon with Greg Fallis: Roy DeCarava', Utata Tribal Photography, available at <http://www.utata.org/sundaysalon/roy-decarava/> (last accessed 27 July 2018).
15. Blair, *Harlem Crossroads*, p. 52.
16. This type of racial ventriloquising also, paradoxically, shares an affinity with Erskine Caldwell's ventriloquising in *You Have Seen Their Faces* and, in other ways, with Wright Morris's stand-in persona in *The Home Place*, as seen in previous chapters.
17. Weiner, 'Narrating Photography', p. 178.
18. Ibid., p. 176.
19. Roy DeCarava, *the sound I saw* (New York: Phaidon, 2001). Conceived, designed, written and made by hand as a prototype by DeCarava in the early 1960s, yet unpublished in hard cover until 2001. The sequencing, layout and design of the book are made to accentuate the spontaneity of the unposed portraits of mostly jazz musicians, which, in turn, are accompanied by text inserted by DeCarava himself.
20. Ivor Miller, '"If It Hasn't Been One of Color": An Interview with Roy DeCarava', *Callaloo*, 13:4 (Autumn, 1990), pp. 847–57.
21. As Blair points out, 'it is startlingly evident that virtually every African American writer of national significance during the post-war period engaged directly with the effects of documentary photography'. Blair, *Harlem Crossroads*, p. 55.
22. DeCarava to Minor White, 21 November 1955, cited in Maren Stange, 'Illusion complete within itself"', p. 280.
23. Quoted in Miller, '"If It Hasn't Been One of Color"', pp. 847–57.
24. Ibid.
25. Ibid.
26. The expression is a likely reference to W. E. B. Du Bois's theory of the 'double consciousness' of the African–American, 'of always looking at one's self through the eyes of others, of measuring one's soul by the tape of a world that looks on in amused contempt and pity. One ever feels his two-ness, – an American, a Negro.' W. E. B. Du Bois, *The Souls of*

Black Folk [1903] (New York: Bantam Classic, 1989). This sentiment is also referenced directly in an earlier instrumental photo-text on African–American life: Richard Wright, *12 Million Black Voices*, photographs compiled by Edwin Rosskam (New York: Viking Press, 1941).

27. Langston Hughes, quoted in Millstein, 'While Sister Mary Sticks Around'.
28. Stange, '"Illusion complete within itself"', p. 289.
29. Weiner, 'Narrating Photography', p. 176.
30. Ibid.
31. Ibid., p. 179.
32. Ibid., p. 176.
33. Ibid.
34. Ibid.
35. Ibid.
36. Stange, '"Illusion complete within itself"', p. 283.
37. DeCarava, *the sound I saw*.
38. 'Preface by Roy DeCarava', in ibid.

CHAPTER 9

Beat Poetics in *The Americans* (1959)

A lesson for any writer. . . . To follow a photographer and look at what he shoots. . . . I mean a great photographer and look at what he shoots. . . . I mean a great photographer, and artist. . . . And how he does it. The result: Whatever it is, it's America.

Jack Kerouac, 'On the Road To Florida' (1955)[1]

Robert Frank's iconic black and white photographs of America in the 1950s, published in book form as *The Americans* in 1958 in Paris and in a US version in 1959, are commonly seen as examples of a definitive post-war turn within documentary photography: the moment when documentary aesthetics – instead of focusing solely on the external landscape as an indicator of the state of America – started to use that landscape as an indicator of the internal landscape of the photographer. None the less, as previous chapters have sought to elucidate, such demarcations rarely function very neatly. If a turn towards a more introspective version of the 1930s documentary aesthetic could be seen in Wright Morris's 1948 *The Home Place*, it was perhaps because the seeds of an internalised, even private, perspective were already present in the pre-war work of Walker Evans. In turn, Evans himself was capitalising on certain literary and philosophical traditions – just like his collaborator, James Agee – that went back to the nineteenth century, even if they were used to define a more modernist turn within photography. Nevertheless, Frank's *The Americans* is still predominantly seen as a departure from earlier photo-texts seeking to identify a quintessentially American landscape. In fact, it is rarely defined as a photo-text in the ways that this study has outlined. Shining a spotlight consistently on Frank's move away from the type of clarity and sharpness seen in Evans's work, for

instance, it is the uniquely recognisable vision of Frank that remains the main subject of most existing work on *The Americans*. With its focus on people on the move, both physically in buses and cars, and emotionally in terms of shifting social and racial alliances, *The Americans* has become synonymous with a vision of America that is both wistful and subtly critical: a vision that is credited largely to Frank's unique photographic style rather than to an existing lineage of photo-textual and documentary work.

This focus on Frank's photography as marked primarily by a distaste for an emerging American landscape marked by commodification and branding has provided the book overall with a sort of renegade status, critically acclaimed but seldom analysed in a literary sense. Side by side, the careful sequencing of images of working-class Americans celebrating holidays, meeting after church and at drive-ins, thus strikes at both a curiously romanticised vision of 1950s America and a palpable sense of the alienation, conservatism and segregation of the McCarthy era. However, Frank did not present his photographs in *The Americans* in a literary vacuum, and it is partly through an investigation of Frank's choice of the equally famous Beat writer, Jack Kerouac, as the writer of the book's Introduction that one can begin to decipher not only the incongruities of the book itself but also the degree to which it leans on and continues various traditions instigated by Evans in the 1930s.

Paradoxically, Frank's choice of Kerouac for the Introduction to the American version came after disappointing editorial alterations in the first French edition that pre-dated publication in the United States. The French publisher Delpire inserted extracts from a variety of sociological texts on America into the main body of the text, thus essentially presenting it more closely as a genuine synthesis between writing and photography. As such, one question is why Frank decided against this format. Did he want the collection of photographs to stand more firmly on their own or was he unhappy with the more sociological and statistical type of commentary that Delpire had chosen? The answer is probably that Frank intuited the book's potential anti-establishment reputation and did not want the meaning of the photographs steered in a particular direction by text chosen by anyone else, and not that he was averse to having any text in the book per se.

On the contrary, when given the opportunity, Frank chose a writer for his Introduction for whom *The Americans*, rather than

being a sociological treatise, was about 'the humour, the sadness, the EVERYTHING-ness of . . . pictures', as Kerouac put it. Constituting no less than a book about 'the vast promise of life', the images represented – according to Kerouac – both the 'humankind-ness' and 'human-kindness' of that 'speechless distance' of a personal America beyond contemporary politics.[2] Kerouac's intense poetic vision of Frank as an artist operating 'beyond contemporary politics' was the complete antithesis to the more commonly held view at the time of the book's publication: that *The Americans* was simply a 'sad poem for sick people', a book about the 'wild, sad, disturbed, adolescent, and largely mythical world' of the Beats, a book whose 'relaxed snapshot quality' – according to Arthur Goldsmith in *Popular Photography* – 'lacked sociological comment, and had no real reportorial function'.[3]

Such criticism did *The Americans* a disservice long after its radical agenda was subsumed and legitimised in the wake of more overtly politicised projects in the late 1950s and onwards. Forced to counter the accusation that *The Americans* paradoxically was primarily anti-American, many admirers – in an attempt to save the book's reputation – neglected Kerouac's Introduction. On the one hand, this could be a testament to the immense vision of Frank's images, to the cohesive nature of their various themes and the places charted.[4] On the other hand, it could also be because the Introduction appeared unmatched and ill suited to a group of photographs whose impetus relied on being unmoored from existing 'visions' of America. Even if those views emanated from a writer enjoying huge international fame after the publication of his most famous book, *On The Road*, only a few years previously in 1957, Kerouac's writing was still part and parcel of a longer lyrical tradition – one that most readers would not equate with documentary photography

As it turned out, *The Americans* has never been reprinted without Kerouac's Introduction. For Frank, then, it was crucial that his reputation as a documentary photographer be 'introduced' to a wider American audience through the voice of Kerouac, even if that voice came without any overt knowledge of photographic practice. None the less, Frank empathised with the Beat movement for many reasons and was, in fact, in the process of collaborating with Kerouac on a different, albeit somewhat related, project. *Pull My Daisy*, a short film from 1959, was directed by Frank and by Alfred Leslie, and partially adapted by Kerouac from the third act of an unfinished play, *Beat Generation*. The narration for the short film

was allegedly improvised by Kerouac, and in the cadence and use of imagery, numerous features appear that are also present in the Introduction to *The Americans*. The film featured, amongst others, the poets Allen Ginsberg, Peter Orlovsky and Gregory Corso, and Kerouac's voice-over provides a lyrical accompaniment to an afternoon get-together in which the poets ruminate on writing and the meaning of life.[5]

As in *Pull My Daisy*, Kerouac's modus operandi in the Introduction to *The Americans* is to provide a heightened aesthetic rendering of the everyday, in which seemingly anecdotal visual events – children lounging in the back seat of a car, a lift girl leaning against a wall – are given emotional significance. In the short film, Ginsberg proclaims the importance of another American poet from the 1930s, Hart Crane, whose *The Bridge* (1930), not coincidentally, was published in an edition accompanied by a selection of photographs by Walker Evans.[6] Through what can only be defined as a distinctly similar lyrical tradition, Kerouac – like Crane and Evans before him – seeks to provide an aesthetic outlook able to render both a love for America and a natural distrust of its politics. In this sense, Kerouac constituted a writer who was conversant with previous homages to American photography, albeit from a distinctly poetic perspective – a fact that Frank would have appreciated. A contemporary of Hart Crane, William Carlos Williams had provided an Introduction for the precursor to *The Americans*, Evans's *American Photographs* (1938), and this was probably familiar to Frank via Ginsberg – a compatriot of Williams's from Paterson, New Jersey. Once again, the intermingling of lyricism and the vernacular – from the 1930s to the late 1950s – not only takes on a heightened meaning during the 1950s, but also becomes a manifest presence in an ever-expanding network of photographically interested writers. In this regard, it is worth remembering Williams's original comment on Evans's *American Photographs*, in which he establishes the importance of the vernacular for photography:

> It is ourselves we see, ourselves lifted from a parochial setting. We see what we have not hitherto realized, ourselves made worthy in our anonymity. What the artist does applies to everything, every day, everywhere to quicken to elucidate, to fortify and enlarge the life about him and make it eloquent. . . . (By this, by the multiplicity of approach . . . Men are drawn closer and made to feel their separate greatness Evans is that. He belongs.)[7]

Williams's delineation of a manifesto for American photography combines, as Kerouac will later do with Frank, an enlarged vision of democracy enabled by a photography that unites the subject, the photographer and the reader in one continuous action. The issue – once again – is how to insert photography into a democratic heritage, and for Kerouac it is through the self-same mechanisms that Williams foregrounds in Evans: the ability to recognise the American landscape as both an internal and an external entity. Kerouac's vision of 'humankind-ness and human-kindness', however, does more than just mimic Williams's assertion that 'men . . . are made to feel their separate greatness'; it is also about a respect for location, for regionalism and for landscape in a wider sense, without which there can be no true American art. As Williams says, 'of only one thing, relative to a work of art, can we be sure: it was bred of a place'.[8]

Seen in the light of this, Kerouac's Introduction to *The Americans* is not just about Frank and Kerouac's fascination with each other as fellow 'Beat' artists; it is about two perceptions of America and how these perceptions mediate and question what photography can and cannot do. For both artists, the representation of America enables a necessary questioning of certain documentary presumptions: how does the interplay between imagination and perception assume substance without pretence, and how, more importantly, does the artist deal with the dichotomy between writing and photography when both function as a form of artistic self-affirmation, as well as social analysis?

For Kerouac, Frank's poetic photography portrays a personalised perspective on the phenomenal world: a perspective that can do no less than transform the everyday, the ordinary, through an intense investigative look, not dissimilar to Agee's reading of Evans's images. Kerouac saw Frank as enabling a vision of America, resonating with his own writing, in which the seemingly innocuous – the car park, the supermarket, the jukebox in the diner – becomes emblematic of life, not just lived, but seen in poetic terms as well: a form of double vision. The idea of a double vision is about the synthesis between art and lived life, and about the transformation of the American people, seen in ordinary situations as extraordinary human beings. Discernible here, then, is something similar to Roy DeCarava's photographs of Harlem residents, going about their daily business and yet, at the same time, vessels for the alienation and occasional despair inherent in urban African–American life.

As DeCarava focused on the resilience of the segregated occupants of New York in an era of civil rights issues, Langston Hughes's response to this was to render the psyche of the residents partly through Sister Mary's narrative. For Kerouac – despite his attempts to stay clear of any ventriloquising of the 'common man' – Frank's ability to comment on events as seen when they happened, and as they appear symbolically charged after the fact, also enables the psyche of the nation to appear. In this sense, *The Americans* mirrors both the wider issues of how Americans felt during the 1950s and Frank's own fundamental aim as an artist.

In the Introduction to *The Americans*, Kerouac spells out a vision of photography as transcendent, as able to use concepts of space and temporality in order to convey certain essential truths – truths that are ever-changing in the context of a rapidly moving America:

> Madroad driving men ahead – the mad road, lonely, leading around the bend into the openings of space towards the horizon Wasatch snows promised us in the vision of the west, spine heights at the world's end, coast of blue Pacific starry night . . . orangebutted west lands of Arcadia, forlorn sands of the isolate earth, dewy exposures to infinity in black space . . . the level of the world, low and flat: the charging restless mute unvoiced road keening . . . ditches by the side of the road, as I look.[9]

In illuminating the mnemonic and iconographical power of the photograph, Frank's ability to show the 'everythingness' of America becomes less a listing of the component parts of a civilisation than an attempt to portray the contradictory meanings inherent in so much American iconography. Turning the photographer into an American *flâneur*, 'the crazed voyageur of the lone automobile', and the highway into the gateway to the heart and soul of America, Kerouac represents Frank as his sidekick on 'the charging restless mute unvoiced road' and himself as the poet giving voice to that road.[10] If Kerouac is the one providing the lyrical accompaniment to the images, he is none the less doing this 'as he looks' at the 'dewy exposures to infinity'. Not only does this render an oblique reference to Frank's camera shutter, but also it aligns the camera – as William Carlos Williams did with Walker Evans – with a transcendent mode of representation.

In these terms, the photographs become poetic rather than social gestures, at least as they appear in Kerouac's writing. Similarly, the ways in which Kerouac's language – although, at first glance, predominantly lyrical and descriptive in tenor – incorporate allusions to the actual process of photography are subtle and yet significant. In fact, there is more of an alignment being created between writer and photographer than might be expected in an introduction. What Kerouac does, effectively, is open up the possibility of a more introspective approach than the images themselves potentially convey. This does not mean that Kerouac deliberately sets out to downplay Frank's critical assessment of post-war America, simply that Frank's 'anti-aestheticism' – his use of blurry and less technically perfect images, read through Kerouac's own literary parameters – becomes a way to improvise on what the photographs mean.

Illuminating Frank's 'anti-aestheticism', his move away from the journalistic conventions of documentary practice through Kerouac's improvised literary style, carries its own pitfalls. Unlike the thought-out response to Evans's *American Photographs* by Lincoln Kirstein and William Carlos Williams, Kerouac's writing is a mismatch of observations, homage and self-reflexivity, enabled by the camera as a metaphor for a form of image-led writing. In this context, Kerouac shares more, as mentioned earlier, with Agee's tendency to move from aesthetics to contemplative writing and back again – all in one sentence. As with Agee, rather than diffuse the book's political content, Kerouac simply repositions it, as Agee often does in *Let Us Now Praise Famous Men*, to fit his own agenda. Like Agee, Kerouac's focus on the beatific, as an entry into a more emotive reading of the photographs, conveys a reluctance to provide a straightforwardly political reading of the images' content, not because he considers them apolitical per se but because it detracts from the beauty of the project itself. As Kerouac puts it, the faces do not editorialise or criticise, or say anything but 'This is the way we are in real life and if you don't like it I don't know anything about it 'cause I'm living my own life my way and may God bless us all. . . .'[11] For Kerouac, the integrity of the project lies in the fundamental respect afforded its subject, and not necessarily in its political astuteness. On the contrary, what Kerouac sees in Frank is a desire to cleanse the collective sins of America, and in this respect, merely pointing them out is insufficient, an approach that is very close to Frank's commentary on

the project itself, in distinct contrast to the ways in which subsequent critics tend to have looked at the book. According to Frank,

> Most of my photographs are of people, they are seen simply, as through the eyes of the man in the street. There is one thing that the photograph must contain the humanity of the moment. This kind of photography is realism. But realism is not enough there has to be vision, and the two together make a good photograph. It is difficult to describe where this thin line, where matter ends and mind begins.[12]

Inherent in this ethos is a fundamental belief in photography's humanist potential: a potential that cannot be divorced from the artist's sense of self-worth. The fact that the Introduction is written as one artist's homage to another, rather than as an informative piece that explains the book's inception, is thus crucial. Within Kerouac's appreciation of Frank lies a simultaneous acceptance of an inward and humanist thrust within photography. Thus while Kerouac and Frank may have been 'countercultural' in the context of the 1950s, their position, in this respect, aligns itself much more with Williams's 1930s demarcation of a photography in which the vernacular, the everyday, is seen as the stuff of both democracy and art.

This intrinsic paradox has to be taken into account in any assessment of *The Americans*. If Frank's images are caught between a representative value, largely determined by the political context of the times and their ability to give a sense of an inward journey in emotional terms, this is not necessarily a flaw. Hence, straightforward readings of them as primarily critiques of racism, materialism and patriotism inevitably fall short. If *The Americans* is a narrative on American values as well as on two men's inward journey through a particular landscape, it is also a narrative on what it means to be a photographer and a writer at the tail end of a particular documentary tradition, instigated in the 1930s but with far-reaching implications: a tradition, as this study has outlined, that sought to reconcile photography's role as both art and social commentary.

The dichotomy faced by both Frank and Kerouac was how to visualise something inherently political through an already idealised American iconography: an iconography largely established in the 1930s and in the work of Evans in particular. This dichotomy,

however, also constitutes the book's strength, in so far as Frank and Kerouac are faced with the same problem faced by Evans and Agee in the 1930s: wanting to be both Emersonian in their belief in the so-called 'common man' and innovative in intellectual and artistic terms.[13] Frank's awareness of situating himself within a specific tradition of American documentary photography is thus implicit within the book and can be seen, crucially, in his choice of Evans as a referee for the Guggenheim application that enabled him to go across the USA – just as DeCarava did – and take the pictures that became *The Americans*. While Frank's list of referees also included Alexey Brodovitch, photographer and art director at *Harper's Bazaar*, and Edward Steichen, curator of photographs at MOMA, Evans was the one who rewrote the application eventually submitted by Frank to the Guggenheim committee.[14] In Frank's application, he (and Evans) position *The Americans* within a longer tradition of documentary photography by connecting the elasticity of the material with the consciousness of the photographer. As Frank puts it,

> I am applying for a fellowship with a very simple intention: I wish to continue, develop, and widen the kind of work I already do, and have been doing for some ten years, and apply it to the American nation. . . . I am submitting work that will be seen to be documentation . . . carrying its own visual impact without much word explanation. The project I have in mind is one that will shape itself as it proceeds, and is essentially elastic. The material is there; the practice will be in the photographer's hand, the vision in his mind . . . one cannot do less than claim vision if one is to ask for consideration.[15]

Frank's claim for vision as paramount to the photographic process may be a spiritual one but he is careful to delineate it in terms that do not undermine the sociological and historical context. He writes that his intention is simple, the work essentially documentary, and yet he wants to spiritualise 'the things that are there, anywhere and everywhere – easily found, not easily selected and interpreted'.[16]

This paradigm of documentary integrity is more than simply reminiscent of Evans's practice. Similar to Evans's choice of subjects in *American Photographs*, Frank searches for 'the things that

are there, anywhere and everywhere'. The implication is not, however, that the mundane be elevated, rather that a vernacular quality is illuminated as symptomatic of something spiritual. The ability to 'select and interpret' – like Evans's – becomes a marker for a photography in which the vernacular is synonymous not just with the cultural artefacts of the average American, but with something beyond the utilitarian value of the objects and places portrayed. One of the political ramifications of such a vision is precisely to illustrate that there are no 'average' Americans. Every person is a thing of beauty, even when not portrayed in heroic terms.

This quality is fundamental to the romantic thrust within Frank's ethos. It is romantic, not in the sense that it mystifies the photographic process, but in the way it maintains the illusion of an America heroically struggling to survive such things as industrialisation, racism and urban alienation, issues that had already taken form in *The Sweet Flypaper of Life*. This sense of the photographer as a heroic agent of sorts bears similarities to many of the collaborative projects in this study: above all, in Agee's elevation of Evans as more than simply the recorder of dismal social and economic circumstances. Like Agee, Kerouac is eager to present Frank as an artist of lyrical and not just realist dimensions: 'Robert Frank, Swiss, unobtrusive, nice, with that little camera that he raises and snaps with one hand he sucked a sad poem right out of America onto film, taking rank among the tragic poets of the world.'[17]

Beyond Agee and Williams, though, the alignment of photography and poetry harks back in large measure to a nineteenth-century tradition. As seen in Chapter 3, the Transcendentalism of Ralph Waldo Emerson and such writers as Walt Whitman consolidated the American landscape as a place where the idea of democracy and language could be realigned, where the visionary and the everyday could coincide. For Kerouac, like Whitman, in order for the poetic quality to be present, the images and writing have to convey the beauty of the indigenous language and culture from which they stem. In this sense, it is not just the equation between the photographic image and poetry that is crucial, although Kerouac categorically states in the Introduction, 'Anybody doesn't like these pitchers don't like potry, see?'; it is about capturing the vernacular speech patterns of the subjects themselves, their veracity and authenticity in linguistic terms. However, for Kerouac – unlike Morris, who leaves the vernacular speech patterns deliberately intact in *The Inhabitants* – the vernacular sounds

are reinscribed into his own prose. Describing an image of a truck driver's profile – 'Car shrouded in fancy expensive tarpolian (I knew a truckdriver pronounced it "tar-polian")' – Kerouac sounds out the words as a way to contextualise an image.[18] For Kerouac, then, the beatific nature of the vernacular – in both a spoken and a visual sense – works on a number of levels. On one level, it aligns itself to the American's landscape's ability to point to the godly and the transcendental through an embrace of vernacular culture, while on another, it provides Kerouac with an allegory for the process of writing itself: 'In old busted car seat in fantastic Venice California backyard, I could sit in it and sketch 30,000 words . . . and Robert's here to tell us so.'[19]

If photography operates as an allegory for the process of writing, it also refers back to the archetypal exploration of America as Kerouac's 'great' theme, albeit a theme that extends beyond the regional parameters witnessed in the photo-textual collaborations so far. Photography in this sense is as much about defining the utilitarian value of American ideals and dreams as it is about creating a new voice. This is made clear at the beginning of the Introduction, where an idealised vision of the landscape is appropriated into the photographer's gaze:

> That crazy feeling in America when the sun is hot on the streets and the music comes out of the jukebox or from a nearby funeral, that's what Robert Frank has captured in tremendous photographs taken as he travelled on the road around practically forty-eight states in an old used car (on Guggenheim fellowship) and with the agility, mystery, genius, sadness and strange secrecy of a shadow photographed. . . . After seeing these pictures you end up finally not knowing whether a jukebox is sadder than a coffin. That's because he's always taking pictures of jukeboxes and coffins – and intermediary mysteries like the Negro priest squatting underneath the bright liquid belly mer of the Mississippi . . . with a white snowy cross and secret incantations . . . I never thought could be caught on film much less described in its beautiful visual entirety in words.[20]

The spiritual quality that permeates the landscape is indefinable and permanent, luminous and dark at the same time (Fig. 9.1). Rather than elevate the iconographical status of objects, as Agee did in *Let Us Now Praise Famous Men*, Kerouac speaks of the

Fig. 9.1 'Mississippi River, Baton Rouge, Louisiana', in Robert Frank, *The Americans* (New York: Grove Press, 1959), p. 103. Copyright © Robert Frank From *The Americans*; courtesy Pace/ Macgill Gallery, New York.

ontological status of the photograph: its ability to catch interme-diary mysteries without rationalisation. Kerouac does not want a rationalised version of the photographic process, but chooses to see Frank's images as markers for an intermediary state: a state that exists, on the one hand, between life and death, and on the other, between material reality and the spiritual. One could argue that Kerouac's work in general hinges on the idea of art as a mediation between life and death but in this instance it uses the photograph specifically as an example. The photograph's mnemonic quality lies in its ability to refer to all those things in America – the juke-boxes, the coffins, 'the cemeterial night' – that will eventually be lost. What photography accentuates is not just the element of time but the ability to synthesise what Kerouac aims for in his own writ-ing: the creation of a narrative that derives from image and always leads to image. It is no coincidence that the writing of the Introduc-tion, as mentioned previously, also followed his well-known novel *On the Road* (1957), written over a number of years and based

on his travels with Neal Cassidy and other 'Beat' writers. Parts of the Introduction to *The Americans* are nearly verbatim copies of material written by Kerouac for another text (eventually published posthumously) entitled *Visions of Cody* (1970), in which a series of experimental prose initially meant for *On The Road* was re-edited as an improvisational homage to Neal Cassidy (Cody).[21] For Kerouac, then, material about one poet/travel companion could be 'recycled' in the context of another, and more importantly, the visual eye of one artist – Frank – could be described in terms that did not significantly differ from that of 'Cody', another poet who 'travelled on the road around practically forty-eight states in an old used car'.

The fact that the idea of travelling was more of a defining aspect than whether he was writing about a poet or a photographer is telling. It is also one of the reasons why Kerouac's definition of photography in *The Americans* locates the action of looking in the very *process* of recording rather than in the rendering of the finished object/photograph. Rather than describe the actual images in *The Americans* as realistically as possible, Kerouac inscribes them into a fluid temporality: the truck driver is rendered distinct through his creative use of language rather than a static description of his appearance; the Mississippi is embodied and humanised through its 'bright liquid belly mer', a vision of something both intimate and constantly in motion. Playing on word use throughout, and sound constructions both intentional and unintentional, Kerouac chooses the word 'mer' to describe the Mississippi, harking back to his French/Canadian background. However, in this example, it does more than simply connote the sea in French; it also sounds out the word 'mother' – as though *The Americans* themselves form an extended family, with the photographer/writer as the proverbial orphan seeking to reconnect with the spaces he traverses.

In such terms, the photograph transcends its subject because of its simultaneous ability to convey culture as it exists symbolically, in the torn flags and neon signs, and in the individual's actual experience of that culture. One could argue that in this lies an impossible desire: the desire to eliminate the dichotomy between actual lived experience – as portrayed in the photos of everyday life – and Kerouac's imagined and possibly idealised experience of that life. Whether these contradictions convey the complex processes involved in the book's composition is a different issue, but it is an

issue that could just as well be gleaned from Agee's deep-rooted desire to portray the sharecroppers in *Let Us Now Praise Famous Men* as idealised versions of an agrarian culture. Such dilemmas, inscribed into the very nature of the photo-text, may not clarify what editorial, creative and sequential means were adopted by Frank to unify his photographic material, but then again, this is not what Kerouac considered his remit. What the embrace of these various contradictions does is position both Kerouac and Frank as artists moving away from the documentary format as envisioned previously, and yet part of a longer tradition as seen in the collaboration between Agee and Evans.

This is not to say that there is a seamless progression from the concerns of the 1930s, regarding how to identify a quintessential American identity, that runs straight through to the 1950s. In comparison to Langston Hughes and Roy DeCarava's Harlem photo-text, which also seeks to render an emotional landscape rather than an overview of a region, the expansive nature of *The Americans* seems fundamentally different. This is not simply because of Frank's 'outsider' status but rather because the observational perspective allows for a sense of distance between the camera eye and the subject, and also because the territory examined spans a much larger and varied area. Kerouac may have intuited this and, in his own way, for better or for worse, sought to bridge this distance by spiritualising the process, by making it something larger and more personal than 'simply' a documentary venture. The problem is that in Kerouac's eagerness to spiritualise Frank's effort, the social and political terrain charted tends to disappear, another thing that distinguishes the writing in *The Americans* from, for instance, that in *The Sweet Flypaper of Life*. The politics of juxtaposing white and black, both photographically and racially, often become subsumed: for example, in Kerouac's obsession with the photograph's ability to do no less than reconcile the artist with his own mortality.

Is Kerouac's Introduction, then, fundamentally a search for spiritual confirmation? More importantly, is it a search for confirmation centred primarily around Kerouac's own redemption rather than that of the photographer or his subjects? Certainly, much of the writing implies that, in the idealised sphere that Frank's images occupy, some fundamental truth also exists. In this respect, the funeral references to coffins and crosses in Kerouac's Introduction are crucial and not merely a couched reference to, for example,

American politics in the Cold War era. For Kerouac, the 'snowy cross' is the cross that the artist has to bear and Frank's images become, in their own way, the redemptive version of that process. Frank's ability to convey 'the sad eternity' and the

> sweet little white baby in the black nurses arms both of them bemused in heaven, a picture that should have been blown up and hung in the street of Little rock, showing love under the sky and in the womb of the universe the mother

becomes a reminder of America's need for absolution as much as a glaring indictment of racism in 1950s America.[22] For Kerouac, there is ultimately no distinction between the politics of Little Rock and 'the womb of the universe' (Fig. 9.2).

Such alignments occur frequently throughout the Beat canon, in both poetic and fictional terms. According to Ginsberg, 'Art lies in the consciousness of doing the thing, in the attention to the happening,

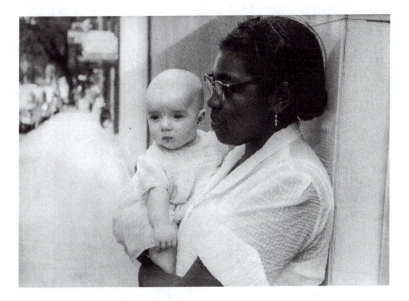

Fig. 9.2 'Charleston, South Carolina', in Robert Frank, *The Americans* (New York: Grove Press, 1959), p. 35. Copyright © Robert Frank From *The Americans*; courtesy Pace/Macgill Gallery, New York.

in the sacramentalization of everyday reality, the God-worship in the present conversation, no matter what.'²³ Ginsberg's 'sacramentalization of everyday reality' is another version of Kerouac's 'The humour, the sadness, the EVERYTHING-ness and American-ness' of *The Americans*, another way to provide an essentialist vision of America through the sacred nature of its citizens. Thus the ability to supply a vision cohesive and 'true' has little to do with realism and everything to do with the redemptive strength of the photographer's eye. Like Williams, Ginsberg clearly shared the poet's obligation to '[sacramentalize] the everyday'. Again, as in Williams's writing on Evans, it is the redemptive strength of the photographer's eye that enables the translation of the transcendental into an actual image. In describing this process, Kerouac creates an America in which the physical landscape, by being photographed, becomes nothing less than godly. Reminiscent of Whitman's expansive vision in *Leaves of Grass* (1855), Kerouac floats the poet's eye above the actual terrain of Frank's images and describes a landscape vastly different from what is actually seen in the book:

> Drain your basins in old Ohio and the Indian and the Illini Plains, bring your big Muddy rivers thru Kansas and the mudlands, . . . Raise your cities in the white plain, cast your mountains up, bedawze the west, bedight the west with brave hedgerow cliffs rising in Promethean heights and fame – plant your prisons in the basin of the Utah moon – nudge Canadian groping lands that end in Arctic bays . . . America – we're going home, going home.²⁴

Although it has elements of an encompassing indexicality, this vision is more than just a Whitmanesque exercise. It is, on a fundamental level, about the writer *creating* a certain type of America. While the listing of places refers obliquely to a sense of movement and travel, Kerouac's descriptions seem more Ansel Adams-like, more picturesque and ultimately less personal than Frank's focus on people in *The Americans*. Here, the natural habitat is described in terms of an idealised homeland, curiously devoid of human faces. It is not that human activity is not present – the raising of cities like children, the setting of prisons and so forth – but these activities, rather than being potentially politicised visions of territorial encroachment, are, on the contrary, synonymous with a vision of America as a safe haven, a pastoral grandeur rising in 'Promethean heights'.

What the long taxonomic passages do is move the reader beyond the parameters of Frank's actual subjects, a process that Agee also initiates in his own taxonomic passages on the sharecroppers' surroundings in *Let Us Now Praise Famous Men*. In 'real' terms, these are not descriptions that accord with the actual images in *The Americans*. In emotional terms, they may nevertheless provide a sense of Frank's ambitions. In interviews, Frank acknowledged his debt to Walker Evans's vision:

> When I did *The Americans* I was very ambitious. . . . I had the right influences – I knew Walker's photographs, I knew what I didn't want, and the whole enormous country sort of coming against my eyes. It was a tremendous experience, . . . seeing those faces, those people, the kind of hidden violence. The country at the time – the McCarthy period – I felt it very strongly. I think that trip was almost pure intuition. I just kept on photographing, I kept on looking. . . . I had a feeling of compassion for the people on the street. That was the main meat of the book.[25]

While allowing for a political reading that takes into account the McCarthy era, Frank none the less chooses, above all, to personalise the project. Rather than establish an all-pervasive critical tone, Frank – not unlike Kerouac – returns to a more emotive and ultimately biographical tone:

> I have attempted to show a cross-section of the American population. My effort was to express it simply and without confusion. The view is personal and, therefore, various facts of American life and society have been ignored. Above all, I know that life for a photographer cannot be a matter of indifference. Opinion often consists of a kind of criticism. But criticism can come out of love. . . . Also it is always the instantaneous reaction to oneself that produces a photograph.[26]

Frank's turning of the photographic subject, from America at a time of political unrest and anxiety, and onwards to that 'instantaneous reaction to oneself', accentuates the belief in photography as ethical and political, personal and emotive in ways that Kerouac's Introduction simply cannot do.[27] Like Kerouac, however, Frank stresses

a vision in which the photographer's state of mind during and after the process of documentation is paramount.

Thus the link between Kerouac's vision and Frank's reaches beyond particular themes and subjects. It is about how a particular form of documentary photography enables the canonisation of the photographer as well as the subjects he photographs, a process that – as seen in previous chapters – was well under way in the pre-war era. While it may be easier to criticise Kerouac's tendency to elevate the photographer's prophetic role, the self-same factors are present within Frank's photographic ethos. According to Frank,

> I did the best I could in *The Americans* to say that life in America was beautiful in spite of all the problems, and it didn't really matter that much to me that so many people thought I had meant to say the opposite.[28]

This does not mean, of course, that Frank was not acutely aware of the social and racial divisions that marked the American landscape. What it does mean is that Kerouac's Introduction allows for an alternative view of *The Americans*, in which the creation of a cohesive view of a nation composed of a multiplicity of entities is more important. It is, on a philosophical level, about the creation of coherency, about using – as Kerouac did – the indexicality of America as a way to turn the potentially chaotic and fragmented parts of the American psyche into a more discernible and attractive whole. In commentary by Frank, this sense of Kerouac being enamoured of the landscape surrounding him is made clear:

> With Kerouac I did like very much what he wrote, the way he writes. Because he really did love America in a very simple and direct way, and in a quiet way. . . . I thought he wrote very well about the pictures and how he felt about them. If I continued with still photography, I would try and be more honest and direct. . . . And I guess the only way I could do it is with writing. I think that's one of the hardest things to do – combine words and photographs.[29]

The interest in how to represent the medium's self-reflexive nature did not, however, come to Frank once he had exhausted the idea of reformulating the relationship between documentary writing

and America. It was already present in the wording of the original Guggenheim application and in the previous photo-textual collaborations from which Frank took his cue. Thus establishing himself as both an outsider in national terms and an insider in terms of photographic know-how became a way to accentuate a unique perspective – a perspective both enthralled and appalled by what it saw:

> The photographing of America is a large order – read at all literally, the phrase would be an absurdity. What I have in mind then, is observation and record of what one naturalized American finds to see in the United States that signifies the kind of civilization born here and spreading elsewhere.[30]

When John Szarkowski, the director of photography at MOMA, wrote on Frank in 1968, he – like so many critics before him – downplayed the book's Introduction in favour of the actual content of the photographs. For Szarkowski, the ways in which the images signified 'a particular civilization' was less about personal observation and record, and more about the materials surrounding all Americans, should they decide to notice them. As such, Frank's insistence that photography must be born out of the 'instantaneous reaction to oneself' was interpreted by Szarkowski to mean that Frank had created 'a new iconography for contemporary America, comprised of bits of bus depots, lunch counters, strip developments, empty spaces, cars, and unknowable faces'.[31] Szarkowski's comments were, above all, about Frank's ability to recognise the iconography of a decidedly post-war culture. However, it also operates as a reminder of how Kerouac's writing – although consistently contextualised within that of other 'Beat' writers – also operates within a wider visual culture. The 'bus depots, lunch counters . . . and unknowable faces' that Szarkowski considered to be a new iconography for contemporary America had, of course, been part of documentary photography as well as the Beat movement for well over a decade when *The Americans* was published. And more importantly, it had also formed a constituent part of Evans's *American Photographs* and, in a very different context, Weegee's *Naked City*.

In the end, the issue of whether *The Americans* should be defined as a form of photo-text hinges on the importance given to Kerouac's Introduction as a guide towards a reading of the images. Frank's photographs have since become even more entrenched emblems of

post-war America, stand-alone images of a nation on the cusp of seismic changes, both politically and psychologically. None the less, this should not detract from the importance of Kerouac's vision: a vision that places *The Americans* in a much wider context philosophically and within the history of twentieth-century documentary photography. Frank came with a continental perspective but the importance of Evans's work, in particular, for how he looked towards the everyday, the average American, cannot be under-estimated. Kerouac understood that within Frank's documentary eye lay a desire both to be a part of what was observed and to remain at a safe distance at the same time. For Szarkowski, as for many others, the desire to radicalise Frank simply superseded any assessment of Kerouac's Introduction. Decades after *The Americans*, Frank continued to argue for an attempted collapse between the subjective and the objective within documentary photography, a collapse that arguably can be traced back to a Beat aesthetic as much as to previous photo-textual collaborations. In the 1970s, Frank left photography behind in order to focus on cinema and yet his position – 'I'm always looking outside, trying to look inside. Trying to tell something that's true' – marks his visual territory in ways that are fundamentally similar to Evans's quest for a transcendent form of documentary photography.[32] Frank managed to return to photography and, as promised, began to experiment truly with how to synthesise words and images. Although he still seeks to move away from the iconic stature of *The Americans*, the book remains a remarkable point in the history of the photo-text, in terms of both its limitations and its potential.

Notes

1. Jack Kerouac, 'On the Road to Florida' (1955), in Jane M. Rabb, ed., *Literature and Photography: Interactions 1840–1990* (Albuquerque: University of New Mexico Press, 1995), p. 397.
2. Jack Kerouac, 'Introduction', in *The Americans* (New York: Grove Press, 1959), p. 8.
3. Quoted in Joel Eisinger, *Trace and Transformation: American Criticism of Photography in the Modernist Period* (Albuquerque: University of New Mexico Press, 1995), pp. 130–1.
4. Frank carefully labelled his negative and contact sheet files by location, event and subject matter. When he finished his Guggenheim journey, he had amassed approximately 20,000 frames, of which he then printed

about 1,000. In June 1957, he delivered a maquette to Delpire consisting of four sections, each beginning with an image containing, in some way or another, the American flag. 'When you deal with simple pictures like in the Americans, you go by elimination; you have a sequence that deals maybe with patriotism or people in cars. You simply eliminate the weaker pictures. It depends what is the strongest picture, and what then becomes the weaker picture. It has to be clear, it has to have a certain composition.' William S. Johnson, ed., *The Pictures Are a Necessity: Robert Frank in Rochester, NY, November 1988* (Rochester: George Eastman House, 1989), p. 174.

5. Robert Frank and Alfred Leslie, directors, *Pull My Daisy* (1959).
6. Hart Crane, *The Bridge* (New York: Black Sun Press, 1930).
7. Williams, William Carlos, 'Sermon with a Camera', *New Republic*, 11 October 1938, available at <https://newrepublic.com/article/78785/sermon-camera>.
8. Ibid.
9. Kerouac, 'Introduction', p. 8.
10. Ibid., p. 7.
11. Ibid., p. 8.
12. Johnson, *The Pictures Are a Necessity*, p. 174.
13. According to Terence Pitts, *The Americans* 'captured the breadth of the American continent, the despair, hypocrisy and loneliness that seemed to pervade American society, and the emptiness that lay behind the façade of Hollywood and consumer hype that masqueraded as the good life'. Terence Pitts, *Reframing America* (Albuquerque: University of New Mexico Press, 1995), p. 86. Similarly, Sarah Greenough writes that while Frank was able to 'describe those people, places, and things that seemed true and genuine, with a spiritual integrity or moral order', the book was nevertheless primarily about the 'profound malaise of the American people of the 1950s', 'the deep-seated violence and racism, and the mind-numbing conformity, and similarity of the ways Americans live, work, and relate to one another'. Greenough's point is that even though Frank was not 'formulating a conscious, rational polemic', the book should be read primarily as a criticism of the American way of life. Quoted in Robert Frank, *Moving Out* (Washington, DC: National Gallery of Art, 1994), p. 115.
14. Robert Frank's Guggenheim application, quoted in Jeff Rosenheim, ed., *Unclassified: A Walker Evans Anthology* (New York: Scalo, 2000), p. 85.
15. Ibid., p. 87.
16. Ibid.
17. Kerouac, 'Introduction', p. 8.
18. Ibid.
19. Ibid., p. 9.

20. Ibid., p. 5.
21. Jack Kerouac, *Visions of Cody*, introduced by Allen Ginsberg (New York: McGraw Hill, 1972).
22. Kerouac, 'Introduction', p. 8.
23. Allen Ginsberg, 'The Great Rememberer', introduction in Kerouac, *Visions of Cody*, p. 7.
24. Kerouac, 'Introduction', p. 8.
25. In the Paris version, counter to what Frank wanted, the idea of the photo-text as a social critique of America was foregrounded through the insertion of secondary material in the form of extracts and quotations. Because it appeared as number three of a monograph series called 'Encyclopédie essentielle', the statistics and quotations enhanced the idea of the text as a piece of social documentation. According to Frank, the title nevertheless refers to Walker Evans's 1938 *American Photographs*.
26. Robert Frank as quoted in Johnson, *The Pictures Are a Necessity*, pp. 40–2.
27. '1960, Decide to put my camera in my closet. Enough of observing and hunting and capturing (sometimes) the essence of what is black or what is good and where is God.' Ibid., p. 75.
28. Johnson, *The Pictures Are a Necessity*, p. 75.
29. Ibid., p. 64. Frank's sporadic interest in foregoing photography for a medium that he considered more honest about its mimetic role – namely, film – indicates the seriousness with which he encountered the moral dilemma of realist representation. When Frank returned to photography, it was through a significantly more abstract style that included the use of collage, Polaroids and writing on negatives, designed to foreground the self-reflexive nature of the medium, its limitations as well as its expressive abilities. For an example of how more recent readings of Frank tend to downplay his ambivalent relationship to photography see Blake Stimson, *The Pivot of the World: Photography and its Nation* (Cambridge, MA: MIT Press, 2006).
30. Johnson, *The Pictures Are a Necessity*, p. 75.
31. John Szarkowski, quoted in Jane Livingstone, *The New York School Photographs 1936–1963* (New York: Stewart, Tabori and Chang, 1992), p. 304.
32. Quoted in Johnson, *The Pictures Are a Necessity*, p. 75.

Conclusion

A field of junked cars, a man in faded overalls, children in rags, a row of unpainted houses, an unshaved farmhand do not speak to Americans of human realities but of social conditions to be remedied. When the conditions are remedied, they are remarkably less photogenic. There is a conflict of imagery in *Let Us Now Praise Famous Men,* where the words soar into the empyrean, but the photographs, happily, remain earthbound. To that extent, the counterpoint is more fruitful than if the words and images were on the same plane.[1]

Wright Morris's comments on Walker Evans and James Agee's *Let Us Now Praise Famous Men* speak volumes about the choices made by documentary photographers in the 1930s, but more importantly, they register the advantages rather than disadvantages of the disjunction between text and imagery in the photo-text overall. If the moments when 'words and images' are not 'on the same plane' are particularly useful, it is because they accentuate the fluidity of meaning in the respective mediums rather than allow one to smooth out the other. For Morris, the 'earthbound' nature of the 'unshaven farmhand' and 'the children in rags' is, for better or worse, proof of the fact that certain 'social conditions' are more photogenic than others. And in many ways, the photo-texts discussed here prove that the documentation of lives lived in abject poverty was indeed a useful, if at times problematic, way to interrogate the state of the nation in the 1930s, 1940s and 1950s. None the less, a large question looms over the perhaps unpalatable fact that so much of the documentary photography that came out of these decades seemed to maintain a deliberate distance towards the subjects rendered, a distance at times accentuated rather than narrowed by the accompanying text.

As seen in the *Roll, Jordan, Roll* and *You Have Seen Their Faces* in particular, the use of previously enslaved subjects, whether it be for racial or economic purposes (and most often the two were one and the same), also became a way to essentialise a form of regionalism at risk of becoming outmoded in a country of increasing industrialisation and urbanisation. Dorothea Lange and Paul Taylor's *American Exodus* – only a few years after Margaret Bourke-White and Erskine Caldwell's attempts to ventriloquise the local sharecroppers in their version of the South – was already trying to move on, both figuratively and metaphorically, from any attempt to posit the United States as a stationary and indeed stable entity. If they too were engaged in utilising their subjects as intermediaries in a search for some vernacular truth – as in *Let Us Now Praise Famous Men* – then the on-going movement of displaced people in *American Exodus* became proof of the fact that an on-going identity crisis was both present and still very palpable at the tail end of the Great Depression.

In this context, the fact that many of these photo-textual collaborations have been neglected as coherent works, in favour of a stronger focus on the photographers themselves, might then rest on what is perceived as the outdated nature of their ethnographic and sociological focus. While Lange, for instance, remains one of the most iconic figures of 1930s documentary photography, her partner Taylor's statistical summarisation of working conditions in rural areas in *American Exodus* is never mentioned as anything other than rather immaterial material in the overall context of the book. Similarly, Caldwell's attempts to summarise the status of the South in *You Have Seen Their Faces* is rarely included in critical assessments of his work – his notoriety as a Southern writer resting more or less on his fiction. It is more surprising, perhaps, that Evans's photographs in both *American Photographs* and *Let Us Now Praise Famous Men* were for decades defined as iconic markers of a particular type of Americana, irrespective of their textual and written context. Apart from the desire to consolidate photography as a twentieth-century art form – distinct from other art forms – the reluctance to see Evans's photography in anything other than modernist terms has also divorced him from being read in a genuine literary context. If the writing in *Roll, Jordan, Roll*, for instance, disqualified itself from being the 'right' form of modernism due

to its use of African–American stereotypes, the writing in *Let Us Now Praise Famous Men* for many years appeared to disqualify itself from being the 'right' kind of modernism because of its messy hybrid nature, compared to the neat symmetry and aesthetic structure of Evans's images.

This sense that the writing in the photo-texts served only to muddy the waters of what might otherwise be a more persuasive form of documentary has since been slowly remedied. The fact that the documentary gaze was constructed to give the appearance of a dignified and socially responsible version of America through its relationship to the writing that accompanied it is one that numerous studies of twentieth-century photography have overlooked. Part of the reason for this is that the study of much documentary photography – or what is perceived as documentary photography – still rests primarily on a content-based analysis. This is, of course, more problematic when books such as Weegee's *Naked City* and Wright Morris's *The Home Place* overtly signal their status as narratives dealing with what it means to be a photographer *and* a writer at the tail end of a particular documentary tradition. More than definitive studies of particular places, these photo-texts are channelled through one distinct authorial eye and voice. Weegee's concept of New York as his own 'Naked City' may have reconciled photography's role as both art and social commentary, but it did so through a sophisticated and often problematic use of puns, captions and imaginative text.

One of the aims of this study has thus been to show how the photo-text as a genre enabled a rethinking of photography as a useful allegory for the process of writing. As William Carlos Williams and Lincoln Kirstein recognised, the very nature of documentary photography lent itself to a continuation of the exploration of America instigated in literary terms through nineteenth-century Transcendentalism. Subsequently reinvigorated by the camera's ability to visualise that bond between humans and nature, which Ralph Waldo Emerson had articulated a century before, Kirstein and Williams turned the camera's focus on the vernacular into a quest with far-reaching moral and artistic consequences. This, I have argued, is a theme that extends beyond the regional parameters witnessed in the photo-texts here and it is – to a large extent – what makes these books uniquely American in their desire to consolidate a democratic

ideal through the synthesis of photography and writing. The photo-text, in this sense, is as much about defining the utilitarian value of American ideals and dreams through various vernacular modes – writing and photography – as it is about critiquing social and economic ills. This creates a series of contradictions, some of which are productive creatively, and some which inevitably foreclose more politically astute readings of certain issues, whether they be the legacy of sharecropping or of ethnic slums.

No wonder, then, that the fraught issue of what constitutes an appropriate political eye is a continuous concern in the work charted here. For some, Evans's photographs enable a more complex vision of unification and democracy than Agee's writing, while for others, the images seem distinctly uneasy with the political context of the writing. As regards Nancy Newhall and Paul Strand's *Time in New England*, the reason why we read the book as more than simply a New England travel guide is the underlying disjunction between images and text: an uneasiness that may not be overt but that none the less questions whether there really is a visible connection between democratic values, as set out in Newhall's textual extracts, and Strand's photographs of a more 'timeless' New England. The question in *Time in New England*, how the camera places itself both in opposition to and with the textual material, is not simply about how to synthesise the regional and the photographic; it is also about the mimetic qualities and purposes of the camera itself.

Strand's pristine shots of the timeless aspects of New England culture are, of course, miles away from Weegee's immersive experience of an often tainted urban environment. In *Naked City*, the ways in which spectators are represented as extensions of his own desires and obsessions are means not simply of signalling the realism of the subject matter, but also of querying the very process of photography. In these examples, both photo-texts use the potential of photo-textual interaction to question the process of naming and to recognise that captions and other textual extracts can be as much about interruption as about cohesion in narrative terms. As such, the confluence of photo-textual practice with a very American embrace of the vernacular is more than simply a short cut towards the 'real' America. In fact, by allowing text to change the course of what a photograph or photographs may otherwise have been saying, certain contradictions within photo-textual and

documentary practice become more visible. Morris's photo-texts are exemplary in this instance of the ways in which the accompanying text hinders what might be the natural supremacy of the image as the chief purveyor of meaning. For Morris, as for Strand, the benefit of the photo-text was precisely the ways in which it could move between different mediums, ensuring that the meaning produced is never stationary.

This sense of mobility between writing and photography lies at the heart of the collaborations charted here. None the less, this mobility, in which the interaction between what we can actually see in front of us and what the captions and prose imply, often disturbs what we might assume to be the photo-text's agenda. As has been seen, Weegee's *Naked City* became a bestseller, not merely because of the gratuitous and violent nature of his material but also because in 1945 his text provided the perfect contemporary commentary on the urban scenario: a commentary recognisable to audiences of the period, even if the photographs were unusually graphic. *Let Us Now Praise Famous Men*, on the other hand, finished in 1936 but not published until 1941, sold only about 600 copies, largely because Agee's text spoke to a very limited audience. Today, historians of photography have reappropriated the book as an essential photo-text of the period, and one of the reasons for this is Agee's attempt to define his own identity as a writer. In his own cumbersome manner, Agee's deliberations regarding the ethics of documentary practice speak to the ways in which we problematise documentary aesthetics today. Agee took the construction of a cohesive identity within an increasingly schizophrenic and contradictory American society as *the* mission of the artist, a mission that ideally would prove the efficacy of the photograph on more than simply a documentary level.

This is not to say that Agee could escape the problems of using actual people in actual places as stepping-stones for his own internal deliberations. By internalising the process of documentation, he was well aware of the risks of turning the photo-text into an exercise in self-representation above all. What he could do was take a visual interest in vernacular culture and turn it into an arena for artistic contemplation. This space, if established correctly, would allow the realist dimensions of the documentary process to coincide with something more lyrical and intuitive – the very thing that Williams saw as operative within Evans's practice.

Not coincidentally, many of the photo-texts investigated here include the photographer and writer as subjects themselves, situated just far enough outside the economic and racial structures that they investigate to be able to provide a bird's-eye view. From Weegee's bums and vagrants and Doris Ulmann's sentimentalised plantation workers, to Roy DeCarava's urban loiterers, an image is often painted of a society in which something tentative and at times even immobile seems to reign, as though the camera itself has fixed the social and cultural scenes before us. This is made all the more noticeable in texts where images sequentially move from explosive moments of action to subjects rendered immobile and still – whether it be because of sudden death (Weegee), unemployment (Lange) or simply in contemplation (as in Robert Frank's *The Americans*). More problematic, perhaps, are those moments where this sense of immobilisation occurs through a rendering of the very act of spectatorship, as though the gaze of the photographer is capable of arresting that of his or her subjects and directing it on his or her own terms.

One of the noticeable features of the photo-textual material here is the attempt by artists and writers to give that immobilised subject some agency – usually through the vernacular accompaniment of quotations pretending to be actual statements (*You Have Seen Their Faces*), extended passages of colloquial writing (*The Inhabitants*) or even the type of complex ventriloquising seen in *Roll, Jordan, Roll* and *The Sweet Flypaper of Life*. This idea, that agency can be bestowed on the people and places photographed through a soundscape of colloquial writing, carries all sorts of ramifications that this study has not gone into but that none the less warrant thinking about. It is no coincidence that film is that other crucial form of documentary endeavour in which ideas of agency and spectatorship can shift according to who is speaking, and according to what images we see when we hear someone speak. As in the photo-text, the documentary filmmaker (and Strand, Agee and Frank all considered themselves filmmakers as well) can disrupt the synchronisation between movement and sound for purposes that extend far beyond the subject matter shown on the screen.

Strand, Agee and Frank went into various filmic projects for a variety of reasons, but they all wanted to see if cinema, the moving image, could overcome the natural tendency we have in

witnessing still images to take a step back in contemplation, no matter how engaging or emotive the image before us might be. This movement back and forth or, one might say, the sense that the photo-text chooses to stay on the periphery of the action (Agee's metaphorical porch, for instance) lends itself to thinking about the genre as somehow hesitant, or unsure of how to manipulate the interaction it proposes between text and images. And, in some ways, this is understandable, given the fact that these photo-texts were all at the vanguard of various discourses that we now take for granted. For someone like Ulmann, however, and paradoxically even someone as 'modern' as Frank, photography owes no innate allegiance to an idea of progress or technology; nor does it have to present itself as a superior or even reliable source of realism. In fact, the photo-texts here are just as likely to be used to advocate against whatever modern forces might impinge on the cultural subjectivity of the artist him- or herself as they are intent on providing a coherent and whole vision of a particular set of people or a region.

Thus, while the format of the photo-text lends itself to the appearance of veracity, the issue of 'cultural subjectivity' inevitably marks the ways in which that veracity is represented. As seen in *Roll, Jordan, Roll*, Julia Peterkin's precarious place, as both inside the plantation system and yet outside the world of her employees, makes for a perspective that, on the one hand, has to be continuously mobile in order to operate effectively and, on the other hand, needs to be convinced of its own ethical superiority, of its own place in the hierarchy of things, to maintain its chosen perspective.

The politics of who is in charge of the look and who is potentially dispossessed by it are always reactivated through the photo-textual process, a process that, I have argued, disrupts the idea of the photograph as an easy entry into documentary veracity. The iconicity of Lange's 'Migrant Mother' image was such that she chose not to include it in *American Exodus*, probably because she realised that, without the potential disturbance of its value through captions and other textual frames, it would maintain an altogether different value. There is much more to be said about what makes a photograph a rarefied object, a collectable, a work of art in a museum, but it is worth keeping in mind that the intentional and, at times,

unintentional side effect of putting text and images together is that both become more shifty, more contradictory, and as such all the more representative of the schisms that lie at the heart of American art and politics.

Notes

1. Wright Morris, 'Photographs, Images, Words' [1979], in *Time Pieces: Photographs, Writing, and Memory* (New York: Aperture, 1999), p. 62.

Bibliography

Archives and Resources

Archives of American photography at the Smithsonian American Art Museum

'Picturing the 1930s' on this site has a useful Resource Credit listing for further research into the period:

http://americanart.si.edu/exhibitions/archive/2013/photographs/

Centre for Creative Photography (a vast collection of American photographic materials):

www.creativephotography.org

International Center of Photography – New York (archives of Weegee's work, amongst others):

https://www.icp.org/collections

Library of Congress Prints and Photographs Division:

https://www.loc.gov

Metropolitan Museum of Art:

http://www.metmuseum.org/toah/hd/evan/hd_evan.htm

Walker Evans Archives

http://www.metmuseum.org/toah/hd/evan/hd_evan.htm

Primary and Secondary Sources

Adams, Ansel and Nancy Newhall, *Eloquent Light* (New York: Aperture, 1963).

— *Fiat Lux* (New York: McGraw-Hill, 1967).

Agee, James and Walker Evans, *Let Us Now Praise Famous Men* [1941] (New York: Houghton Mifflin, 1988).

Barth, Miles, ed., *Weegee's World* (New York: Little Brown & Co., 1997).

Barthes, Roland, *Camera Lucida* [1980], trans. Richard Howard (London: Vintage, 1993).

Baughman, James L., *Henry R. Luce and the Rise of the American News Media* (Baltimore: Johns Hopkins University Press, 2001).

Blair, Sara, *Harlem Crossroads: Black Writers and the Photograph in the Twentieth Century* (Princeton: Princeton University Press, 2007).

Blinder, Caroline, 'The Bachelor's Drawer: Art and Artefact in the Work of Wright Morris', in *Writing with Light*, ed. Mick Gidley (London: Peter Lang, 2010).

— ed., *New Critical Essays on James Agee and Walker Evans: Let Us Now Praise Famous Men* (New York: Palgrave Macmillan, 2010).

— 'The Transparent Eyeball: Emerson and Walker Evans', *Mosaic: A Journal for the Interdisciplinary Study of Literature*, 37:4 (December 2004).

Bourke-White, Margaret and Erskine Caldwell, *You Have Seen Their Faces* (New York: Duell, Sloan and Pierce, 1937).

Brinkley, Alan, *The Publisher: Henry Luce and his American Century* (New York: Alfred A. Knopf, 2010).

Brown, Milton, 'Photography Year Book 1963', in *Paul Strand: A Retrospective Monograph, 1971* (New York: Aperture, 1971).

Brunet, François, *Photography and Literature* (London: Reaktion, 2009).

Burgin, Victor, ed., *Thinking Photography* (London: Macmillan, 1982).

Casey, Janet Gallingani, *A New Heartland: Women, Modernity, and the Agrarian Ideal in America* (Oxford: Oxford University Press, 2009).

Chapin, Ruth, 'Which Lives In All That Is Free, Noble, and Courageous', *Christian Science Monitor*, 18 November 1950.

Corwin, Sharon, Jessica May and Terri Weissman, eds, *American Modern: Documentary Photography by Abbott, Evans, and Bourke-White* (Chicago: Art Institute, 2010).

Crane, Hart, *The Bridge* (New York: Black Sun Press, 1930).

Cummings, Paul, 'Walker Evans', in *Artists in Their Own Words* (New York: St Martin's Press, 1979).

Davey, Elizabeth, 'The Souths of Sterling A. Brown', *Southern Cultures*, 5:2 (January 1999).

Davidov, Judith Fryer, *Women's Camera Work* (London: Duke University Press, 1998).

DeCarava, Roy, *the sound I saw* (New York: Phaidon, 2001).

Du Bois, W. E. B., *The Souls of Black Folk* [1903] (New York: Bantam Classic, 1989).

Eisinger, Joel, *Trace and Transformation: American Criticism of Photography in the Modernist Period* (Albuquerque: University of New Mexico Press, 1995).

Emerson, Ralph Waldo, 'Historic Notes of Life and Letters in New England', *Atlantic Monthly*, October 1883.

— 'On Nature' [1836], reprinted in Carl Bode, ed., *The Portable Emerson* (New York: Penguin, 1946).

— *The Journals and Miscellaneous Notebooks*, ed. Alfred R. Ferguson and Ralph H. Orth (Cambridge: Harvard University Press, 1960–82), vol. 4.

Evans, Walker, *American Photographs* (New York: Museum of Modern Art, 1938).

Fellig, Arthur (also known as Weegee), *Naked City* (New York: Da Capo/ Essential Books, 1945).

— *Weegee: The Autobiography* (New York: Ziff-Davis, 1961).

Frampton, Hollis, 'Mediations around Paul Strand' [1972], in *Circles of Confusion: Film, Photography, Video: Texts, 1968-1980* (San Francisco: Visual Studies Workshop, 1983).

Frank, Robert, *Moving Out* (Washington, DC: National Gallery of Art, 1994).

— *The Americans* [Paris: Delpire, 1958] (New York: Grove Press, 1959).

— and Alfred Leslie, directors, *Pull My Daisy* [short film] (1959).

Gidley, Mick, *Photography and the U.S.A.* (London: Reaktion, 2011).

Goggans, Jan, *California on the Breadlines: Dorothea Lange, Paul Taylor, and the Making of a New Deal Narrative* (Berkeley: University of California Press, 2010).

Gualtieri, Elena, ed., *Paul Strand Cesare Zavattini: Lettere e Immagini* (Bologna: Bora, 2005).

Hannigan, William, *New York Noir: Crime Photos from the Daily News Archive* (New York: Rizzoli, 1999).

Hansom, Paul, ed., *Literary Modernism and Photography* (London: Praeger, 2002).

— '*You Have Seen Their Faces*, of Course: The American South as Modernist Space', in Paul Hansom, ed., *Literary Modernism and Photography* (London: Praeger, 2002).

Hills, Crystal Margie, 'Wees Gonna Tell It Like We Know It Tuh Be: Coded Language in the Works of Julia Peterkin and Gloria Naylor', Thesis (Georgia State University, 2008), available at <http://scholarworks.gsu. edu/english_theses/45> (last accessed 23 July 2018).

Hughes, Langston and Roy DeCarava, *The Sweet Flypaper of Life* (New York: Simon and Schuster, 1955).

I'll Take My Stand by Twelve Southerners (New York: Harper and Brothers, 1930).

Ings, Richard, '"And You Slip into the Breaks and Look Around": Jazz and Everyday Life in the Photographs of Roy DeCarava', in Graham Lock and David Murray, eds, *The Hearing Eye: Jazz & Blues Influences in African American Visual Art* (Oxford: Oxford University Press, 2009).

Jacobs, Philip Walker, *The Life and Photography of Doris Ulmann* (Louisville: University of Kentucky Press, 2001).

Johnson, William S., ed., *The Pictures Are a Necessity: Robert Frank in Rochester, NY, November 1988* (Rochester: George Eastman House, 1989).

Joyner, Charles, 'Foreword', in Julia Peterkin, *Green Thursday* (Athens: University of Georgia Press, 1998).

Kaplan, Louis, '"We don't know": Archibald Macleish's *Land of the Free* and the Question of American Community', in *American Exposures: Photography and Community in the Twentieth Century* (Minneapolis: University of Minnesota Press, 2005).

Kazin, Alfred, *On Native Grounds: An Interpretation of Modern American Prose Literature* (New York: Reynal and Hitchcock, 1942).

Kerouac, Jack, 'Introduction', in *The Americans* (New York: Grove Press, 1959).

— 'On the Road to Florida' (1955), in Jane M. Rabb, ed., *Literature and Photography: Interactions 1840-1990* (Albuquerque: University of New Mexico Press, 1995).

— *Visions of Cody*, intro. Allen Ginsberg (New York: McGraw Hill, 1972).

Kirstein, Lincoln, 'Afterword', in Walker Evans, *American Photographs* (New York: Museum of Modern Art, 1938).

Klein, Mason and Catherine Evans, eds, *The Radical Camera: New York's Photo League 1936-1951* (New Haven, CT: Yale University Press, 2011).

Knoll, Robert E., *Conversations with Wright Morris: Critical Views and Responses* (Lincoln: University of Nebraska Press, 1977).

Kreidler, Jan, 'Reviving Julia Peterkin as a Trickster Writer', *The Journal of American Culture*, 29:4 (2006).

Lange, Dorothea and Paul Taylor, *American Photographs* (San Francisco: Chronicle Books, 1994).

— *An American Exodus: A Record of Human Erosion* [New York: Reynall and Hitchcock, 1939] (Paris: Jean Michel Place, 1999).

Laude, André, 'Introduction', in *Weegee* (London: Thames and Hudson, 1989).

Letters of James Agee to Father Flye (New York: George Braziller, 1962).

Levin, Howard M. and Katherine Northrup, *Dorothea Lange: Farm Security Administration Photographs, 1935–1939*, vols 1 and 2, text Paul S. Taylor (Washington, DC: Library of Congress, 1980).

Lewis, Nghana Tamu, 'The Rhetoric of Mobility, the Politics of Consciousness: Julia Mood Peterkin and the Case of a White Black Writer', *African American Review*, 38:4 (2004).

Livingstone, Jane, *The New York School Photographs 1936-1963* (New York: Stewart, Tabori and Chang, 1992).

Lock, Graham and David Murray, eds, *The Hearing Eye: Jazz & Blues Influences in African American Visual Art* (Oxford: Oxford University Press, 2009).

Machethan, Lucinda H. '"I'll Take My Stand": The Relevance of the Agrarian Vision', *Virginia Quarterly Review* (Autumn, 1980), vol. 56.

McEuen, Melissa A., *Seeing America: Women Photographers Between the Wars* (Lexington: University Press of Kentucky, 2004).

Macieski, Robert, *Picturing Class: Lewis W. Hine Photographs Child Labor in New England* (Boston: University of Massachusetts Press, 2015).

Macleish, Archibald, *Land of the Free* (New York: Harcourt, Brace, 1938).

— and Jeffrey J. Folks, eds, *Remembering James Agee* (Athens: University of Georgia Press, 1997).

Matthiessen, F. O., 'Method and Scope', in *American Renaissance* (Oxford: Oxford University Press, 1941).

Miller, Ivor, '"If It Hasn't Been One of Color": An Interview with Roy DeCarava', *Callaloo*, 13:4 (Autumn, 1990).

Millstein, Gilbert, 'While Sister Mary Sticks Around', *The New York Times Book Review*, 27 November 1955.

Mora, Giles and John T. Hill, eds, *Walker Evans: The Hungry Eye* (London: Thames and Hudson, 2004).

Morris, Wright, *Earthly Delights, Unearthly Adornments: American Writers as Image-Makers* (New York: Harper and Row, 1978).

— *God's Country and My People* (New York: Harper and Row, 1968).

— *Love Affair – A Venetian Journal* (New York: Harper & Row, 1972).

— *Photographs and Words* (Carmel: Friends of Photography Press, 1982).

— *Plains Song: For Female Voices* (New York: Harper & Row, 1980).

— *Structures and Artifacts: Photographs 1933-1954* (Lincoln: University of Nebraska Press, 1976).

— *The Field of Vision* (Lincoln: University of Nebraska Press, 2002).

— *The Home Place* [New York: Charles Scribner's Sons, 1948] (Lincoln: University of Nebraska Press, 1999).

— *The Inhabitants* (New York: Charles Scribner's Sons, 1946).

— *The Territory Ahead* (New York: Harcourt Brace, 1958).

— *Time Pieces: Photographs, Writing, and Memory* (New York: Aperture, 1999).

Newhall, Beaumont, *The History of Photography* (New York: MOMA, 1937).

Newhall, Nancy, 'The Caption: The Mutual Relation Between Words/ Photographs', in *From Adams to Stieglitz: Pioneers of Modern Photography* (New York: Aperture, 1999); originally printed in *Aperture 1* [1952].

— *From Adams to Stieglitz: Pioneers of Modern Photography* (New York: Aperture, 1999); originally printed in *Paul Strand: Photographs, 1915– 1945* [New York: MOMA, 1945].

Nye, David E., *Narratives and Spaces: Technology and the Construction of American Culture* (New York: Columbia University Press, 1998).

Orlan, Pierre Mac, 'Elements of a Social Fantastic' [1929], in Christopher Phillips, ed., *Photography in the Modern Era – European Documents and Critical Writings, 1913–1940* (New York: Aperture, 1989).

Orvell, Miles, *The Real Thing: Imitation and Authenticity in American Culture, 1880–1940* (Chapel Hill: University of North Carolina Press, 1989).

— 'Weegee's Voyeurism and the Mastery of Urban Disorder', *American Art*, 6:1 (Winter, 1992).

Owens, Olga, 'The True Christmas Spirit Survives in New England', *Boston Sunday Post*, 3 December 1950.

Parrington, Vernon Louis, *Main Currents in American Thought* (New York: Harcourt Brace, 1930).

Patterson, Tiffany R., *Zora Neale Hurston and a History of Southern Life* (Philadelphia: Temple University Press, 2005).

Peterkin, Julia and Doris Ulmann, *Roll, Jordan, Roll* (New York: Robert O. Ballou, 1933).

Pitts, Terence, *Reframing America* (Albuquerque: University of New Mexico Press, 1995).

Puckett, John Rogers, *Five Photo-Textual Documentaries from the Great Depression*, Studies in Photography, no. 6 (Ann Arbor: UMI Research Press, 1984).

Quinn, Jeanne Follansbee, 'The Work of Art: Irony and Identification in *Let Us Now Praise Famous Men*', *Novel*, 34:3 (Summer, 2001).

Rabb, Jane M., ed., *Literature and Photography: Interactions 1840–1990* (Albuquerque: University of New Mexico Press, 1995).

Rabinowitz, Paula, *Black & White & Noir: America's Pulp Modernism* (New York: Columbia University Press, 2002).

— '"Two Prickes": The Colon as Practice', in Caroline Blinder, ed., *New Critical Essays on James Agee and Walker Evans: Perspectives on Let Us Now Praise Famous Men* (New York: Palgrave Macmillan, 2010)

Riis, Jacob A., *How the Other Half Lives: Studies Among the Tenements of New York* [1890] (New York: Kessinger, 2004).

Roberts, Pam, *Alfred Stieglitz: Camera Work* (London: Taschen, 2013).

Robeson, Elizabeth, 'The Ambiguity of Julia Peterkin', *The Journal of Southern History*, 61:4 (1995).

Rohrbach, John, '*Time in New England*: Creating a Usable Past', in *Paul Strand: Essays on His Life and Work* (New York: Aperture, 1990).

Rosenheim, Jeff, ed., *Unclassified: A Walker Evans Anthology* (New York: Scalo, 2000).

Roy DeCarava: A Retrospective January 25th–May 7th, 1996, Press Release, Museum of Modern Art, New York.

Sekula, Allan, 'On the Invention of Photographic Meaning', in Victor Burgin, ed., *Thinking Photography* (London: Macmillan, 1982).

Stange, Maren, '"Illusion complete within itself": Roy DeCarava's Photography', in Townsend Ludington, ed., *A Modern Mosaic: Art and Modernism in the United States* (Chapel Hill: University of North Carolina Press, 2000).

— ed., *Paul Strand: Essays on His Life and Work*, intro. Alan Trachtenberg (New York: Aperture, 1990).

— *Symbols of Ideal Life: Social Documentary Photography in America 1890–1950* (Cambridge: Cambridge University Press, 1989).

Steichen, Edward, *The Family of Man* (New York: MOMA, 1955).

Stimson, Blake, *The Pivot of the World: Photography and its Nation* (Cambridge, MA: MIT Press, 2006).

Stott, William, *Documentary Expression and Thirties America* (Chicago: University of Chicago Press, 1973).

Strand, Paul, *Ghana: An African Portrait*, text Basil Davidson (New York: Aperture, 1976).

— *Living Egypt*, text James Aldridge (New York: Horizon Press, 1969).

— *Tir a'Mhurain: Outer Hebrides*, text Basil Davidson (London: McGibbon and Kee, 1962).

— and Nancy Newhall, *Time in New England* (New York: Oxford University Press, 1950).

— and Cesare Zavattini, *Un Paese: Portrait of an Italian Village* [1955], in English (New York: Aperture, 1997).

'Sunday Salon with Greg Fallis: Roy DeCarava', Utata Tribal Photography, available at <http://www.utata.org/sundaysalon/roy-decarava/> (last accessed 27 July 2018).

Thompson, J. L., ed., *Walker Evans at Work* (London: Thames and Hudson, 1984).

Trachtenberg, Alan, *Distinctly American: The Photography of Wright Morris* (London: Merrell, 2002).

— *Documenting America 1934-1943* (San Francisco: University of California Press, 1992).

— 'Foreword', in Erskine Caldwell and Margaret Bourke-White, *You Have Seen Their Faces* (Athens: University of Georgia Press, 1995), pp. v–viii, p. vii.

— 'Introduction', in Maren Stange, ed., *Paul Strand: Essays on His Life and Work* (New York: Aperture, 1990).

— *Reading American Photographs: Images as History. Mathew Brady to Walker Evans* (New York: Hill and Wang, 1989).

Trilling, Lionel, 'Greatness with One Fault in it', *Kenyon Review*, 4 (1942).

Ulmann, Doris, *A Book of Portraits of the Faculty of the Medical Department of the Johns Hopkins University* (Baltimore: Johns Hopkins Press, 1922).

— 'Among the Southern Mountaineers: Camera Portraits of Types of Character Reproduced from Photographs Recently made in the Highlands of the South', *The Mentor* (New York: Crowell, 1928).

— *A Portrait Gallery of American Editors* (New York: W. E. Rudge, 1925).

— *The Faculty of the College of Physicians & Surgeons* (New York: Columbia University, Hoeber Press, 1919).

Weaver, Mike, *The Photographic Art: Pictorial Traditions in Britain and America* (New York: Harper & Row, 1986).

Weiner, Sonia, 'Narrating Photography in *The Sweet Flypaper of Life*', *MELUS*, 37:1 (Spring, 2012).

Wexler, Laura, 'The Puritan in the Photograph', in Nan Goodman and Michael Kramer, eds, *The Turn Around Religion: American Literature, Culture and the Work of Sacvan Bercovitch* (London: Ashgate, 2011).

Williams, Keith, 'Post/Modern Documentary: Orwell, Agee and the New Reportage', in Keith Williams and Steven Matthews, eds, *Rewriting the Thirties – Modernism and After* (London: Longman, 1997).

Williams, Susan Millar, *A Devil and a Good Woman, Too: The Lives of Julia Peterkin* (Athens: University of Georgia Press, 1997).

Williams, William Carlos, 'Sermon with a Camera', *New Republic*, 11 October 1938, available at <https://newrepublic.com/article/78785/ sermon-camera> (last accessed 24 July 2018).

Wright, Richard, *12 Million Black Voices*, photographs compiled by Edwin Rosskam (New York: Viking Press, 1941).

Yochelson, Bonnie, *Jacob A. Riis – Revealing New York's 'Other Half': A Complete Catalogue of his Photographs* (New Haven, CT: Yale University Press, 2015).

— 'The Clarence White School of Photography', available at <https:// www.moma.org/interactives/objectphoto/assets/essays/Yochelson.pdf> (last accessed 23 July 2018).

Links to Useful Digital Materials

Archives of American photography at the Smithsonian American Art Museum

'Picturing the 1930s' on this site has a useful Resource Credit listing for further research into the period:

http://americanart.si.edu/exhibitions/archive/2013/photographs/

Center for Creative Photography (a vast collection of American photographic materials):

www.creativephotography.org

International Center of Photography – New York (archives of Weegee's work, amongst others):

https://www.icp.org/collections

Library of Congress Prints and Photographs division:

https://www.loc.gov

On international photographers and projects:

www.magnumphotos.com

The Metropolitan Museum of Art:

http://www.metmuseum.org/toah/hd/evan/hd_evan.htm

On Jacob Riis – at the New York Historical Society:

http://www.mcny.org/jacobariis

Walker Evans Archives at The Metropolitan Museum of Art:

http://www.metmuseum.org/toah/hd/evan/hd_evan.htm

Index

BRITISH ASSOCIATION
FOR AMERICAN STUDIES

Series Editors: Martin Halliwell, Professor of American Studies at the University of Leicester; and Emily West, Professor of American History at the University of Reading.

The British Association for American Studies (BAAS)

The British Association for American Studies was founded in 1955 to promote the study of the United States of America. It welcomes applications for membership from anyone interested in the history, society, government and politics, economics, geography, literature, creative arts, culture and thought of the USA.

The Association publishes a newsletter twice yearly, holds an annual national conference, supports regional branches and provides other membership services, including preferential subscription rates to the *Journal of American Studies*.

Membership enquiries may be addressed to the BAAS Secretary. For contact details visit our website: www.baas.ac.uk